S0-CEZ-403

The Metropolitan Museum of Art Symposia

Perspectives on
American Sculpture before 1925

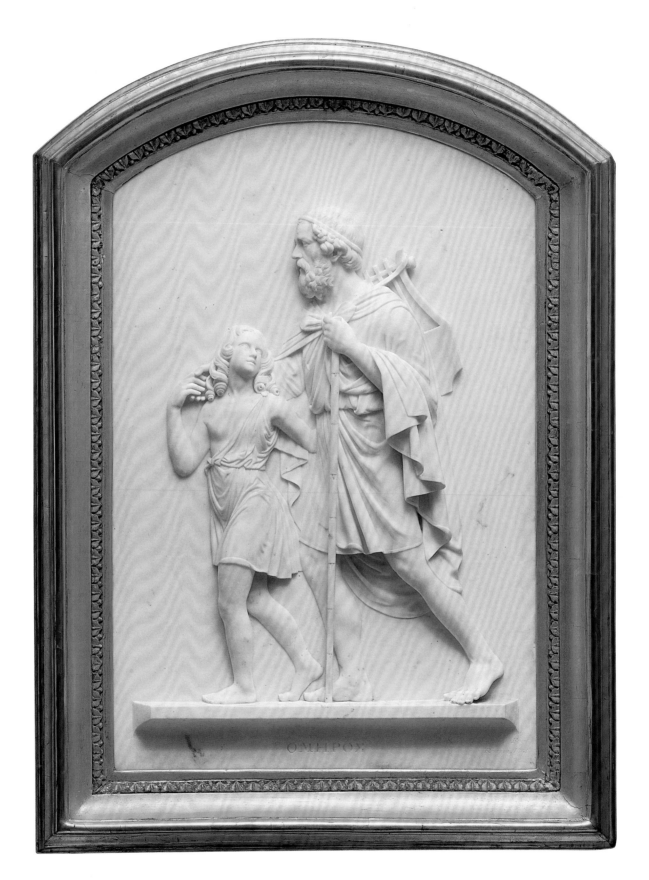

ΟΜΗΡΟΣ

The Metropolitan Museum of Art Symposia

Perspectives on American Sculpture before 1925

Edited by
Thayer Tolles

THE METROPOLITAN MUSEUM OF ART, NEW YORK

YALE UNIVERSITY PRESS, NEW HAVEN AND LONDON

*This publication is made possible
by the William Cullen Bryant Fellows of the Metropolitan Museum.*

Published by The Metropolitan Museum of Art, New York
John P. O'Neill, Editor in Chief
Dale Tucker, Editor
Sally VanDevanter, Production Manager
Minjee Cho, Desktop Publishing Assistant

Design implemented by Jo Ellen Ackerman,
of Bessas & Ackerman, based on a format established
by Tsang Seymour Design Inc.

Separations by Professional Graphics, Inc.,
Rockford, Illinois
Printed by Brizzolis Arte en Gráficas, Madrid
Bound by Encuardernación Ramos, S. A., Madrid
Printing and binding coordinated by Ediciones El Viso,
S. A., Madrid

Cover: Herbert Adams, *La Jeunesse* (fig. 51)
Frontispiece: Edward Sheffield Bartholomew, *Blind Homer
Led by the Genius of Poetry* (fig. 14)

Copyright © 2003 by The Metropolitan Museum of Art
All rights reserved
No part of this publication may be reproduced
or transmitted in any form or by any means, electronic or
mechanical, including photocopying, recording, or any
information storage or retrieval system, without permission
in writing from the publishers.

Library of Congress Cataloging-in-Publication Data

Perspectives on American sculpture before 1925 / edited by
Thayer Tolles.
 p. cm. — (The Metropolitan Museum of Art symposia)
Papers from a symposium held at the Metropolitan
Museum of Art, New York, on Oct. 26, 2001.
Includes bibliographical references.
 ISBN 1-58839-105-1 (Paperback)—ISBN 0-300-10320-4
 (Yale University Press)
1. Sculpture, American—19th century—Congresses.
2. Sculpture, American—20th century—Congresses.
3. Sculpture—New York (State)—New York Congresses.
4. Metropolitan Museum of Art (New York, N.Y.)—
Congresses. I. Tolles, Thayer. II. Metropolitan Museum of
Art (New York, N.Y.) III. Series.
 NB210.P47 2003
 730'.973—dc22 2003022712

Contents

Preface

The eight essays in this volume were originally presented as lectures in a symposium entitled "American Sculpture before 1925," held at The Metropolitan Museum of Art on October 26, 2001, in an atmosphere of excitement, collegiality, and shared purpose. Organized by Thayer Tolles, the curator responsible for American sculpture at the Metropolitan, the symposium was in large part a scholarly celebration of the Museum's collections. But it also demonstrated how research, writing, and collecting in this often underpublished field might be galvanized by the recently completed two-volume catalogue *American Sculpture in the Metropolitan Museum of Art*. As part of renovations now being planned for the American Wing, sculpture will have an enhanced presence befitting a collection of such importance. In the Charles Engelhard Court, for example, many of the Museum's superb Neoclassical marbles are being moved to more prominent, central locations. These recent events are just a few examples of how American sculpture continues to occupy a rightfully integral place within the vast and varied collections of The Metropolitan Museum of Art.

I want particularly to acknowledge The Henry Luce Foundation, Inc., the Surdna Foundation, Inc., and the National Endowment for the Arts for their generous support of the American sculpture collection catalogue; the Clara Lloyd-Smith Weber Fund, which made the symposium possible; and the William Cullen Bryant Fellows of the Metropolitan Museum, whose contributions underwrote this publication.

Morrison H. Heckscher
*Lawrence A. Fleischman Chairman
of the American Wing*

Introduction

The Metropolitan Museum of Art is home to the world's finest collection of American Neoclassical and Beaux-Arts sculpture. With its history and physical building so closely allied with American sculptors, the Museum has long been a focal point for the study of their work. John Quincy Adams Ward, a member of the Museum's board of incorporators in 1870 and a trustee until 1901, oversaw the earliest sculpture acquisitions, notably our core holdings of ideal Neoclassical marbles. Daniel Chester French, a trustee from 1903 to 1931 and head of the trustees' committee on sculpture, exhibited and acquired figurative sculpture from living artists, systematically assembling a comprehensive model of modern sculptural production. In the last three decades, a consistent program of exhibitions and scholarly publications has enhanced a collection renowned for its richness and diversity. In addition, outstanding recent acquisitions by such artists as Augustus Saint-Gaudens, Gaston Lachaise, and Paul Manship have refined and strengthened an already mature collection.

The completion in 2001 of *American Sculpture in The Metropolitan Museum of Art*, the catalogue of the Museum's holdings in American sculpture by artists born by 1885, was the culmination of years of research and writing, much of it drawn from previously unpublished documentation. While the publication of the catalogue—by Lauretta Dimmick, Donna J. Hassler, Joan M. Marter, and Thayer Tolles—concluded one phase of

study, we hope and expect it will foster further inquiry and dialogue among scholars, connoisseurs, and the Museum's public audience. To that end, the symposium held at the Metropolitan on October 26, 2001—which celebrated the recent completion of the collection catalogue—along with the record of the proceedings published in this volume, are evidence of our ongoing commitment to encourage scholarship on our holdings of American sculpture and to maintain a public presence at the forefront of the field.

In the sparsely populated discipline of American nineteenth- and early-twentieth-century sculpture studies, museums have played a seminal role. To an extent arguably greater than in other art historical specialties, museums have led or, at the very least, equaled the academy in forwarding scholarly investigation. The proliferation of catalogues dedicated to major collections of American sculpture—at the Museum of Fine Arts, Boston; Brookgreen Gardens, Murrells Inlet, South Carolina; The Chrysler Museum of Art, Norfolk, Virginia; the Pennsylvania Academy of the Fine Arts, Philadelphia; Yale University Art Gallery, New Haven; and, of course, the Metropolitan, to name just a few—provides a fundamental factual foundation for our field, a collective springboard for further intellectual inquiry. As our discipline burgeons and eventually comes of age, these object-based catalogues will continue to stand as indispensable resources. Indeed, the recent publication of several extraordinary contextual studies indicates that our field is at something of a methodological and interpretive crossroads. And still there remains enormous potential for exciting new research and scholarship, even—perhaps especially—on the most prominent artists. As long as archival resources remain untapped and avenues of inquiry go unexplored, we will have discovered only the tip of the proverbial iceberg.

The eight papers presented in this volume—by academic, museum, and independent professionals—offer a representative cross section of current thematic interests

and scholarly approaches to American sculpture studies. Although topically diverse, they have in common the use of a sculpture or group of sculptures in the Metropolitan's collection as a starting point for further contextual examination, whether formal, cultural, social, or race- or gender-based. The first paper, by William H. Gerdts, professor emeritus of art history, The Graduate School, The City University of New York, presents an overview of relief sculpture in the oeuvres of American Neoclassical expatriate and stay-at-home artists, adding a much-needed American perspective on this ancient art form. Melissa Dabakis, professor of art history, Kenyon College, focuses on Harriet Hosmer's earliest years in Rome, especially how the heady atmosphere there in the mid-nineteenth century informed Hosmer's choice of subjects, her circle of associates, and her self-perception and presentation as a woman artist. Joyce K. Schiller, curator of nineteenth- and early-twentieth-century art, Delaware Art Museum, details the complicated history of Augustus Saint-Gaudens's *Sherman Monument* in New York, in particular the protracted debate over its location in light of political, social, and aesthetic ramifications. Thayer Tolles, associate curator, American Paintings and Sculpture, The Metropolitan Museum of Art, investigates the topic of color in American sculpture, specifically Herbert Adams's decorative portrait busts of women as gauges of contemporary attitudes toward the introduction of color to form and its limited artistic response. Thomas P. Somma, director, Mary Washington College Galleries, delves into an overlooked aspect of Paul Wayland Bartlett's sculptural production: his experimentation with bronze casting and patination in his Paris foundry, which resulted in a remarkable series of small figurative and animal pieces. Andrew J. Walker, senior curator of collections, Missouri History Museum, discusses Hermon Atkins MacNeil's exploration of Native American themes and how his sculptures were informed by contemporary attitudes about ethnographic authenticity and

the future of what was then termed a "vanishing race." Alexis L. Boylan, assistant professor, Art and Art History Department, Lawrence University, considers Abastenia St. Leger Eberle's statuette *Girl Skating* as evidence of the artist's interest in reshaping perceptions of poor urban youth in the context of the early-twentieth-century women's movement. The final paper, by Janis Conner, Conner-Rosenkranz, New York, illuminates Malvina Hoffman's worshipful admiration of powerful people and how it shaped her persona, her writings, and her art.

As editor of this volume of proceedings, I offer sincere thanks to my fellow authors for their lucid and thought-provoking papers, which, like our collection catalogue, will stimulate further interest in American sculpture studies. Their timely meeting of deadlines and attentive responses during the preparation and editing of texts made the publication process all the more rewarding. I am grateful to Philippe de Montebello, director of The Metropolitan Museum of Art, who has consistently encouraged this institution's program of scholarly symposia and supported the publication of these proceedings, the fourth in a series of such volumes. Kent Lydecker, associate director for education, enthusiastically endorsed the proposal for the symposium, and Elizabeth Hammer-Munemura, associate museum educator, attended to myriad details of organization and planning. In the American Wing, I deeply value the ongoing support and counsel of Morrison H. Heckscher, Lawrence H. Fleischman Chairman of the American Wing; Peter M. Kenny, curator of American Decorative Arts and administrator of the American Wing; and H. Barbara Weinberg, Alice Pratt Brown Curator, American Paintings and Sculpture. Kathryn Sill, formerly administrative assistant, American Paintings and Sculpture, capably accumulated the photographs for this volume.

In the Editorial Department, John P. O'Neill, editor in chief and general manager of publications, offered an early endorsement of this project. His ongoing support for the

book and the efforts of his talented staff are greatly appreciated. Dale Tucker edited this volume with proficiency and a discerning insight for its subject; Sally VanDevanter capably stewarded the publication through the many details of production; Jo Ellen Ackerman, of Bessas & Ackerman, trained a creative eye on the implementation of the design, and she was ably overseen in this respect by Minjee Cho; and Connie Harper-Castle handled organizational and financial matters with her customary efficiency.

Finally, it is a pleasure to recognize the Clara Lloyd-Smith Weber Fund, which supported this symposium along with an ongoing program of lectures and symposia in the American Wing. The William Cullen Bryant Fellows of the Metropolitan Museum have underwritten expenses associated with numerous American Wing publications. This distinguished group has generously assumed all costs for this volume, for which we are most grateful.

Thayer Tolles

The Metropolitan Museum of Art Symposia

Perspectives on
American Sculpture before 1925

William H. Gerdts

The Neoclassic Relief

Sculpture in relief dates back almost to the beginnings of sculptural expression, to ancient Egypt and the cultures of the Near East, on through Classical Greece and Rome, through successive civilizations and cultures, both East and West, to our own time. Yet there has been little literature devoted specifically to this form of sculptural expression, and most of what does exist concerns the relief sculpture of the ancient world.[1]

The question might well arise as to the need for, or purpose of, an essay specifically on the relief work of the American Neoclassic sculptors; the basic response here is simply that not only has the subject been overlooked in most studies, surveys, and exhibitions of American sculpture, but also that the distinction of relief sculpture may deserve to be better understood.[2] It is not true, of course, that we are unaware of some of the finest achievements of Americans in this regard. Specifically, the bronze relief sculptures begun in the late 1870s by Augustus Saint-Gaudens, such as his *Children of Jacob H. Schiff* (fig. 1), have been much admired and discussed, and their precedent in terms of the delicacy and finesse of subtle low-relief work as found in the sculptures of such masters of the Florentine Renaissance as Desiderio da Settignano has been widely acknowledged.[3] Yet even this topic could benefit from further scholarship, especially on the dissemination of interest in this sculptural form by Saint-Gaudens's contemporaries, such as Herbert Adams, among others.

My concern here is the sculpture of the several generations preceding Saint-Gaudens: those Americans who were working primarily in marble, and the majority of whom were working abroad, in Florence and Rome. Almost all of these artists produced relief sculpture, works that are neither unknown nor unstudied but which have often taken a back seat in comparison with the more celebrated sculptures of these artists (although some of the same artists, in their own time, were at least as celebrated for their relief sculpture as for their work in the round). I am thus discussing two generations of American sculptors generally characterized as Neoclassicists: the generation of Hiram Powers, Horatio Greenough, and Thomas Crawford, all of whom began producing work during the 1820s and 1830s; and a second generation led by Randolph Rogers, William H. Rinehart, and William Wetmore Story, along with their female counterparts, such as Harriet Hosmer, who rose to professional status in the 1850s.[4]

A relief is generally a sculptured surface raised from a background, although the ancient Egyptians, for instance, also devised intaglio relief—that is, sculptured relief *within* a bordered boundary, referred to as coelanaglyphic relief.[5] The basic characteristic of relief that distinguishes it from sculpture in the round is its physical dependence on some kind of background or matrix. Relief can be high or low—alto or bas relievo—and that, I think, need not concern us here. What a relief *is not* is a sculpture in the round—one that can be addressed from all sides.

Let us consider then what this means in aesthetic and experiential terms. For one thing, given that most sculpture is figurative—depicting either humans, as in Hiram Powers's *Greek Slave* (see fig. 33), or animal, such as John Cruikshank King's *Cat* (n.d., private collection), or both, as in the many equestrian monuments of the period—the relief can seldom approximate reality to

2

the same degree as sculpture in the round, even if "lifesize." It was this "stealing the thunder of Godly creation," as well as what was seen as a resulting moral ambiguity, that made many writers—Americans, such as Nathaniel Hawthorne, and Europeans—so very critical of the English sculptor John Gibson when he colored a number of his sculptures, even though it was well known that the ancients had also done this. Actually, a few American Neoclassic sculptors also experimented with tinting, but not, to my knowledge, with relief sculpture, perhaps because a relief, by its very nature, cannot convey the lifelikeness of sculpture in the round.

However, if a relief is *not* a work in the round, but rather a design upon a flat surface, then it is actually close to the realm of painting. Indeed, throughout history relief sculpture has adopted pictorial effects inconceivable for sculpture in the round, such as, in the Renaissance, Lorenzo Ghiberti's doors of the Baptistery in Florence, and, in the Baroque period, Alessandro Algardi's *Encounter of Saint Leo the Great and Attila* (1653) in Saint Peter's, Rome, where the principal figures project almost three-dimensionally.

In nineteenth-century America there was, in fact, recognition of the role that relief sculpture could play as an intermediary between painting and sculpture. One writer in 1855, addressing the reliefs on the pedestal of Henry Kirke Brown's sculpture of De Witt Clinton, stated:

> A bas-relief seems to us to be a
> compromise between sculpture
> proper and painting, giving with the
> single idea of form, the relation of
> several objects in action to one
> another, or what we call incident, as

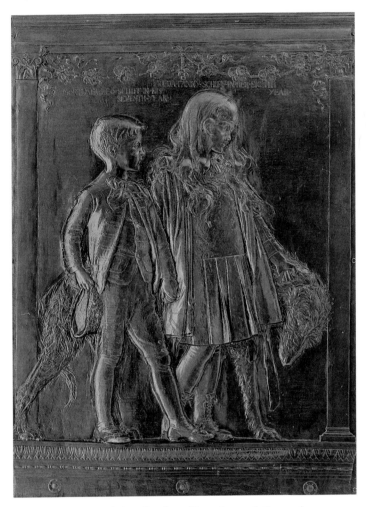

Figure 1. Augustus Saint-Gaudens (American, 1848–1907). *The Children of Jacob H. Schiff,* 1884–85; this cast, 1885. Bronze, 67⁵⁄₁₆ x 50⅜ in. (171 x 128 cm). U.S. Department of the Interior, National Park Service, Saint-Gaudens National Historic Site, Cornish, New Hampshire

3

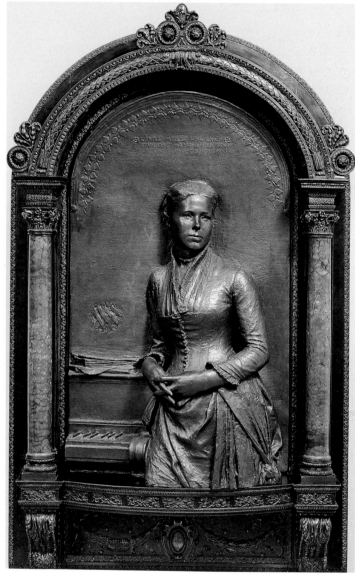

Figure 2. Augustus Saint-Gaudens (American, 1848–1907).
Louise Miller Howland, 1888. Bronze, 39⅛ x 23½ in. (99.4 x 59.7 cm).
Private collection

in those of the Parthenon, the models of relief. It is, in short, a story told in marble, and the only advantage over sculpture it offers in attainment of true artistic motive, is that of grouping several figures in one conception. On the pedestal of Brown's statue of Clinton, were some reliefs of this kind—they were incidents illustrating the life of Clinton—not studies of ideal form, &c., but the simplest and most forcible expressions of the ideas to be conveyed, which the artist could give.[6]

Brown's bronze statue of Clinton—the figure itself and the two reliefs, *The Digging of the Erie Canal* and *Commerce on the Erie Canal*—was installed in Brooklyn's Green-Wood Cemetery in 1853 and became one of the most admired sculptures of the midcentury.

Let us now consider the placement of reliefs—their spatial references and how they are distinct from sculptures in the round. Sculptures in the round may or may not be situated where they can be circumnavigated, but that is the form they take, and they are therefore positioned either directly on a flat surface or on a pedestal that elevates them. Reliefs, like paintings, are viewed straight on, from only one vantage point, and those created as private commissions were, for the most part, like paintings, often hung against walls. This distinction is true of both full-length sculptures and busts, although full-length reliefs are comparatively rare.

Hiram Powers's *Greek Slave* (see fig. 33) stands on a pedestal more decorative than the sleekly surfaced subject herself, while Augustus Saint-Gaudens's *Louise Miller Howland* (fig. 2) projects outward at high relief with a trompe l'oeil still life by her side. Most portrait busts were presumably fashioned to be placed upon a pedestal. However, when the French-born Philadelphia sculptor Joseph Alexis Bailly was commissioned to create a relief portrait of an unidentified

Figure 3. Joseph Alexis Bailly (American, 1825–1883). *Portrait of a Boy,* 1865. Marble, 18 x 14 x 5½ in. (45.7 x 35.6 x 14 cm). Biggs Museum of American Art, Dover, Delaware (96.3)

youth (fig. 3), the family, it seems, wanted a complete sculpture of the young man that would hang rather than sit or stand; the only solution was a work that almost defies the identification of "relief" in its near-total three-dimensionality.

Both the Saint-Gaudens sculpture and the Bailly relief were privately commissioned portraits. Ideal subjects—those taken from literature, mythology, and the Bible—were also undertaken in relief. These sculptures might include decorative accessories to furnishings, especially marble mantelpieces, such as those

created in 1818 by the New York carver John Frazee for the pair of mantels in the Alexander Telfair mansion in Savannah, Georgia.[7] The subjects of such reliefs usually originated in the mind of the sculptor, though they could also be suggested by a patron or prospective patron. If the former, they would probably be modeled in clay and brought to the plaster stage, awaiting a firm offer from a patron before being translated into marble, which could then be replicated. One such sculpture is Horatio Greenough's *Castor and Pollux* (fig. 4), whose original

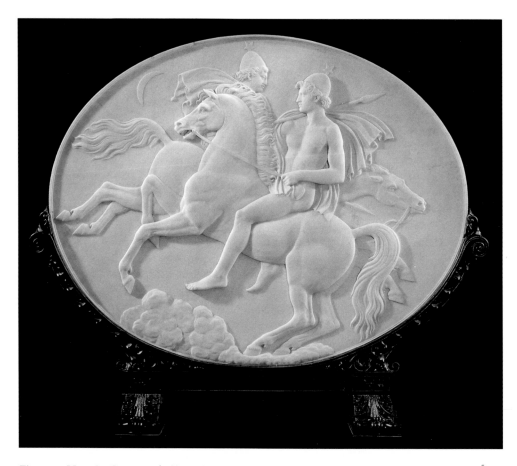

Figure 4. Horatio Greenough (American, 1805–1852). *Castor and Pollux,* ca. 1847. Marble, 34⅝ x 45³⁄₁₆ in. (87.9 x 114.8 cm). Museum of Fine Arts, Boston; Bequest of Mrs. Horatio Greenough

commission is unlocated; the present replica, not hung on a wall but placed in a half-frame, was meant, in one sense like a sculpture in the round, to be placed on a pedestal.[8]

One further analogy between painting and relief sculpture needs to be addressed, namely, that most Neoclassic narrative reliefs were conceived as compositions to be read laterally. This is more than a matter of their flatness, even though, like Classical reliefs, the preferred form was indeed flattened bas-relief rather than high relief. Narrative "movement" here usually involves a minimum of overlapping and is generally read sequentially, from side to side, disdaining the overlapping, and thus projecting forms of such Baroque

monuments as the Algardi relief. Neoclassic reliefs seldom break the sculptural equivalent of the picture plane or move out into the viewer's space. Rather, the reading of these reliefs is transmitted from figure to figure within and across a horizontal spatial axis.

There is also the matter of installation. When a painting is hung, the hooks and wires are attached not to the canvas or panel, but to a frame, which encompasses and protects it. The same is true of a relief sculpture, but the larger the relief, the heavier it will be, sometimes making hanging impractical. In any case, the relief, like a painting, is usually framed. An alternative to hanging was to place the relief in a shadow-box

Perspectives on American Sculpture before 1925

frame, which could in turn rest on a piece of furniture, where it would not necessarily require a pedestal.

Another factor, presumably, was cost. Although figures are difficult to come by, it would seem likely that a relief sculpture, whether portrait or ideal, would be less expensive than a sculpture in the round: less costly for the basic material, such as marble; less time consuming, both for the artist who designed the work and for his artisans who were employed to do the actual carving; and more economical in terms of packing and shipping. This cost differentiation, however, was not always in place, as we shall see in the case of Hiram Powers.

A great deal of relief sculpture was also public, or at least semipublic. The tradition of gravestone carving, after all, has continued through the nineteenth century to the present time. About 1849–50, Baltimore's William H. Rinehart, who began his career working for the firm of Bevan and Son, carved the draped female figure for the *J. Appleton Wilson Monument,* which stands in Green Mount Cemetery, Baltimore. If they could afford it, patrons chose full-length figures for cemetery memorials, sometimes complex multifigured arrangements such as Rinehart's later *Fitzgerald Monument,* which consists of Christ, the Angel of the Resurrection, and two funerary urns, carved in 1865 in Rome and placed in Baltimore's Loudon Park Cemetery.[9]

Relief sculpture was also incorporated in larger public projects as subsidiary decoration on the pedestals of sculptures in the round. Perhaps the most prominent of these are the scenes from Classical mythology that decorate the pedestal of Horatio Greenough's colossal seated sculpture of George Washington (1832–41, installed at the National Museum of American History, Smithsonian Institution, Washington, D.C.). These scenes, on two sides of the pedestal, reinforce the identification of Washington as an American Zeus. One relief, *Apollo Driving the Chariot of the Sun* (fig. 5), characterizes the Apollonian

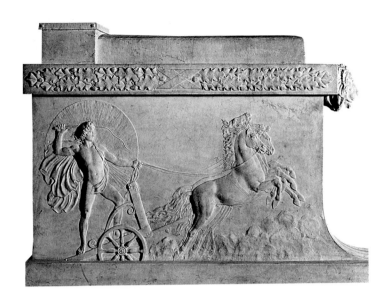

Figure 5. Horatio Greenough (American, 1805–1852). *Apollo Driving the Chariot of the Sun,* bas-relief from the seat of a statue of George Washington, 1840. Marble, 23¾ x 43¾ in. (60.3 x 111.1 cm). Smithsonian American Art Museum, Washington, D.C.; Transfer from the U.S. Capitol (1910.10.3)

Figure 6. Horatio Greenough (American, 1805–1852). *Infants Hercules and Iphicles,* bas-relief from the seat of a statue of George Washington, 1840. Marble, 23¾ x 41¾ in. (60.3 x 106 cm). Smithsonian American Art Museum, Washington, D.C.; Transfer from the U.S. Capitol (1910.10.3)

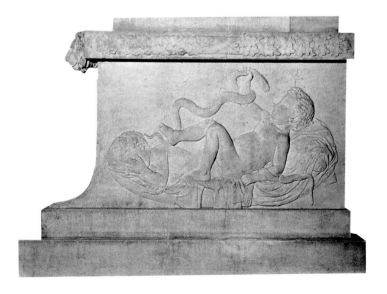

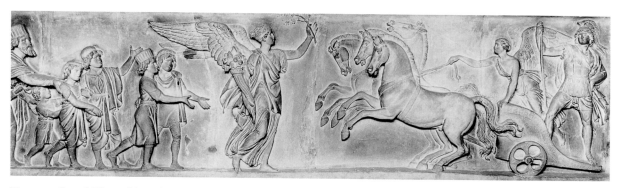

Figure 7. Bertel Thorvaldsen (Danish, 1770–1848). *Alexander the Great's Triumphal Entry into Babylon,* 1812. Plaster, 41⅞ x 135½ in. (106.4 x 344.2 cm). Thorvaldsens Museum, Copenhagen

theory of progress best known to us through Bishop George Berkeley's *Verses on the Prospect of Planting Arts and Learning in America,* written in 1726 but not published until 1752, which contains the celebrated line, "Westward the Course of Empire takes its Way." The other relief, *Infants Hercules and Iphicles* (fig. 6), represents North and South America, respectively, and deals with their political existence.[10]

Marble relief sculpture was produced in America beginning with the importation of Italian carvers to work on the new United States Capitol in 1806, but most of the sculpture of these carvers was destroyed when the Capitol was burned by British troops during the War of 1812. However, some sculptures created by those artists are still extant in Baltimore, such as *Ceres and Neptune,* by Giovanni Andrei and Giuseppe Franzoni, carved in 1808 for the Union Bank (now the Peale Museum).[11] Another group of European, primarily Italian, carvers subsequently provided Neoclassic relief sculptures for the rebuilt Capitol building. The earliest of these—the plaster was installed in 1817—was *Justice,* by Giuseppe Franzoni's brother, Carlo, for the Old Supreme Court Chamber.[12] Better known are the four installed in the Capitol Rotunda. The first two, installed in 1825, were by two Italian sculptors: Antonio Capellano's *Preservation of*

Captain Smith by Pocahontas, 1606, and Enrico Causici's *Landing of the Pilgrims, 1620.* These two square reliefs were followed in the next two years by Causici's *Conflict of Daniel Boone and the Indians, 1773,* and French sculptor Nicholas Gevelot's *William Penn's Treaty with the Indians, 1682.*

The subjects of these four works must strike us as peculiarly pictorial; all but Daniel Boone figure prominently in the repertory of American painting. Moreover, all of the reliefs include subsidiary landscape details, an approach at odds with the favored aesthetic of Neoclassicism. Classical prototypes were one source of inspiration for the Neoclassicists— the Parthenon frieze of the *Battle between the Centaurs and Lapiths,* for instance, is an obvious source, if one much modified, for Greenough's *Castor and Pollux,* as James Jackson Jarves recognized when he called the horses "beautiful creations, full of fire and spirit; steeds of eternity, like those of Phidias."[13] But an even more indisputable authority was the work of the most celebrated European sculptor of the period, the Dane Bertel Thorvaldsen, who was active in Rome at the time when the first American sculptors appeared there.[14] Thorvaldsen's most acclaimed works were, naturally, sculptures in the round, such as his *Christ and the Apostles* (begun 1821), carved for the Church of Our Lady in Copenhagen; the plasters of

Perspectives on American Sculpture before 1925

Figure 8. Thomas Crawford (American, ca. 1813–1857). *Venus as Shepherdess,* ca. 1840.
Marble, 23 ¼ x 21 ¾ in. (59.1 x 55.2 cm). Museum of Fine Arts, Boston; Bequest of Miss Ida
Elizabeth Deacon

Figure 9. William Wetmore Story (American, 1819–1895). *Minerva Dictating the Constitution to Young America,* originally from the base of a statue of John Marshall, 1883. Marble, 75 x 33 in. (190.5 x 83.8 cm). Supreme Court of the United States, Washington, D.C.

these appeared in the New York Crystal Palace Exposition in 1853, and the figure of Christ was the inspiration for many representations of the Savior by American sculptors, including Rinehart in his *Fitzgerald Monument.*[15] But Thorvaldsen was also esteemed for his relief work, far more than his predecessor, the Italian Antonio Canova, whose works smacked to some Americans of a sensuality they approvingly found absent in Thorvaldsen's more austere sculptures. Typical of this admiration, George Ticknor, writing in 1837, found that the "poetry of [Thorvaldsen's] bas reliefs seem[s] to me to exceed anything in modern sculpture."[16]

In the early nineteenth century, Thorvaldsen's enormous relief depicting Alexander the Great's triumph over Babylon (fig. 7), originally designed in 1811 for the Quirinale Palace in Rome and then, after Napoleon's fall, put into marble for Count Sommariva's home in Tremezzo (now the Villa Carlotta), was considered by many as one of the greatest achievements of modern art. It was admired for the ideality of the figures and the grave purity and clarity of the forms, which are unhampered by ancillary background distractions, such as those clut-

tering the Capitol Rotunda reliefs.[17] Three of Thorvaldsen's reliefs were purchased in 1839 by the National Academy of Design in New York as models for students in their school;[18] by 1846, according to an inventory of that year, the Academy also owned casts of Thorvaldsen's *Four Seasons* reliefs.

In 1832 the young Thomas Crawford went to work in the shop of John Frazee and Robert Launitz, the leading carvers of decorative marble works in New York. One of the best-known sculptures of the Latvian-born Launitz, who had studied in Rome with Thorvaldsen, is his relief on the monument to Do-Hum-Me in Brooklyn's Green-Wood Cemetery; the subject was a Sac Indian who had died in 1843 soon after her marriage to a youthful Iowa Indian warrior. Launitz provided Crawford with a letter of introduction to Thorvaldsen, and when Crawford settled in Rome in the fall of 1835, he became the only American-born sculptor to study with the Danish master. Two years later, Crawford wrote to Launitz about the experience, noting of Thorvaldsen that "in his bas-reliefs it is established beyond doubt that he has no equal."[19]

It is not surprising, therefore, that Crawford became one of the most prolific

Perspectives on American Sculpture before 1925

Neoclassic Americans to produce bas-relief sculpture. This aspect of his art has not received much attention, given his monumental commissions for the United States Capitol and for his equestrian Washington sculpture for the capitol at Richmond, Virginia, but he did produce numerous Classical bas-reliefs, among the earliest being his *Venus as Shepherdess* (fig. 8), itself a copy of Thorvaldsen's *A Basket of Loves* (1831, Württembergisches Landesmuseum Stuttgart). When the American writer Bayard Taylor visited Crawford's studio in Rome about New Year's Day 1846, he noted "some fine bas-reliefs of classical subjects."[20] And Henry T. Tuckerman, in his tribute to Crawford published the year after the sculptor's death, noted that, "Like Thorwaldsen, Crawford excelled in *basso-rilievo* [sic], and was a remarkable pictorial sculptor."[21] Indeed, of the almost 150 ideal works by Crawford, at least 43 were bas-reliefs, not including the bronze doors of both the U. S. Senate and House of Representatives.[22]

As a pupil of Thorvaldsen, Crawford was understandably drawn to bas-relief, probably more so than most of his fellow Americans among the Neoclassicists. However, it is likely that almost all of his colleagues investigated relief sculpture, some much more than others, with a few realizing considerable celebrity. We have already noted several reliefs by Horatio Greenough, the earliest of the Neoclassicists in Italy, but in total these works appear to number only about a dozen, which were created in Florence primarily in the late 1830s, when the medium appears to have especially attracted him.[23] These include a memorial relief to George and Mary Gibbs, possibly based on a design by Washington Allston, that was erected in Saint Mary's Episcopal Church in Portsmouth, Rhode Island.[24] When writing of his *The Angel Warning to St. John* (ca. 1839, Yale University Art Gallery, New Haven), Greenough noted that he thought relief sculpture, as a form, was well suited to the relatively small homes in America.[25] The work took such effort, how-

ever, that he later wrote his patron: "You will perhaps be surprised when I tell you that the bas relief has cost me more time and greater expense of models in short a greater outlay than the Abdiel [statue in the round]—yet such is the fact, and I truly believe that I could have made 2 busts which would have yield me 800 Francesconi in the time that I have spent on that composition."[26]

Involvement with bas-relief by Greenough's friend and colleague Hiram Powers appears to have been minimal: one late, posthumous portrait of Elisha Litchfield commissioned in 1865 and carved the following year. Powers informed the subject's son that he would have to charge two hundred pounds, the same price as if it had been a standard-size bust in the round.[27] Similarly, William Wetmore Story, the most celebrated of the second generation of American Neoclassicists, dealt with relief sculpture only minimally, as in his late marble memorial tablet of John Gorham Palfrey at Harvard University, completed in 1892, and a more impressive and public work, the two marble panels decorating the pedestal of his 1883 bronze sculpture of John Marshall outside the Capitol: *Minerva Dictating the Constitution to Young America* (fig. 9) and *Victory Leading Young America to Swear Fidelity to the Union.*[28]

Likewise, the marble sculptures produced by Randolph Rogers, Story's contemporary in Rome, are almost all in the round. His major relief works were the commissions for the Columbus Doors, which were designed and modeled in 1858 for the passageway leading from Statuary Hall to the House of Representatives and that are now at the east entrance to the Capitol Rotunda. The doors are based, in terms of aesthetic and design, on Ghiberti's doors for the Baptistery in Florence, where Rogers had earlier studied and worked. Relief sculptures also decorate the pedestals of several of Rogers's later Civil War monuments, and there are records of a few religious reliefs that are not located. His most fascinating piece, however, is *Flight of the Spirit* (fig. 10), the *Joshua W. Waterman*

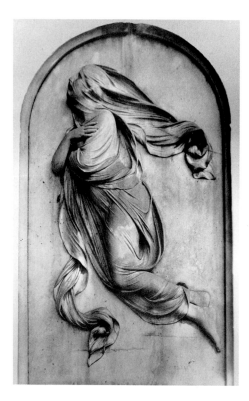

Figure 10. Randolph Rogers (American, 1825–1892). *Flight of the Spirit (Joshua W. Waterman Monument)*, ca. 1868. Marble (panel within framework), 39 x 71 in. (99.1 x 180.3 cm). Elmwood Cemetery, Detroit

Monument in Detroit's Elmwood Cemetery, a replica of which surmounts the grave of the sculptor's wife, Rosa Gibson Rogers, who had died in 1890 and is interred in Rome's Campo Verano Cemetery.[29] *Flight of the Spirit* is one of the more spectacular American responses to the superveristic, see-through illusionism adopted about the mid-nineteenth century by a number of Italian sculptors, most notably Rafaello Monti.[30]

A less celebrated and studied, but at the time still much respected sculptor, was Thomas Ridgeway Gould, who worked in Florence. He, too, was a sculptor primarily of figures in the round. A number of Gould's sculptures are Shakespearean subjects, including what is arguably Gould's most fascinating

work, his relief *The Ghost in Hamlet* (fig. 11).[31] Gould based the likeness on that of a colleague, the engraver Seth W. Cheney, whom he had earlier modeled from life.[32] Referred to by one admirer as "ghostly but not ghastly,"[33] the unearthly emergence into high relief here seems almost a refutation of Sir Joshua Reynolds's dictum in his *Discourses* "that the form and attitude of the figure should be seen clearly, and without any ambiguity at the first glance of the eye. . . ."[34] When Gould's *Ghost* was first exhibited in his native Boston in 1874, one admirer recognized that, "To the thought of most men . . . the sculptor appears to work with materials from which coldness, earthiness and materiality can be removed only by the utmost stress of inspired and agonizing genius; and here the artist has dared not only to reach for the purest ideality, but to reach for it beyond the confines of this world into the very land of spirits! To represent a spirit in marble—the idea seems almost preposterous!" The writer concluded, "The first feeling will be a mixture of awe and wonder."[35] Gould's *The Ghost in Hamlet* is a rare example of a relief that advances from low to high, actually breaking the usual flat frontal plane and moving out into the viewer's space.

Among the major American sculptors in Rome in the third quarter of the nineteenth century, William H. Rinehart, whom we have noted began his career with cemetery relief work, such as the *J. Appleton Wilson Monument* in Baltimore, was also admired for his reliefs. Again, these constituted only a small portion of his oeuvre, but several pairs, including his *Morning* and *Evening* (fig. 12), are among the most beautiful of American reliefs. Modeled by Rinehart soon after he first went to Italy in 1855, they incorporate an almost rococo grace and fluidity that would be far more difficult to attain in sculpture in the round.[36] Their theme is a direct translation of the most popular of all nineteenth-century relief work, Thorvaldsen's *Night* and *Day* (fig. 13). Replicas of the pair—copies in marble, bronze, and plaster, as well as engravings—

hung in countless homes in both Europe and America. Thomas Crawford copied them in 1842,[37] and Randolph Rogers also modeled a now lost set of reliefs of *Day* and *Night* that may be either copies or variants of the Thorvaldsen sculptures.[38]

The American sculptor working in Italy who produced the finest reliefs was the short-lived Edward Sheffield Bartholomew from Connecticut.[39] Bartholomew arrived in Rome in early 1851, having already made (by 1847) what is believed to be his earliest sculptural piece, a bas-relief portrait of the well-known poet Lydia Sigourney, who was called the "Sweet Singer of Hartford" (Wadsworth Atheneum, Hartford, Conn.).[40] He, too, produced a good number of sculptures in the round, but he became especially recognized for his reliefs of both classical, historic, and religious subjects, including *Blind Homer Led by the Genius of Poetry* (fig. 14), also referred to as *Blind Homer Led by His Daughter,* and *Belisarius at the Porta Pinciana* (1853, Wadsworth Atheneum, Hartford, Conn.). The *Homer* is one of the first works Bartholomew modeled after he arrived in Rome; the *Belisarius* of two years later appears to be a companion piece, and both are said to incorporate likenesses of prominent citizens of Baltimore, which, with Hartford, provided Bartholomew with his principal patronage.[41] Bartholomew subsequently turned to Old Testament subjects, producing *Hagar and Ishmael* (1856, The Art Institute of Chicago)[42] and *Ruth, Orpah, and Naomi* (fig. 15). All of these are archetypal Neoclassic themes of loyalty, devotion, and sacrifice. Grace Greenwood, like other Americans who visited Rome and then published their travel diaries, found grace and delicacy in the faces of Bartholomew's "Homer and Guide," writing in 1853 that the sculptor "specializes in bas relief."[43]

With few exceptions, the band of American women sculptors working in Rome—the group that Henry James designated "The White Marmorean Flock"—seems to have been relatively little involved with relief sculpture. A significant number of

Figure 11. Thomas Ridgeway Gould (American, 1818–1881). *The Ghost in Hamlet,* 1880. Marble, 20¼ x 16½ in. (51.4 x 41.9 cm). Worcester Art Museum, Massachusetts; Gift of Mrs. Kingsmill Marrs and Grenville H. Norcross

reliefs by Harriet Hosmer, the most prominent of the group, are recorded,[44] including four portrait medallions; one of these was of her teacher, John Gibson (1866, Free Public Library, Watertown, Mass.), the most acclaimed English sculptor in Rome and himself a former student of Thorvaldsen. Hosmer also produced a pair of allegories: *Phosphor and Hesper* and its companion, *Night and the Rising of the Stars* (1856), yet another avatar of Thorvaldsen's famous *Night and Day.*[45] Hosmer then went on to sculpt a companion for the latter, *Morning and the*

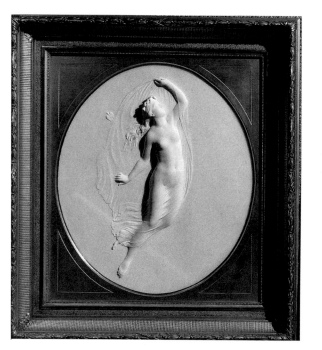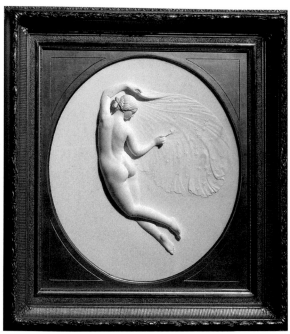

Figure 12. William H. Rinehart (American, 1825–1874). *Morning* and *Evening,* 1873. Marble, each 24 x 22 in. (61 x 55.9 cm). Hirschl and Adler Galleries, New York

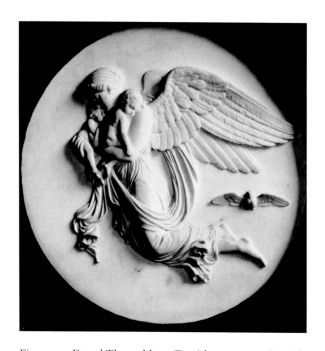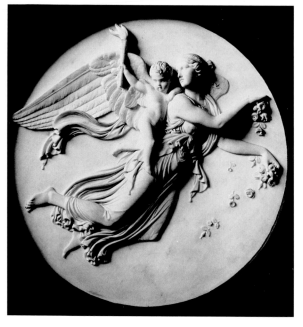

Figure 13. Bertel Thorvaldsen (Danish, 1770–1848). *Night* and *Day,* 1815. Marble; *Night,* H. 31¾ in. (80.6 cm); *Day,* Diam. 31½ in. (80 cm). Thorvaldsens Museum, Copenhagen

Setting of the Stars (1856); *Night* is presently unlocated, but *Phosphor and Hesper* and *Morning* are in a private collection. These two, and possibly all three, are likely marble versions of a set of twelve reliefs of the Hours of the Night that were to be incorporated into bronze gates for an art gallery at Ashridge Hall, Great Britain, the home of Hosmer's patron, Lady Marian Alford, and her son, Lord Brownlow. First conceived by 1864, this project appears to have never been completed, although in 1869 the casting was reported as under way in Munich.[46]

Much more involved with relief sculpture was Margaret F. Foley.[47] Foley created a monumental multifigured fountain that was exhibited at the Philadelphia Centennial, as well as other sculptures in the round, but the greater part of her oeuvre consisted of relief medallions. These included portraits, such as *William Cullen Bryant* (1867, Mead Art Museum, Amherst College, Mass.), and more ideal subjects, such as *Pascuccia,* which depicts the celebrated Roman model (fig. 16). Her medallions were exhibited at international expositions in Dublin (1865), Paris (1867), Munich (1869), and Philadelphia (1876), and it is for these works that she was distinguished in her own time.

The most significant expression, as well as development, in American Neoclassic relief sculpture took place not in Florence or Rome but in the Albany studio of Erastus Dow Palmer. Like Foley and Saint-Gaudens, Palmer began his sculpture career as a cameo cutter, primarily of portraits but also of more ideal literary themes.[48] These offered the logical transition to relief sculpture in large. Palmer, too, was renowned for his figures in the round, especially *Indian Girl* or *The Dawn of Christianity* (1855–56) and *White Captive* 7Art, New York). Still, even excepting his cameos, it would seem that almost half of Palmer's production was sculptures in relief. Among Palmer's best-known and most popular works—that is, most replicated—were *Morning* (1850) and its companion, *Evening* (1851). At least thirteen or fourteen sets of the

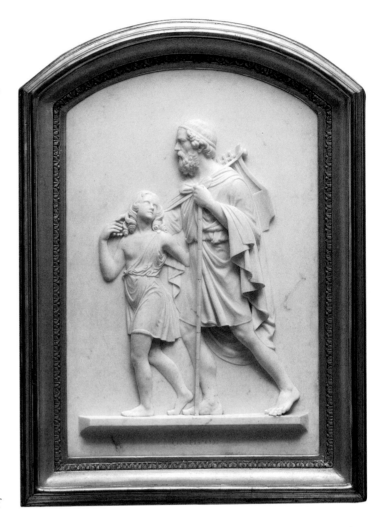

Figure 14. Edward Sheffield Bartholomew (American, 1822–1858). *Blind Homer Led by the Genius of Poetry,* 1851. Marble, 29¾ x 20⅜ in. (75.6 x 51.8 cm). The Metropolitan Museum of Art, New York; Purchase, Morris K. Jesup Fund, and Gift of William Nelson, by exchange, 1996 (1996.74)

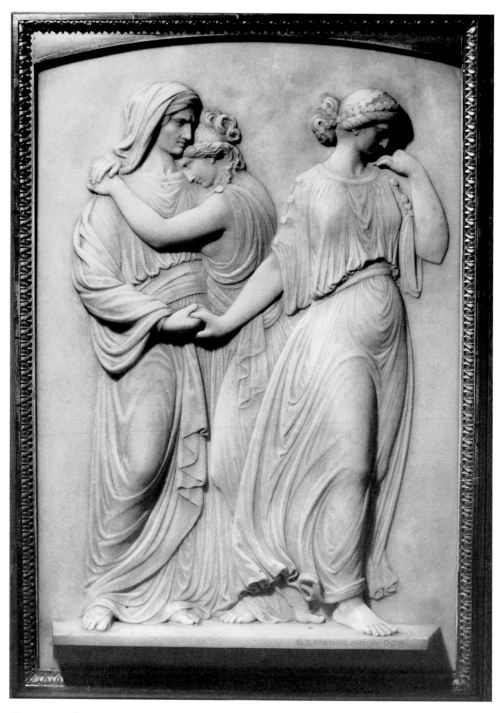

Figure 15. Edward Sheffield Bartholomew (American, 1822–1858). *Ruth, Orpah, and Naomi,* 1855. Marble, 30 x 20½ in. (76.2 x 52.1 cm) sight. Private collection

pair—which inspired the poem "Palmer's Marble Medallions," published in the *Knickerbocker* in 1859[49]—were created in plaster and marble. They reflect, yet again, the enormous popularity of Thorvaldsen's *Night* and *Day*. Probably Palmer's most respected relief is *Peace in Bondage* (fig. 17), once deemed "the single piece of plastic poetry which the Civil War produced."[50] Palmer described the figure this way: "Her head wreathed with a broken olive branch, contemplating the ills of war, with compassion and sorrow."[51]

Not all critics championed Palmer's extended practice of relief sculpture. A controversy on the subject arose in the early issues of *The Crayon,* the first sustained arts magazine published in the United States. Writing from Albany on March 10, 1855, the magazine's coeditor, William J. Stillman, noted of relief sculpture: "There must be a *sentiment,* but that does not necessitate *incident,* which limits the range of feeling in a work of Art. This annoys me particularly in Palmer's bas reliefs, because they are works more peculiarly dependent upon incident, and incapable of giving a high attainment of ideality in form, and the mingling of the two elements gives me more pain than pleasure. . . . Many like these reliefs. I do not."[52] Two weeks later, another writer from Albany, noting Stillman's comments, criticized Palmer's reliefs in comparison with those adorning the pedestal of Brown's statue of De Witt Clinton. He wrote in the *Crayon* that Palmer's reliefs had "the same motive as his statue, viz. the realization of beauty of form, and the relief will not do this as well as the statue, as all perfection in form must be lost in the reduction to relief. Imagine any of the fine ideal statues reduced to reliefs, and they lose their position at once. So Palmer's works gain nothing in motive by taking the guise of reliefs, but lose that which must ever be *their* highest quality—beauty of form."[53] These diverse analyses of Palmer's reliefs addressed the competing objectives of relief sculpture—whether they should, unlike stat-

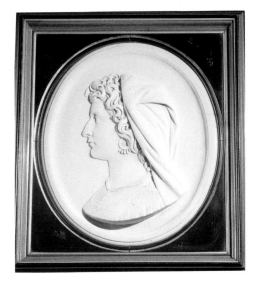

Figure 16. Margaret F. Foley (American, 1827–1877). *Pascuccia,* 1865. Marble, 22 x 19 in. (55.9 x 48.3 cm) sight. Conner-Rosenkranz, New York

ues, embody narrative considerations, or if their purpose was an extension of ideality of form that sculpture in the round could more fully achieve.

With such a considerable investment in relief sculpture, it is natural that Palmer also investigated variations of the form. His *Good Morning* (1863, two marble versions are in private collections), for instance, is antithetical to the profound poignancy of *Peace in Bondage.* The subject is both trivial and playful, with its implication of the momentary emergence of a child from behind a pair of thick curtains, but fascinating in its trompe l'oeil contrast of high and low relief.

More lasting was another format that may be, at least in part, Palmer's innovation. Perhaps referenced as a "dish relief," the form was introduced by Palmer early on in the diminutive high-relief *Flora* of 1849 (now unlocated), but it is seen at its most sophisticated in *Sappho* (1855), one of Palmer's most popular subjects, judging by the twelve to fifteen recorded examples, including one in

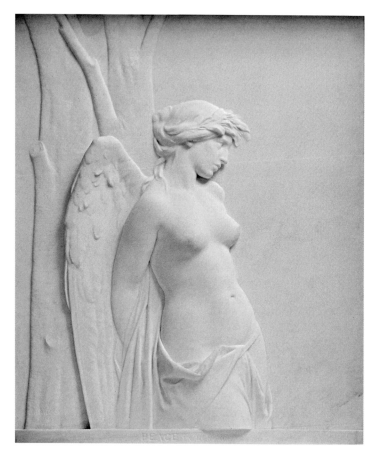

Figure 17. Erastus Dow Palmer (American, 1817–1904). *Peace in Bondage,* 1863. Marble, 30 x 25¾ in. (76.2 x 65.4 cm). Albany Institute of History and Art, New York; Gift of Frederick Townsend

are readily identified on the walls of Palmer's studio: the popular *Morning* and *Evening* flanking his *Faith* of 1851, and, on the wall at right, *Dream of the Spirit's Flight* (1854).[55] Both of the latter are also "dish reliefs."[56]

Matteson's painting points to an interesting phenomenon that impacts on the development of relief sculpture in America. Unlike his colleagues working in Italy, Palmer had no access to artisans trained in marble carving and other sculpture studio procedures; instead, he had to train his own American assistants, such as those pictured by Matteson. Moreover, unlike the artisanal workmen in the Florentine and Roman studios, the majority of Palmer's identified assistants went on to independent careers of their own, sometimes to considerable success.[57] While none of these men specialized in relief sculpture to the degree that Palmer did, a number of them can count reliefs among their finest works. One of them, Richard Park, who was with Palmer from 1855 to 1861, even utilized the peculiar dish relief form that Palmer had earlier adopted. Charles Calverley was with Palmer longer, from 1853 to 1868,[58] and perhaps the best known of all, Launt Thompson, joined the studio in 1854 and remained there for four or five years. Park, Calverley, and Thompson are, in fact, the three assistants who appear in Matteson's picture. Thompson is seated at right, and Calverley and Park are employed as marble cutters in the far room. Each of them went on to independent careers in New York City. At the end of 1858 Thompson began working as a carver of cameos and medallions, and his relief of Candace T. Wheeler (fig. 19), the daughter of the American designer Candace Wheeler,[59] not only resembles his teacher's work but also suggests cameo enlargement in both style and format.[60] A number of other future sculptors, such as J. Scott Hartley, joined Palmer's studio later, establishing a native sculpture dynasty of sorts that, at least to some degree, played a significant role in the history of American relief sculpture.

the collection of The Metropolitan Museum of Art. Here the lovely head of the Greek poet emerges from a concave background to successive degrees of relief, the highest of which is still within the plane of the protruding edge of the marble enframement. What this means in practical terms is that the marble is thicker and more weighty at the edge than in the normal relief.[54]

The importance of relief sculpture in Palmer's oeuvre is verified by the well-known painting *A Sculptor's Studio* (fig. 18) by Tompkins H. Matteson, in which four reliefs

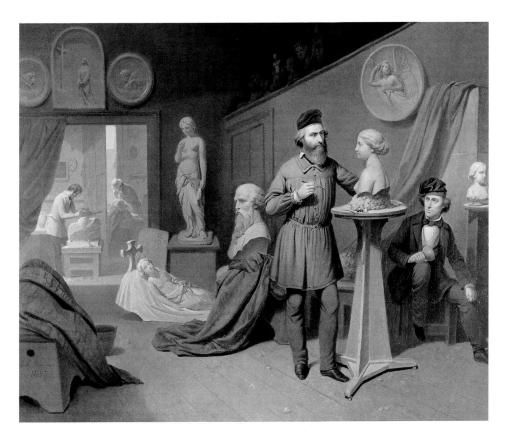

Figure 18. Tompkins H. Matteson (American, 1813–1884). *A Sculptor's Studio,* 1857. Oil on canvas, 29 x 37½ in. (73.7 x 95.3 cm). Albany Institute of History and Art, New York; Gift of Walter Launt Palmer in memory of his mother, Mary Jane Seamans (Mrs. Erastus Dow) Palmer

Figure 19. Launt Thompson (American, 1833–1894). *Candace T. Wheeler,* 1863. Marble, 21½ x 18 in. (54.6 x 45.7 cm). The New-York Historical Society; Gift of Mrs. Boudinot Keith, 1940 (1940.859)

1. The one book I have found dealing specifically with this subject, L. R. Rogers, *Relief Sculpture* (London: Oxford University Press, 1974), covers the entire range of Eastern and Western sculpture, conspicuously omitting only the nineteenth century.

2. It should be noted that Thayer Tolles organized the exhibition "American Relief Sculpture," from the collection of The Metropolitan Museum of Art in the Museum's Henry R. Luce Center for the Study of American Art (August 15–November 5, 1995). There was no catalogue for this exhibition.

3. See especially John H. Dryfhout and Beverly Cox, *Augustus Saint-Gaudens: The Portrait Reliefs,* exh. cat. (Washington, D.C.: Smithsonian Institution for the National Portrait Gallery, 1969); and John H. Dryfhout, *The Work of Augustus Saint-Gaudens* (Hanover, N.H.: University Press of New England, 1982).

4. Although relief sculpture was little known in America before this time, our earliest sculptural expression was in relief, namely, the gravestones of the seventeenth century. Relief appeared in a variety of forms by the late eighteenth century, from the wax miniatures of artists such as Patience Wright to the monumental celebratory portraits of George Washington carved in wood about 1805 by Samuel McIntire for the four arched gateways of Washington Square, or Salem Common, in Massachusetts. Likewise, designs on both coinage and medals have necessarily been the product of relief sculpture, though some of the earliest of these were produced by foreign artists such as Augustin Dupré, who never ventured to this continent.

5. Actually, this variant approach to relief has occasionally resurfaced, even in the twentieth century, as in Hildreth Meière's Municipal Center frieze sculpted in 1941 for the Municipal Center building in Washington, D.C., and funded by the WPA. See Janis Conner, "Hildreth Meière," in *Conner-Rosenkranz: American Sculpture, 1845–1925* (New York: Conner-Rosenkranz, 2001), pp. 42–43.

6. "Sketchings," *Crayon* 1 (April 11, 1855), p. 235. Some critics appear to have admired the subsidiary reliefs more than the figure of Clinton; see, for instance: "City Intelligence: Statue of De Witt Clinton," *New York Herald,* May 25, 1853, p. 4.

7. These carvings are mentioned, and one is illustrated, in Frederick S. Voss, with Dennis Montagna and Jean Henry, *John Frazee, 1790–1852: Sculptor,* exh. cat. (Washington, D.C.: National Portrait Gallery, Smithsonian Institution; Boston: Boston Athenaeum, 1986), pp. 24–25.

8. See the discussion of this sculpture by Jan Seidler Ramirez in Kathryn Greenthal, Paula M. Kozol, and Jan Seidler Ramirez, *American Figurative Sculpture in the Museum of Fine Arts, Boston* (Boston: Museum of Fine Arts, 1986), pp. 24–26.

9. William Sener Rusk, *William Henry Rinehart: Sculptor* (Baltimore: Norman T. A. Munder, 1939), p. 70, for the *Wilson Monument,* and pp. 67–69 for the *Fitzgerald Monument;* see also Marvin Chauncey Ross and Anna Wells Rutledge, *A Catalogue of the Work of William Henry Rinehart: Maryland Sculptor, 1825–1874,* exh. cat. (Baltimore: Trustees of the Peabody Institute and the Walters Art Gallery, 1948), p. 38, for the *Wilson Monument,* and p. 24 for the *Fitzgerald Monument.*

10. "The bas relief on the right side of the chair represents the Rising Sun which was the first crest of our national arms. . . . In that on the left side I have represented the Genii of North and South America under the forms of the infants Hercules and Iphiclus [*sic*]— the latter shrinking in dread while the former struggles successfully with the obstacles and dangers of an incipient political existence." Greenough to Lady Rosina Wheeler Bulwer-Lytton, before May 8, 1841, Miscellaneous Manuscript Collection, Library of Congress, Washington, D.C., quoted in Nathalia Wright, ed., *Letters of Horatio Greenough: American Sculptor* (Madison: University of Wisconsin Press, 1972), p. 309. See also Vivien Green Fryd, *Art and Empire: The Politics of Ethnicity in the United States Capitol, 1815–1860* (New Haven: Yale University Press, 1992), p. 83.

11. Richard R. Borneman, "Franzoni and Andrei: Italian Sculptors in Baltimore, 1808," *William and Mary Quarterly* 10 (January 1953), pp. 108–11; R. P. Harriss, "The Lively Arts. A Thing of Beauty Is a Joy Forever—If *Saved,*" *Baltimore News American,* June 13, 1976, p. 2E.

12. For the work of these sculptors, see Kathleen Ruben Castiello, "The Italian Sculptors of the United States Capitol, 1806–1834" (Ph.D. diss., University of Michigan, 1975).

13. James Jackson Jarves, *The Art-Idea: Sculpture, Painting, and Architecture in America,* 3rd ed. (New York: Hurd and Houghton, 1864), p. 260.

14. For the American admiration for Thorvaldsen, see Lauretta Dimmick, "Mythic Proportion: Bertel Thorvaldsen's Influence in America," in Patrick Kragelund and Mogens Nykjaer, *Thorvaldsen: L'Ambiente, l'Influsso, il Mito* (Rome: L'Erma di Bretschneider, 1991), pp. 169–91.

15. Noted by both Rusk, *William Henry Rinehart,* and by Ross and Rutledge, *William Henry Rinehart.*

16. George S. Hillard, ed., *Life, Letters, and Journals of George Ticknor* (Boston: J. R. Osgood, 1876), vol. 2, p. 76.

17. William M. Gillespie called *Alexander the Great's Triumphal Entry into Babylon* "the great work of modern times, and compared to the friezes of the Parthenon," in Gillespie, *Rome: as Seen by a New-Yorker in 1843–4* (New York and London: Wiley and Putnam, 1845), p. 177. Philip Hone had previously noted in his diary on May 21, 1831: "I received this day a letter from Samuel F. B. Morse, dated Rome, February 15. He informs me that he has shipped for me at Leghorn a fine portrait by himself of

Thorvaldsen the celebrated sculptor, and a cast executed by that artist of the 'Triumph of Alexander the Great,' from the original bas-relief made for the Marquis Sommariva"; quoted in Allan Nevins, ed., *The Diary of Philip Hone, 1828–1851* (New York: Dodd, Mead and Co., 1927), vol. 1, p. 42.

18. Minutes of the National Academy of Design, October 18, 1839; these works are listed in the *Constitution and By-Laws of the National Academy of Design, with a Catalogue of the Library and Property of the Academy* (New York, 1843). My thanks to David Dearinger, chief curator of the Academy, for this information.

19. Crawford to Launitz, June 27, 1837, reprinted in "Reminiscences of Crawford," *Crayon* 6 (January 1859), p. 28.

20. Bayard Taylor, *Views A-Foot; or Europe Seen with Knapsack and Staff* (1846; rev. ed., New York: G. P. Putnam, 1863), p. 420. For this sculpture, see: "Il Trionfo di Alessandro e l'Appartamento Napoleonico al Quirinale," *Palantino* 9 (1965), pp. 97–109; and Bjarne Jornes, "Thorvaldsen's Triumph of Alexander in the *Palazzo del Quirinale*," in Kragelund and Nykjaer, *Thorvaldsen*, pp. 35–42.

21. Henry T. Tuckerman, "Crawford and Sculpture," *Atlantic Monthly* 2 (June 1858), p. 70.

22. Lauretta Dimmick, "A Catalogue of the Portrait Busts and Ideal Works of Thomas Crawford (1813?–1857), American Sculptor in Rome" (Ph.D. diss., University of Pittsburgh, 1986). Numerous reliefs appear in the studio photographs; see Robert L. Gale, *Thomas Crawford: American Sculptor* (Pittsburgh: University of Pittsburgh Press, 1964), pl. VIII, opp. p. 55.

23. Richard H. Saunders noted Greenough's concentration on relief carving beginning in the late 1830s in *Horatio Greenough: An American Sculptor's Drawings,* exh. cat. (Middlebury, Vt.: Middlebury College Museum of Art, 1999), pp. 27–28.

24. Allston's input into the design of the *Gibbs Monument* has never been elaborated. The relief depicts the Angel of Death parting the family, leading Mary Gibbs to Heaven, as her daughter, Sarah, mourns at her father's shrine. Thomas Brendle Brumbaugh, "Horatio and Richard Greenough: A Critical Study with a Catalogue of Their Sculpture" (Ph.D. diss., Ohio State University, 1955), pp. 101–2, 224, fig. 34. Brumbaugh attributes the work entirely to Greenough. Edgar Preston Richardson indicates that the design was by Allston; see Richardson, *Washington Allston: A Study of the Romantic Artist in America* (Chicago: University of Chicago Press, 1948), p. 219. Richardson presumably drew upon Elizabeth Palmer Peabody, *Reminiscences of Rev. Wm. Ellery Channing, D.D.* (Boston: Roberts Brothers, 1880), p. 107: "It is curious that I Have omitted mention of the fine Italian marble monument in Saint Mary's Church, designed by Washington Allston, to the memory of Mr. and Mrs. George Gibbs, the parents of Miss Sarah Gibbs. . . . The border is a skillful combination of the fruits of this soil and thoroughly in accord with the lives of the eminently virtuous pair for whom the stone was erected."

25. Greenough's conception was described to his patron, Edward Elbridge Salisbury, January 3, 1838. See Wright, ed., *Letters of Horatio Greenough,* p. 225.

26. Greenough to Salisbury, April 28, 1839 quoted in ibid., pp. 251–52. He also noted that this was his earliest commission for a relief sculpture. Greenough also carved, or conceived of carving, reliefs of such Classical subjects as the Judgment of Paris, Bacchante and Faun, and Apollo the Avenger; an allegory of an Artist's Labors Suspending by Failure of Light; and a Genius of Italy and a Genius of Poesy. See Brumbaugh, "Horatio and Richard Greenough"; and Nathalia Wright, *Horatio Greenough: The First American Sculptor* (Philadelphia: University of Pennsylvania Press, 1963).

27. Richard P. Wunder, *Hiram Powers: Vermont Sculptor, 1805–1873* (Newark: University of Delaware Press, 1991), vol. 2, p. 64.

28. The bronze sculpture of Marshall was cast at the Nelli foundry in Rome in 1883 and installed at the west front of the Capitol the following year. The bas-reliefs on the sides of the base are in marble. Jan M. Seidler [Ramirez], "A Critical Reappraisal of the Career of William Wetmore Story (1819–1895), American Sculptor and Man of Letters" (Ph.D. diss., Boston University, 1985), pp. 588–89.

29. Rogers grew up in Ann Arbor, Michigan, but the commission for the *Waterman Monument* almost surely drew directly from his contract for the *Michigan Soldiers' and Sailors' Monument* in Detroit's Cadillac Square, commemorating Michigan's participation in the Civil War, on which he began work in 1867. Millard F. Rogers Jr., *Randolph Rogers: American Sculptor in Rome* (Amherst: University of Massachusetts Press, 1971), pp. 115, 215.

30. Monti's most famous and most elaborate veristic sculpture of see-through drapery is his Risorgimento monument, *The Sleep of Sorrow and the Dream of Joy* (1861), now in the Victoria and Albert Museum, London.

31. William J. Hennessey, "White Marble Idealism: Four American Neo-Classical Sculptors," *Worcester Art Museum Bulletin,* n.s., 2, no. 1 (November 1972), pp. 5–6. A terracotta version of this piece was at the gallery Conner-Rosenkranz, New York, and is now in a private collection. Two marble versions are known, one at the Robert Hull Fleming Museum, University of Vermont, Burlington, and the one illustrated here, in the collection of the Worcester Art Museum, Massachusetts. With this work, as in most cases, it is difficult if not impossible to determine the number of replicas issuing from the studios of the sculptors.

32. Ednah Dow Cheney, *Memoir of Seth W. Cheney: Artist* (Boston: Lee and Shepard, 1881), p. 143.

33. "Gould the Sculptor," *Old and New* 11 (October 1874), p. 527. This work received extensive critical

acclaim. See also, for example, "Art Notes," *Ladies' Repository* 14 (October 1874), p. 302.

34. *The Discourses of Sir Joshua Reynolds* (1820; London: James Carpenter, 1842), [Tenth Discourse, December 11th, 1780], p. 178. Modern relief sculpture is discussed on pp. 179–81.

35. "Art Matters. The Ghost in Hamlet—by Thomas R. Gould," *Boston Daily Advertiser,* July 9, 1874, p. 2.

36. Ross and Rutledge, *William Henry Rinehart,* p. 29, lists eight marble pairs of *Morning* and *Evening* as well as a single marble of *Morning* carved between 1856 and 1874.

37. Dimmick, "Thomas Crawford," vol. 2, pp. 401–5.

38. Rogers, *Randolph Rogers,* p. 229.

39. The only "modern" treatment of Bartholomew is William G. Wendell, "Edward Sheffield Bartholomew: Sculptor," *Wadsworth Atheneum Bulletin,* ser. 5, no. 12 (winter 1962), pp. 1–18.

40. One of Sigourney's "songs" was composed as a memorial to the deceased sculptor. See "Edward Sheffield Bartholomew," *Cosmopolitan Art Journal* 4 (March 1860), p. 5.

41. The first is said to represent James Howard McHenry in the character of Homer, and the second, William George Read in the character of Belisarius. Read, a brilliant lawyer and scholar who died in 1846, was believed to have been Bartholomew's first patron; he was the uncle of McHenry, who was also a socially prominent lawyer as well as a gentleman farmer. Information from Eugenia Calvert Holland, June 15, 1971, Maryland Historical Society, Baltimore, which owns replicas of these works. Also in the collection of the Society is a bust of Read carved in Rome by Bartholomew in 1852. All three works were donated to the Society by Mrs. Florence Read Beaton, the reliefs in 1931, the bust in 1946.

42. *Hagar and Ishmael* was put into marble in 1856, late in the sculptor's short career. The laudatory illustrated article on the piece, "Hagar and Ishmael," *Art Journal* (London) 8 (April 1, 1856), p. 116, concludes, "[I]t still remains unsold in the atelier of the sculptor, though many of his inferior works have found purchasers." This article may have encouraged the patronage for this sculpture that year.

43. Grace Greenwood [Sarah Jane Clarke Lippincott], *Haps and Mishaps of a Tour in Europe* (Boston: Ticknor, Reed and Fields, 1854), p. 223.

44. According to a letter to her closest friend and biographer, Cornelia Crow, Hosmer began making bas-reliefs by April 23, 1853; quoted in Cornelia [Crow] Carr, ed., *Harriet Hosmer: Letters and Memories* (New York: Moffat, Yard and Co., 1912), p. 27. For Hosmer's reliefs, see Margaret Wendell LaBarre, "Harriet Hosmer: Her Era and Art" (master's thesis, University of Illinois, 1966), pp. 229ff.

45. In a letter to Carr (June 30, 1856), Hosmer specifically refers to these as "the stars of the Morning and the Evening"; quoted in Carr, ed., *Harriet Hosmer,* p. 70. A photograph of *Night and the Rising of the Stars* (Free Public Library, Watertown, Mass.) is reproduced in Dolly Sherwood, *Harriet Hosmer, American Sculptor, 1830–1908* (Columbia: University of Missouri Press, 1991), p. 139.

46. The history of these unlocated and probably unfinished sculptures is complicated. The fullest description of the gates can be found in Carr, ed., *Harriet Hosmer,* p. 198. Ruth A. Bradford noted that Hosmer only completed four of the twelve bas-reliefs, three of which she gave away; Bradford, "The Life and Works of Harriet Hosmer, Then American Sculptor," *New England Magazine* 45 (November 1911), p. 268. One relief panel, sixteen inches in diameter, is reported to be in the Bigelow Chapel of Mount Auburn Cemetery, Watertown, Massachusetts. See Joseph L. Curran, ed., "Hosmeriana: A Guide to Works by and about Harriet G. Hosmer," unpublished manuscript, 1975, nos. 22, 39. See also Reverend R. B. Thurston, *Eminent Women of the Age; Being Narratives of the Lives and Deeds of the Most Prominent Women of the Present Generation* (Hartford, Conn.: S. M. Betts and Co., 1869), p. 588; LaBarre, "Harriet Hosmer," pp. 230–32; and Sherwood, *Harriet Hosmer,* pp. 310–11.

47. For Foley, see Eleanor Tufts, "Margaret Foley's Metamorphosis: A Merrimack 'Female Operative' in Neo-Classical Rome," *Arts* 56 (January 1982), pp. 89–95. The Bixby Memorial Free Library in Vergennes, Vermont, holds a wealth of material on Foley; my thanks to Lois N. Noonan for sharing this material.

48. The definitive study of Palmer and his sculpture is J. Carson Webster, *Erastus D. Palmer* (Newark: University of Delaware Press, 1983).

49. "Palmer's Marble Medallions," *Knickerbocker* 54 (August 1859), p. 173.

50. Charles Rufus Morey, "Sculpture," in Frank Jewett Mather Jr., Charles Rufus Morey, and William James Henderson, *The American Spirit in Art* (New Haven: Yale University Press, 1927), p. 184.

51. *Catalogue of Painting and Sculpture Exhibited at Palmer's Studio, in Aid of the United States Sanitary Commission, February 22, 1864* (Albany, N.Y.: Van Benthuysen's Steam Printing House, 1864), p. 5.

52. W[illiam] J. S[tillman], "Sketchings: Editorial Correspondence," *Crayon* 1 (March 28, 1855), p. 202. Palmer reacted to this criticism in a letter to Stillman and his co-editor, John Durand, dated April 11, 1855: "I have read S's last article on 'Relief,' and (without tending disrespect) think it so destitute of poetic feeling and imagination and of a perception or knowledge of what relief is, or of its province in art productions, as not to provoke a reply from this quarter." John Durand Papers, Manuscripts and Archives Division, New York Public Library, quoted in Webster, *Erastus D. Palmer,* pp. 264–65.

53. "Sketchings," *Crayon* 1 (April 11, 1855), p. 235.

54. Because of their additional weight, dish sculptures are often better suited to installation in a shadow box

rather than by a hanging frame; one such example is known to house a work by Richard Park (private collection), one of Palmer's many Albany assistants. The subject here has been identified as *Early Sorrow,* taken from Charles Dickens's 1848 novel *Dombey and Son.* This is discussed concerning another version of Park's sculpture in *Conner-Rosenkranz,* p. 20, while the identification of the piece—both its title and its literary source—derives from another replica in the collection of the Suffolk County Historical Society, Riverhead, New York. However, a discussion of *First Sorrow* (presumably the same sculpture) described it as a child holding a dead bird in her hands, a motif not present in this work. See "Italian Notes," *Philadelphia Evening Bulletin,* December 12, 1874, p. 1. Park's many medallion sculptures had generic titles such as *Memory, Present,* and *Future,* and this example—obviously a popular one, judging by its replication—may at present be misidentified.

55. See the discussion of this painting by William H. Gerdts in Tammis K. Groft and Mary Alice Mackay, eds., *Albany Institute of History and Art: Two Hundred Years of Collecting* (New York: Hudson Hills Press; Albany, N.Y.: Albany Institute of History and Art, 1998), p. 114.

56. American sculptors in Europe also utilized this scooped-out "dish" format—Gould's enthralling *Ghost in Hamlet* (see fig. 11) is one such example.

57. For a list of Palmer's assistants, see Webster, *Erastus D. Palmer,* p. 25.

58. See Elizabeth K. Allen, *From Stonecutter to Sculptor: Charles Calverley, 1833–1914,* exh. cat. (Albany, N.Y.: Albany Institute of History and Art, 1996). Of the twenty-one sculptures included in the catalogue, fourteen are reliefs. At least one, *Taking Comfort (Daisy Calverley)* (1873, Albany Institute of History and Art, New York), was a dish relief.

59. In her autobiography, Wheeler noted that she also had Thompson's medallions of two of her friends, the painters Sanford R. Gifford and Jervis McEntee, hanging in her home. Candace Wheeler, *Yesterdays in a Busy Life* (New York and London: Harper & Brothers, 1918), p. 115.

60. Toward the end of Thompson's career, when alcoholism and paralysis necessitated his confinement to an asylum, he remained well regarded for his reliefs. A report in 1892, two years before his death, noted, "The friends of Launcelot Thompson, and the artistic world generally, will be grieved to learn that he is afflicted with paresis, and there is little hope of his recovery. . . . For many years he was considered the foremost sculptor of America. His chief talent was for medallion portraits. . . ." "American Notes," *Studio* 7 (July 16, 1892), p. 276. Palmer's influence probably extended also to the elusive Walter Robinson, a sculptor active in Auburn, New York, where Palmer had first established his own reputation. Robinson is best known for his portraits of Auburn's most famous citizen, William Henry Seward (relief in the collection of the National Academy of Design, New York). T. J. Kennedy, "A Paper on Art and Professional Artists of Cayuga County," March 12, 1878, New York Archives, Cayuga Museum of History and Art; and Elliott G. Storke, *History of Cayuga County* (Syracuse, N.Y.: D. Mason & Co., 1879), p. 64.

Melissa Dabakis

"The Eccentric Life of a Perfectly 'Emancipated Female'": Harriet Hosmer's Early Years in Rome

Harriet Goodhue Hosmer (1830–1908) was the first among a remarkable group of American women artists who traveled or expatriated to Rome in the mid-nineteenth century.[1] Arriving in the Eternal City in 1852, Hosmer (fig. 20) pioneered the way for a highly competent group of Neoclassical sculptors—including Emma Stebbins (1815–1882), Sarah Fisher Ames (1817–1901), Margaret F. Foley (1820–1877), Anne Whitney (1821–1915), Florence Freeman (1825–1876), Louisa Lander (1826–1923), Edmonia Lewis (1834/35–1911?), Blanche Nevin (1841–1925), and Vinnie Ream (Hoxie) (1847–1914)—who together demonstrated an unprecedented commitment to artistic production. By competing for and winning public commissions, creating ideal statuary (that is, mythological, historical, or biblical subjects), modeling portrait busts, and selling many "fancy pieces" (those with fanciful subjects), these sculptors provide us with the first collective model of women's professional accomplishment in the history of American art. This essay focuses on Hosmer's initial years in Rome, from 1852 to 1856. The Metropolitan Museum of Art owns two of the first pieces

Hosmer produced while abroad: *Clasped Hands of Robert and Elizabeth Barrett Browning* (fig. 21) and *Daphne* (fig. 22). The Roman environment that Hosmer inhabited—both the lively women's community to which she was devoted and the international artistic colony in which she participated—is brought to life through a study of these sculptures and related works.

Harriet Hosmer was a lively, precocious child, brimming with intelligence and creativity. She suffered much loss at a young age, however; her mother died of tuberculosis when she was six, and all of her siblings (two brothers and one sister) succumbed to the disease in the next few years. In the wake of these deaths, Dr. Hiram Hosmer lavished loving attention on his remaining child. Inspired by the spirit of reform that suffused his Watertown, Massachusetts, community, he raised his daughter in a progressive manner unfettered by the strict rules then governing feminine decorum. Perhaps at the urging of his friend Lydia Maria Child, an abolitionist and feminist, he sent young Hattie to study in Elizabeth Sedgwick's Lenox School in the Berkshires. As Child explained later, "Here, was a woman, who at the very outset of her life, refused to have her feet cramped by the little Chinese shoes, which society places on us all, and then misnames our feeble tottering, feminine grace."[2] At the Lenox School Hattie met and became lifelong friends with the novelist Catherine Sedgwick (Elizabeth's sister-in-law) and the actress Fanny Kemble, who believed that children should develop their innate capabilities and that girls in particular had the right to nurture their talents.[3]

With early encouragement from family and friends, Hosmer pursued her gift for artistic expression. In 1849 she studied with Peter Stephenson, a British-born sculptor active in Boston. According to contemporary

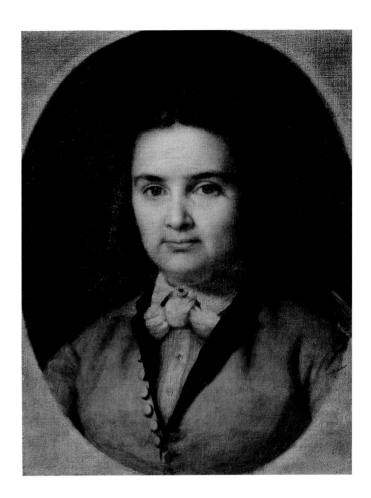

Figure 20. William Page (American, 1811–1885). *Harriet Hosmer,* ca. 1854–57. Oil on canvas, 21 ½ x 16⅝ in. (54.6 x 42.2 cm). Museum of Fine Arts, Boston; Gift of the Estate of Mrs. Lucien Carr

Figure 21. Harriet Hosmer (American, 1830–1908). *Clasped Hands of Robert and Elizabeth Barrett Browning,* 1853; this cast, after 1853. Bronze, 3 ¼ x 8 ¼ x 4 ¼ in. (8.3 x 21 x 10.8 cm). The Metropolitan Museum of Art, New York; Purchase, Mrs. Frederick A. Stoughton Gift, 1986 (1986.52)

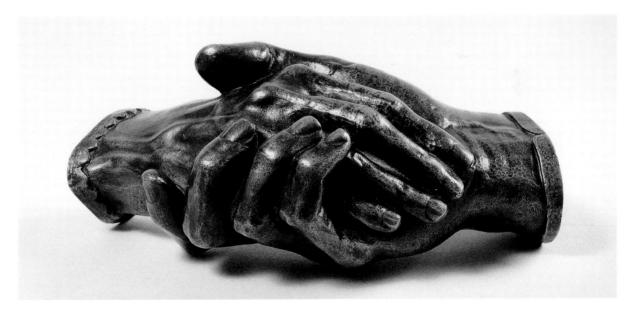

Figure 22. Harriet Hosmer (American, 1830–1908). *Daphne,* 1853; this carving, 1854. Marble, $27\frac{1}{2}$ x $19\frac{5}{8}$ x $12\frac{1}{2}$ in. (69.9 x 49.8 x 31.8 cm). The Metropolitan Museum of Art, New York; Morris K. Jesup Fund, 1973 (1973.133)

Perspectives on American Sculpture before 1925

reports, her studio near the Charles River in Watertown was filled with all manner of curiosities, from rare and variegated insects to numerous stuffed birds, bats, butterflies, beetles, and the skeletons of various small animals.[4] As an artist in Rome, Hosmer would later return to the memory of this menagerie when creating her famed fancy piece, *Puck* (see fig. 34). In 1850 she traveled to St. Louis to study anatomy with Joseph Nash McDowell, M.D.[5] While there, she cemented a lifelong friendship with Cornelia Crow, a classmate from her boarding school days, and with Cornelia's father, Wayman Crow, a leading citizen and philanthropist in St. Louis who would later become one of her primary patrons and benefactors.

Upon returning to Watertown in 1852, Hosmer completed two works in marble: a medallion portrait of Joseph McDowell, and an ideal piece, *Hesper* (fig. 23), the first of several busts of female mythological figures she would produce in the next few years. Hosmer mastered the difficult medium of marble with ease. She began by making a model in clay. A workman then chopped the corners off the marble block, which she carved into the final version herself. In *Hesper,* Hosmer may have been inspired to give visual form to her own feelings of grief and personal loss after reading Tennyson's *In Memoriam,* the poet's lament to a departed young friend. Hesper, a personification of the evening star, is here depicted with classicized features—longish face, aquiline nose, and small mouth. Her eyelids are heavy with sleep, and her head is tilted slightly downward, reflecting her traditionally somnolent state.[6] Her hair is ornately carved, with capsules of poppies entwined among the curls, and the evening star ornaments her crown. The crescent moon outlines the lower line of the sculpture, forming a transition from figure to base. The overly decorative design of the hair compensates, in part, for Hosmer's lack of success in rendering the body. The figure's shoulders slope as if they lack an underlying bone structure, and her arms terminate in an awkward manner.

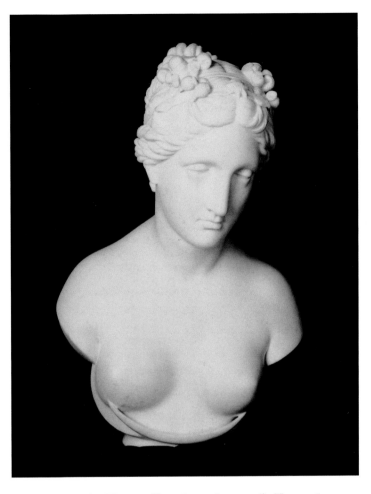

Figure 23. Harriet Hosmer (American, 1830–1908). *Hesper,* 1852. Marble, H. 24 in. (61 cm). Watertown Free Public Library, Massachusetts

Nonetheless, as Hosmer's first major sculptural work, the bust deserves commendation.

Aside from regular visits to the Boston Athenaeum—where she could study plaster casts of the Capitoline Venus and the Laocoön—Hosmer found that Boston did not suit her as a young artist. In a witty poem titled "Boston and Boston People in 1850," she complained that Bostonians "passed amid the joust of trade,/ Dwelling on happy bargains made,/ . . . Such O Bostonians! Is your

case./ Deplore the arts in such a place!"[7] Hosmer was not alone in her assessment of the moribund artistic environment in Boston and, by extension, the United States. As early as the 1830s American sculptors had begun to flee their homeland for Italy, where they enjoyed access to Roman antiquities, the aid of skilled Italian carvers, proximity to Carrara and Serravezza marble, and the inspiration of an international coterie of artists.[8] On November 12, 1852, accompanied by her father and Charlotte Saunders Cushman, the famous thespian whom she had recently met in Boston, Hosmer arrived in Rome.

For American artists in the 1850s Rome held the mystique of an exotic land, but it was also the center of a thriving art market supported by legions of European and American tourists. Americans traveled there to gain knowledge of the antique world, to admire the great artistic traditions of Western civilization, and to acquire cultural refinement and intellectual sophistication. The contemporary political situation—the failure of the republic in 1849, the ensuing French occupation of the city, and the tyrannical rule of Pope Pius IX—was generally of little interest to such tourists. The Rome most Americans experienced was steeped in Old World traditions: intriguing yet beguiling in its Catholic pomp and rituals; picturesque in its charming dereliction and quaint peasants; and romanticized as an arcadian ideal. Italy thus contrasted greatly with America, the New World, which held unsurpassed promise for the future but remained bereft of both history and culture.[9]

Indeed artists held center stage in Rome, where they were respected and admired by the prominent people of the day, from statesmen and authors to businessmen and royalty. Sculptors in particular were the most highly regarded among the American artists in Rome, a fact that the famous landscape painter Thomas Cole grudgingly acknowledged in a letter home in 1847: "It seems to me that sculpture has risen above par, of late: painters are but an inferior grade of artists. This exalta-

tion of sculpture over painting, which in this country has prevailed, is unjust, and has never been acknowledged in the past."[10]

For creative and intellectual women, a complicated nexus of meanings inhered to Italy, and particularly to Rome. Since the eighteenth century Rome had offered exceptional women the opportunity for literary and artistic expression. The city served as a welcoming environment for talented European expatriate painters such as Angelica Kauffman and Elizabeth Vigée-Lebrun. Moreover, the Italian *improvisatrice,* or female poetic improvisers, like Isabella Pellegrini and Corilla Olympica (Maria Magdalena Morelli), attracted much fame and attention for their literary performances. In fact, Corilla Olympica was crowned poet laureate on the Capitoline in 1776, the only woman to share the honor with the likes of Tasso and Petrarch. This literary tradition continued until the 1850s, with performances in Rome by Giannina Milli and Elena dei Conti Guoli.[11]

Madame de Staël (Germaine Necker) championed the city's female literary heritage in her extraordinarily popular novel of 1807, *Corinne, or Italy,* in which the beautiful Corinne, of Italian and British parentage, was celebrated as the most creative and erudite woman in Rome. Commemorating, no doubt, episodes from Corilla Olympica's life, the novel includes a scene in which Corinne is ceremoniously crowned on the steps of the Capitoline. As an autonomous agent, the fictional character Corinne became a model of liberation for many contemporary women despite her eventual downfall after the loss of her British lover.[12] With Corinne as her inspiration, for example, Elizabeth Barrett Browning examined the creative life of a woman poet in her epic poem of 1856, *Aurora Leigh.*[13]

During the nineteenth century many educated American women envisioned Corinne's Rome as an enlightened center of female creativity. In the elite New England community of reform-oriented women artists, writers, and intellectuals among whom

Hosmer had been raised, Corinne was viewed as a new model of female accomplishment. Between 1839 and 1843, Margaret Fuller—journalist, political thinker, and progressive reformer—led a group of similarly minded women in weekly "conversations" about intellectual and worldly affairs. She was dubbed a "new Corinne" by Ralph Waldo Emerson, among others, because of her erudition. Fuller blazed a path for many intellectual and creative women when she traveled to Rome in 1847 as a journalist for the *New York Tribune*. From 1848 to 1849 she covered (with much sympathy) the failed attempt by republicans to wrest control of Rome from papal authority. Fuller married an Italian nobleman (who was also a revolutionary) and gave birth to a child in Italy, but tragically she and her family died in a shipwreck off Fire Island, New York, in 1850.[14] Nevertheless, as Henry James later wrote, "the Margaret-ghost" continued to haunt "the old passages" of Rome.[15]

Sophia Peabody Hawthorne, wife of Nathaniel Hawthorne and a talented artist in her own right, and her sister, Elizabeth Peabody, a Boston-area educator and reformer, regularly attended Fuller's "conversations." They had both read *Corinne* and were inspired by its new model of feminine virtue. Having given up her artistic career after marriage, Sophia accompanied her husband to Rome in 1858. She flourished in the city's cultural milieu, recording her visits to galleries and artists' studios with great detail in her European diary.[16] Many accomplished American women who traveled to Rome at that time—among them the writer and progressive reformer Julia Ward Howe and the sculptor Vinnie Ream—came to be identified as "American Corinnes." These women, longing for a world hospitable to feminine achievement, turned to Rome as a site of newfound freedoms unavailable to them at home.

Not surprisingly, some of these women, like many American tourists, understood Italy in mythic as much as in historic terms. The mythic Italy was conceived as "feminine": a land devoted to culture rather than to material and political affairs, the vulnerable victim of foreign incursion and illiberal rule. For many tourists the country also offered access to an imaginary realm steeped in the arcadian past. In popular Romantic literature, Italy was represented as "a land where one could be free to be oneself," as Lord Byron wrote in *Childe Harold's Pilgrimage*. Ironically, Italy was not politically liberated, but it did afford opportunity for artistic expression.[17] Madame de Staël understood this popular "mythology" of Rome, and she used it in her novel to great effect, evoking a city where women might enjoy unparalleled creativity. Thus Rome—with its mythic character (as a land of romantic freedom) and its historical resonance (as a creative site for both expatriate artists and *improvisatrice*)—beckoned to many American women, especially the colony of women sculptors in New England who were seeking freedom, enlightenment, and liberation from the strictures of their Puritan environs. In 1853, for example, Hosmer exclaimed in a letter to her friend Cornelia Carr (née Crow), "It never entered my head that anybody could be so content on this earth, as I am here. I wouldn't live anywhere else but Rome. . . . I can learn more and do more here, in one year, than I could in America in ten."[18]

When she first arrived in Rome, Hosmer lived for several years under the wing of Charlotte Saunders Cushman, the doyenne of Rome's circle of creative women. Cushman had established herself on the British stage in the 1840s and at the age of forty-one had retired to Rome (fig. 24). They lived together at via del Corso 28—in the neighborhood between the Piazza del Popolo and the Piazza di Spagna, where the Anglo-Americans congregated—along with Mathilda Hayes, Cushman's partner and translator of the works of George Sand, and Sarah Jane Clarke Lippincott, the author and journalist known professionally as Grace Greenwood. In this heady atmosphere Hosmer began her career, teasingly referring to her home as "The Old Maid's Hall." She attended

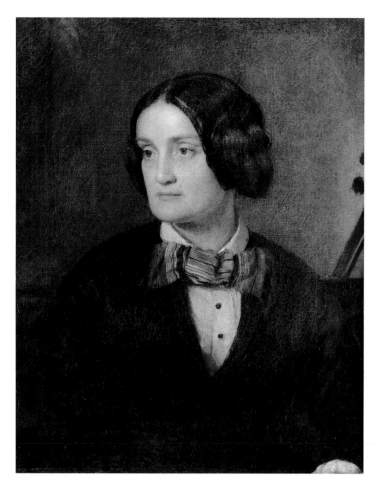

Figure 24. William Page (American, 1811–1885). *Charlotte Saunders Cushman,* 1853. Oil on canvas, 27½ x 22 in. (69.9 x 55.9 cm). National Portrait Gallery, Smithsonian Institution, Washington, D.C. (NPG.72.15)

Cushman's weekly salons, one of the centers of Anglo-American society in Rome, where she met artists, writers, and, most important, wealthy patrons.[19] Hosmer felt completely content in Rome, as she explained to Wayman Crow soon after her arrival: "[Rome is a] delightful place which I now consider my home."[20] Indeed she would live most of her life in the Eternal City, returning to Watertown only in 1903, just five years before her death.

Almost immediately Hosmer began to study with John Gibson, a prominent British sculptor who had come to Rome in 1817 to work with Bertel Thorvaldsen and Antonio Canova, the leading lights of Neoclassicism. After viewing photographs of *Hesper,* Gibson was suitably impressed by Hosmer's talent to summon her to his studio at via Fontanella 4 and offer her a place to work, under his supervision. Hosmer remained Gibson's student until 1860 and maintained a close personal relationship with him until his death in 1866. He taught her to find inspiration in nature and the antique, especially the severity of early Classical Greek sculpture. In his *Tinted Venus* (see fig. 55), for example, he combined his commitment to nature with a sense of historical authenticity by adding color to his marble statuary, a controversial practice originating, he argued, with the Greeks.[21]

Hosmer met Robert and Elizabeth Barrett Browning in November 1853, when they left their Florentine home to winter in Rome, and it was during this period that she produced the *Clasped Hands of Robert and Elizabeth Barrett Browning* (see fig. 21).[22] Originally cast in plaster from life, this sentimental sculpture of their two hands, enfolded one in the other—hers with the slight decorative rickrack at the wrist, his with a more austere cuff—serves as a testament to the famous love between the two poets. It also represented a tribute to the community of artists in Rome. The sculpture remained in plaster for many years before a number of bronzes were cast, among them the version now in the Metropolitan.

Hosmer became close friends with the poets at a time when she was striving to develop her professional talents. Barrett Browning (fig. 25) and Hosmer, who shared similar backgrounds, were drawn to one another. They both had lost their mothers at an early age and had enjoyed active childhoods, in Barrett Browning's case despite bouts of unexplained illness. The two women represented different models of female creativity, however. Barrett Browning admired Hosmer, who, she wrote, "emancipates the eccentric life of a perfectly 'emancipated female,' from all shadow of blame, by the purity of her's. She lives here all alone (at twenty-two) . . . dines and breakfasts at the caffès precisely as a young man would,— works from six o clock in the morning till night, as a great artist must, . . . and this with an absence of pretension and simplicity of manners which accord rather with the childish dimples in her rosy cheeks than with her broad forehead and high aims."[23] In this extraordinary statement, Barrett Browning tells us much about Hosmer's strategies for negotiating her professional life, which differed markedly from her own. Although "emancipated" in her own right, outwardly Barrett Browning represented herself in more traditionally feminine terms—through marriage, motherhood, and in her consistently fragile health. Hosmer, in contrast, swore to celibacy, renounced marriage, and lived an independent and active life, all the while maintaining a boyish appearance with her small stature, short-cut hair, and studio garb of beret and trousers (fig. 26). Through this "eccentric" life, Hosmer created a self-image that allowed her to function in the public sphere as a "child-woman," as she was described by her friend Grace Greenwood.[24] She cultivated a childlike, almost impish demeanor devoid of what would have been considered dangerous feminine guiles, thereby inoculating herself against "all shadow of blame." Hosmer thus mitigated the challenges she posed to masculine artistic

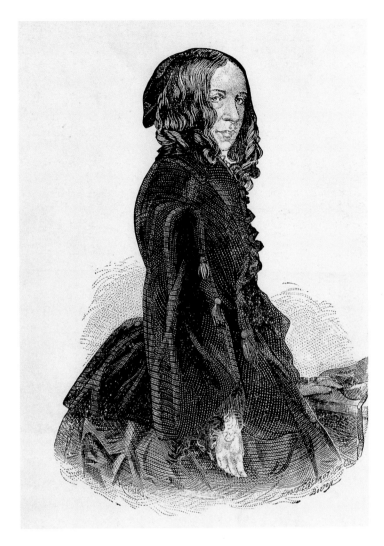

Figure 25. *Elizabeth Barrett Browning.* Engraving, frontispiece to *Aurora Leigh* (4th ed., 1857). General Research Division, The New York Public Library, Astor, Lenox and Tilden Foundations

Figure 26. *Harriet Goodhue Hosmer,* ca. 1855. Salted paper print, 6⅛ x 4¹¹⁄₁₆ in. (15.6 x 12.1 cm). National Portrait Gallery, Smithsonian Institution, Washington, D.C. (NPG.84.150)

hegemony by all but concealing her professional aspirations behind a childlike facade.

Two other American women sculptors joined Hosmer in Rome in the 1850s: Louisa Lander, in 1855, and Emma Stebbins the following year. Lander studied with the famed American sculptor Thomas Crawford; Stebbins would eventually work in the atelier of Maine-born Paul Akers and join Cushman and Hosmer in their new residence on the via Gregoriana. Together they assumed nationalistic significance as embodiments of the expansiveness and vigor of American culture. Hosmer, for example, was celebrated in the American press as "the Yankee Girl" and as "one of our representative women."[25]

Such high-profile status all but guaranteed women artists professional success in Rome. They lived independent lives, traveled without chaperone, and had unprecedented access to the city. As the sculptor William Wetmore Story wrote in 1853: "Hatty [Hosmer] takes a high hand here with Rome, and would have the Romans know that a Yankee girl can do anything she pleases, walk alone, ride her horse alone, and laugh at their rules."[26] In a small undated sketch captioned *The Sister Sculptresses Taking a Ride* (fig. 27), Hosmer, with whimsy and charm, depicts herself and Emma Stebbins galloping with abandon across the Roman Campagna. Nathaniel Hawthorne modeled aspects of the character Hilda from *The Marble Faun,* his 1859 romance about American artists in Rome, on the lives of Hosmer and Lander, endowing his artistic heroine with extraordinary freedoms:

> This young American girl [Hilda] was an example of the freedom of life which is possible for a female artist to enjoy in Rome. . . . The customs of artistic life bestow such liberty upon the sex, which is elsewhere restricted within so much narrower limits; and it is perhaps an indication that, whenever we admit women to a wider scope of pursuits

Figure 27. Harriet Hosmer (American, 1830–1908). *The Sister Sculptresses Taking a Ride,* early to mid-1850s. Pen and ink on paper, 3¾ x 12 in. (9.5 x 30.5 cm). Harriet Goodhue Hosmer Papers, Schlesinger Library, Radcliffe Institute for Advanced Study, Harvard University, Cambridge (Cat. no. A-162-82)

and professions, we must also remove the shackles of our present conventional rules, which would then become an insufferable restraint on either maid or wife. The system seems to work unexceptionally in Rome. . . .[27]

But this Roman world of feminine creativity was not without its obstacles and complications. Hawthorne saw Hilda as an amateur—a copyist rather than an original artist—a characterization that was bestowed on many nineteenth-century American women artists, including Hawthorne's wife, Sophia. Story, whose presence dominated American expatriate life in Rome, shared Hawthorne's suspicion of female creativity when he wrote in 1853: "[Hattie Hosmer] is . . . very wilful, and too independent by half, and is mixed up with a set whom I do not like, and I can therefore do very little for her. She is doing very well and shows a capitol spirit, and I have no doubt will succeed. But it is one thing to copy and another to create. She may or may not have inventive

powers as an artist, but if she [has, will she not] be the first woman?"[28] Hosmer would be forced to counter these and other spurious notions—especially claims that she did not carve her own work—many times during her career.

To be sure, expatriate women in Rome were considered curiosities for the lives they led, and at times their lifestyles were examined more carefully than the art they produced. In the published engraving *Memorable Women of America: Harriet Hosmer—Harriet Hosmer in Her Studio* (fig. 28), Hosmer—posed on a stage-like podium and illuminated by a spotlight as she carves a bust of a woman—is as much the center of attention as her sculptural work. A bourgeois couple, attended by son, daughter, and dog, stares at her out of curiosity. Hosmer enjoyed the patronage of European and American travelers, inhabiting a liminal zone of cultural tourism that was created in part by the writings of Hawthorne and James. Her studio was a popular stop on the grand tour, as noted in most contemporary guidebooks. By sharing the stage with her sculpture, she served as a

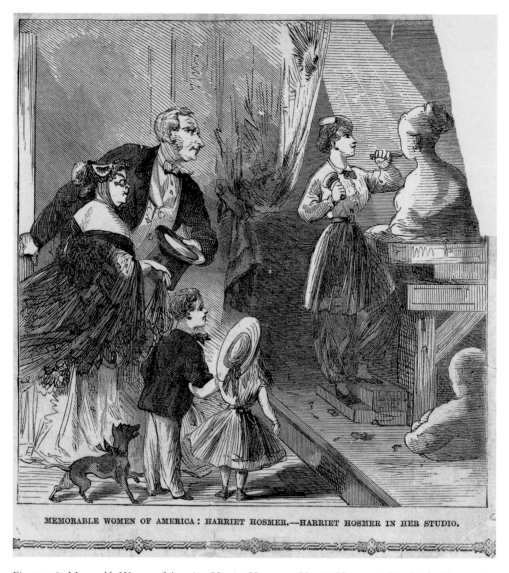

Figure 28. *Memorable Women of America: Harriet Hosmer—Harriet Hosmer in Her Studio*. Engraving (clipping from an unidentified periodical), 5 x 6½ in. (12.7 x 16.5 cm). Schlesinger Library, Radcliffe Institute for Advanced Study, Harvard University, Cambridge (Cat. no. A-162-82)

picturesque spectacle for the touring classes. Thus positioned as an intriguing object of the mostly (but not always, as evidenced by this illustration) male gaze, Hosmer negotiated this somewhat dangerous public terrain by adopting her self-consciously exotic character—she often dressed in a beret and wore pantaloons under her skirt. It was savvy

business practice, too. By entertaining patrons, and thus trying to ensure their return, she was also enhancing sales.

Less successful in this regard was Louisa Lander, who was forced to leave Rome in 1859 after being shunned by the American artistic community—led by Story and Hawthorne— for ostensibly crossing the border of acceptable

Perspectives on American Sculpture before 1925

feminine behavior by modeling nude for an artist. No proof of this allegation existed, but at the time the mere semblance of impropriety was enough to destroy a woman's reputation. Hosmer, with alarming perspicacity, had constructed a public persona that essentially "desexed" her identity. In so doing, she lived the "emancipated" life, relatively free of scandal or innuendo.

Since the eighteenth century, American painters and sculptors had sought an intimate knowledge of antique art. Both artists and their patrons held that an understanding of the Classical past was necessary to the development of a civilized society. Through contact with antique statuary, such as the Apollo Belvedere in the Vatican, nineteenth-century viewers felt they could imbibe the universal truths embodied in the sculpture's physical perfection. Neoclassical sculpture reinstated these values and, in the minds of the American elite, thus exerted an "elevating" influence on this young frontier nation and its citizenry.[29]

Throughout her career, Harriet Hosmer remained committed to the humanist mission of Neoclassicism. She produced few portrait busts, instead dedicating herself, for the most part, to ideal statuary. Among her first works in Rome was the bust of *Daphne* (see fig. 22) that she modeled between 1853 and 1854, a mythological figure who to a nineteenth-century audience symbolized purity and chastity. Daphne, daughter of the river god Peneus, preferred running unfettered in the forest to accepting the bonds of marriage. Apollo pursued the unwilling nymph until, exhausted from the chase, she prayed to her father to save her and was transformed into a laurel tree. Apollo then claimed the laurel tree as his own, the leaves of which would forever after be used to crown great heroes.[30]

Hosmer's *Daphne* possesses a serene and contemplative demeanor, far removed from the dynamic excitement of Bernini's famed *Apollo and Daphne* (1624), which she probably knew from her visits to the Borghese Gallery in Rome. Bernini's Baroque exuberance was

anathema to Neoclassical sculptors, who esteemed the simple restraint of Classical Greek statuary. Hosmer's *Daphne* demonstrates the Classical austerity that she learned from her teacher, John Gibson. At the forefront of sculptural ideas in Rome, she most likely looked to Severe-style figures, such as those from the Temple of Zeus at Olympia (fig. 29), rather than contemporary sources, for inspiration.[31] In place of the complicated curls and decorative poppies that adorn the head of the earlier *Hesper, Daphne*'s coif consists of a simple chignon and headband. The proportions of the figure are more carefully rendered: the shoulders and arms fuller, the breasts more sensuously modeled, as if from life. Her head turns away from the viewer modestly, with eyes gazing down. The features, ideally rendered, express inner calm and strength. The most decorative element of the sculpture is the festoon, carved with interlacing laurel leaves and berries, that terminates the bust.[32]

It is tempting to read Hosmer's work in purely autobiographical terms. Her focus on images of women is significant, as is the case with most of the American expatriate women sculptors in Rome. Because the river nymph Daphne shunned marriage and remained chaste, she has often been identified with the artist, who proudly championed her own celibate independence in an August 1854 letter to Wayman Crow:

> Everyone is being married but myself. I am the only faithful worshipper of Celibacy . . . Even if so inclined, an artist has no business to marry. For a man, it may be well enough, but for a woman, on whom matrimonial duties and cares weigh more heavily, it is a moral wrong, I think, for she must either neglect her profession or her family, becoming neither a good wife and mother nor a good artist. My ambition is to become the latter, so I wage eternal feud with the consolidating knot.[33]

Figure 29. Head of Hippodamia, Figure K from the East Pediment of the Temple of Zeus at Olympia, 440–410 B.C.E. Marble. Olympia Museum, Greece; Alison Frantz Collection, American School of Classical Studies at Athens (PE 80)

Hosmer no doubt sympathized with Daphne's plight. Describing Hosmer's development as an artist, a commentator in 1857 made the symbolic association explicit: "The sculptress was struggling out of her prison, reversing the fable of Daphne."[34] Hosmer, this writer suggested, had freed herself from Daphne's enforced paralysis to arrive—as a free, creative spirit—in her new Roman home. Given Hosmer's exceptional standing as an artist in Rome, it is easy to understand why viewers often read her sculptures as visual allegories to the challenges she faced as a woman in the male-dominated art world. When interpreting her work, however, it is also important to note that other aesthetic and social factors came into play. We must be wary of narrowly assigning autobiographical meaning to her sculpture for fear of affirming the traditional assumption that women are endowed with personal revelation but not the power of universal expression.

Hosmer produced sculptures within a complex milieu and in response to a myriad of professional as well as personal concerns. Obviously aesthetics were a large factor; in emulating the restraint of the Severe style, she chose a visual language that communicated a universal truth and a Western ideal of beauty. She was also a working artist, however, and an active participant in Rome's international art community. (For example, since mythological figures such as Daphne served as popular subjects for other American sculptors, Hosmer most likely shared ideas with her colleague and friend Joseph Mozier, who was also at work on a bust of Daphne in January of 1853.) Moreover, Hosmer, who as we have seen was savvy about the art market in Rome, probably knew that busts sold more easily than full figures and that busts with both breasts exposed sold better than those draped.[35] She chose subjects that expressed her own unique experience of womanhood but also reflected the realities of working among a group of peers at once dedicated to Neoclassical ideals and responsive to the demands of the contemporary art market.

In 1854 Hosmer produced *Medusa* (fig. 30), a companion piece to *Daphne* in that they share the theme of metamorphosis. Medusa was a woman of great beauty whom Neptune ravished in the Temple of Athena. In revenge for this desecration, Athena transformed Medusa into a Gorgon, with snakes for hair. Thereafter a glance at her terrible face would turn a viewer to stone. By safely looking at Medusa's reflection in his bronze shield, Perseus was able to slay her, and in triumph he cut off her head. Hosmer chose to stress Medusa's humanity—and great beauty—rather than her monstrousness, as seen for example in Bernini's *Head of Medusa*

(ca. 1636, Palazzo dei Conservatori, Rome).[36] She depicted Medusa during a piteous moment of transformation, when her beauty was still intact but her hair was turning irrevocably into a snaky mass. *Medusa* gazes directly out at the viewer, her head turned slightly to the left, in an expression that suggests profound melancholy. Her aquiline brow and nose are tempered by her full face and soft lips, which suggest a naturalism rendered from life. The graceful shoulders and torso terminate in a simple ribbon of snakes.

Hosmer's *Daphne* and *Medusa* offer a striking commentary on female subjectivity. Both sculptures reach beyond a simple representation of victimhood to communicate a feminine consciousness and agency. Daphne demonstrates strength and resilience through her stoic demeanor; Medusa expresses a pathos and humanity rarely allowed to her. With these two works, Hosmer expanded the boundaries of Neoclassicism by asserting the centrality of women's experience to the universal ideals of high art.

In 1855 Hosmer was prepared to attempt a more challenging, and controversial, work: a full-length nude figure, *Oenone*. Commissioned by Wayman Crow, the sculpture (fig. 31) was one of the few female nudes that Hosmer produced. Oenone was a Naiad, or nymph of fountains and streams, who resided on Mount Ida and was beloved by Paris before he deserted her for the Trojan queen, Helen. For guidance in this daunting task, Hosmer turned to her teacher, John Gibson. She most likely knew of Gibson's *Oenone,* modeled on a shepherd girl he had seen on a walk in the Campagna. She had carefully studied his *Narcissus* (fig. 32), also inspired from life (on a boy he saw sitting by a Roman fountain),[37] and Hosmer borrowed the seated pose and contemplative demeanor for use in her *Oenone*. She depicted the nymph, who is not quite lifesize, collapsed with grief after having been abandoned by Paris. In her tender rendering of the subject, she was no doubt responding to Tennyson's poem "Oenone": "My eyes are full of tears, my heart of love,/

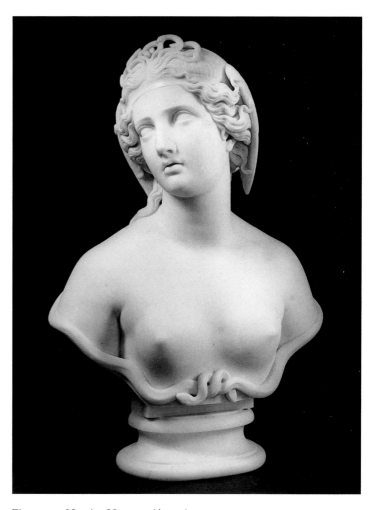

Figure 30. Harriet Hosmer (American, 1830–1908). *Medusa,* 1854. Marble, 27½ x 19 x 10 in. (69.9 x 48.3 x 25.4 cm). The Minneapolis Institute of Arts; The Walter C. and Mary C. Briggs Purchase Fund (2003.125)

My heart is breaking, and my eyes are dim,/ And I am all aweary of my life."[38]

While at work on this sculpture, Hosmer caused quite a stir among the Anglo-American community in Rome. Following Gibson's example, she modeled her figure from life, using a nude model. Outraged by Hosmer's "impertinence," Thomas Crawford

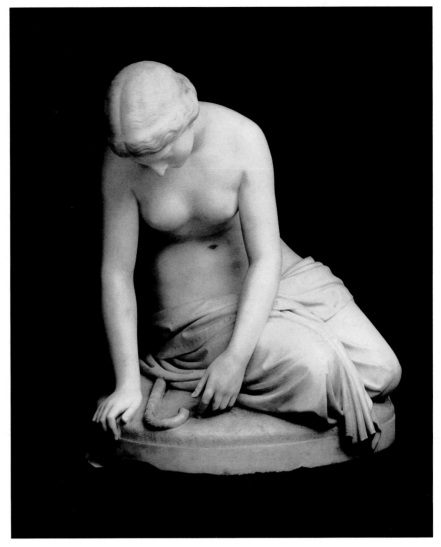

Figure 31. Harriet Hosmer (American, 1830–1908). *Oenone,* 1854–55. Marble, 43½ x 34 x 27½ in. (110.5 x 86.4 x 69.9 cm). Washington University Gallery of Art, St. Louis; Gift of Wayman Crow Sr., 1855

wrote to his wife in 1854: "Miss H[osmer]'s want of modesty is enough to disgust a dog. She has had casts for the *entire female* model made and exhibited in a shockingly indecent manner to all the young artists who called upon her. This is going it rather strong."[39] Even Elizabeth Barrett Browning chafed upon entering Hosmer's studio. Her modesty offended, she wrote, "not being 'professional' there was not much reason, I thought, to struggle against my womanly instincts."[40] What was particularly galling to Crawford— and uncomfortable for Barrett Browning— was that a "professional" female sculptor would have the same access to the nude figure as would a male sculptor. In fact, the

Perspectives on American Sculpture before 1925

availability of live models in Rome was a great boon to expatriate women sculptors. In the United States, life classes were closed to women art students. Hosmer, as we learned, had earlier acquired a knowledge of anatomy by special arrangement in St. Louis.

With her customary courage Hosmer entered into a long-lived controversy regarding the nude figure in American art. Most commonly realized through the ideal imagery of mythology, the nude was central to the humanistic tradition of Neoclassicism. For an American audience, however, modesty remained an essential condition of the female nude, whether through the strategic placement of drapery or hands, as seen in one of the most famous female nudes of the nineteenth century, Hiram Powers's *Greek Slave* (fig. 33).[41] Ironically, *Oenone* far surpasses Powers's work in terms of modesty. She wears a drape that covers her lower body; her head and upper torso lean to the left over Paris's abandoned shepherd's crook. Her gaze and posture are turned inward in a sorrowful lament, a self-contained pose that shields the body from prying eyes. The figure is rendered in the Severe style: her hair, worn in a chignon, is tightly controlled, and her features are solemn and contained. The body is coldly burnished, a departure from the warm naturalism and sensuality of Hosmer's earlier busts. *Oenone* embodies a private moment of mournful subjectivity from which the viewer is excluded. The closed posture refuses objectification, just as the marble's finish mitigates the sculpture's eroticism. Indeed, in producing her first female nude, Hosmer succeeded in the highest aims of Neoclassicism while at the same time subverting the conventional pleasures of spectatorship.

By 1856 Hosmer had attained a professional stature in Rome. She understood the art market well and turned to fancy pieces, or conceits—imaginative works intended to amuse and delight—to assure her financial independence. Not surprisingly, children often served as subjects of these works. In *Puck* (fig. 34), Hosmer depicted the famed

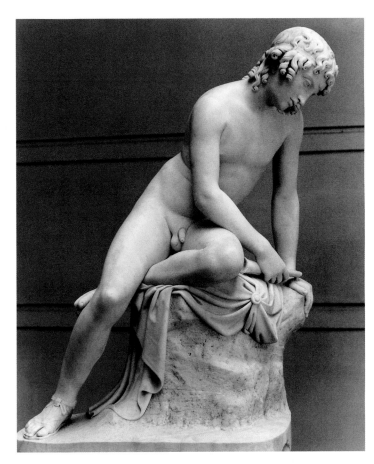

Figure 32. John Gibson (British, 1790–1866). *Narcissus,* 1838. Marble, 43¼ x 34¼ x 17¾ in. (109.9 x 87 x 45.1 cm). Royal Academy of Arts, London

impish character from Shakespeare's *A Midsummer Night's Dream.* The little boy— a playful and mischievous sprite, replete with bat wings—sits cross-legged on a toadstool. He raises his right arm, about to toss a giant beetle at an unsuspecting passerby, while with his left hand he traps a chameleon. No doubt Hosmer recalled the insects and small, stuffed reptiles once housed in her Watertown studio. With its compact dimensions, *Puck* was ideally suited for a domestic setting, and Hosmer produced many versions for American and British tourists. She sold fifty, including one to the Prince of Wales,

Figure 33. Hiram Powers
(American, 1805–1873). *The Greek
Slave,* 1841–43; this carving, 1851.
Marble, 65¼ x 21 x 18¼ in.
(165.7 x 53.3 x 46.4 cm); marble
base, 25 x 34 in. (63.5 x 86.4 cm).
Yale University Art Gallery,
New Haven; Olive Louise Dann
Fund (1962.43)

Figure 34. Harriet Hosmer (American, 1830–1908). *Puck,* 1854; this carving, 1856. Marble, 30½ x 16⅝ x 19¾ in. (77.5 x 42.2 x 50.2 cm). Smithsonian American Art Museum, Washington, D.C.; Gift of Mrs. George Merrill (1918.3.5)

who visited her studio in 1859.[42] By the time Hosmer exhibited her *Beatrice Cenci* (1856, St. Louis Mercantile Association) in London, her international reputation was assured. That same year she received a commission for a tomb sculpture, the *Judith Falconnet Memorial* (1857–58, Sant'Andrea delle Fratte), the only permanent sculpture in a Roman church by an American sculptor. She would continue to pursue a successful career in Rome for several more decades, all the while promoting the work of a prominent and productive group of women Neoclassical sculptors. Hosmer's personal warmth and professional generosity would serve her sister artists well.

1. This essay forms part of a book on nineteenth-century American women sculptors in Rome, *The American Corinnes: Women Sculptors and the Eternal City, 1850–1875.* I would like to thank Thayer Tolles for her careful editing of the essay.

2. Lydia Maria Child, "Miss Harriet Hosmer," *Littell's Living Age* 56 (March 13, 1858), p. 697.

3. Mrs. [E. F.] Ellet, *Women Artists in All Ages and Countries* (New York: Harper and Brothers, 1859), p. 354. See also Joseph Leach, "Harriet Hosmer: Feminist in Bronze and Marble," *Feminist Art Journal* 5 (summer 1976), p. 10.

4. "Editor's Department," *Arthur's Home Magazine* 1 (January 1853), p. 318; and Ellet, *Women Artists,* p. 354.

5. "Editor's Table," *Godey's Lady's Book* 45 (April 1852), p. 293.

6. William H. Gerdts, "The *Medusa* of Harriet Hosmer," *Bulletin of the Detroit Institute of Arts* 56 (1978), p. 97; and Dolly Sherwood, *Harriet Hosmer: American Sculptor, 1830–1908* (Columbia: University of Missouri Press, 1991), pp. 44–47.

7. Harriet Goodhue Hosmer, *Boston and Boston People in 1850* (Boston, 1850), p. 24.

8. Margaret Farrand Thorp, *The Literary Sculptors* (Durham, N.C.: Duke University Press, 1965), p. 85; William L. Vance, *America's Rome,* vol. 1, *Classical Rome* (New Haven: Yale University Press, 1989), p. 204; and William H. Gerdts, "Celebrities of the Grand Tour: The American Sculptors in Florence and Rome," in Theodore E. Stebbins Jr., *The Lure of Italy: American Artists and the Italian Experience, 1760–1914,* exh. cat. (Boston: Museum of Fine Arts, 1992), p. 88.

9. Rome was then filled with American travelers partly as a result of the decade's economic prosperity, which lasted at least until the Panic of 1857 (Gerdts, "Celebrities of the Grand Tour," p. 67). See also Joshua Taylor, *William Page: The American Titian* (Chicago: University of Chicago Press, 1957), pp. 115–16, 121; and John W. Coffey, *Twilight of Arcadia: American Landscape Painters in Rome, 1830–1880,* exh. cat. (Brunswick, Maine: Bowdoin College Museum of Art, 1987), p. 11.

10. Louis L. Noble, *Course of Empire, Voyage of Life, and Other Pictures of Thomas Cole, N.A.* (New York: Cornish, Lamport and Co., 1853), p. 377.

11. R. De Cesare, *The Last Days of Papal Rome, 1850–1870,* trans. Helen Zimmern (London: Archibald Constable and Co., 1909), pp. 148, 157; Madelyn Gutwirth, *Madame de Staël, Novelist: The Emergence of the Artist as Woman* (Urbana: University of Illinois Press, 1978), p. 173 n. 38; and Paola Giuli, "Tracing a Sisterhood: Corilla Olympica as Corinne's Unacknowledged Alter Ego," in *The Novel's Seductions: Staël's Corinne in Critical Inquiry,* ed. Karyna Szmurlo (London: Associated University Presses, 1999), p. 165.

12. Staël chose to ignore the actual controversy that accompanied Corilla Olympica's crowning, when she was jeered and belittled by men in the audience. In the opening chapter of the novel, the Englishman Oswald, Lord Nelvil, Corinne's eventual lover, muses that "it was the first time he had witnessed honour done to a woman, to a woman renowned only for the gifts of genius." Madame de Staël, *Corinne, or Italy,* trans. Sylvia Raphael (New York: Oxford University Press, 1998), p. 23. See also Ellen Moers, *Literary Women* (Garden City, N.Y.: Doubleday & Co., 1976), p. 177; and English Showalter Jr., "Corinne as an Autonomous Heroine," in *Germaine de Staël: Crossing the Borders,* ed. Madelyn Gutwirth, Avriel Goldberger, and Karyna Szmurlo (New Brunswick, N.J.: Rutgers University Press, 1991), p. 189.

13. Elizabeth Barrett Browning, *Aurora Leigh* (1857; new ed., ed. Margaret Reynolds, Athens: Ohio University Press, 1992).

14. Van Wyck Brooks, *The Dream of Arcadia: American Writers and Artists in Italy, 1760–1915* (New York: E. P. Dutton, 1958), pp. 114–17; Ann Douglas, *The Feminization of American Culture* (1977; reprint, New York: Farrar, Straus and Giroux, 1998), pp. 270–73; William Stowe, *Going Abroad: European Travel in Nineteenth-Century American Culture* (Princeton, N.J.: Princeton University Press, 1994), p. 103; and Leonardo Buonomo, *Backward Glances: Exploring Italy, Reinterpreting America (1831–1866)* (London: Associated Presses, 1996), pp. 27–28.

15. Henry James, *William Wetmore Story and His Friends* (Boston: Houghton, Mifflin & Co., 1903), vol. 1, pp. 130–31.

16. Sophia Hawthorne, *Notes in England and Italy* (New York: G. P. Putnam's Sons, 1878). See also Mary Suzanne Schriber, *Writing Home: American Women Abroad, 1830–1920* (Charlottesville: University of Virginia Press, 1997), pp. 117–18; and Katherine Rodier, "Nathaniel Hawthorne and *The Marble Faun,*" in *The Novel's Seductions,* pp. 230, 233, 235.

17. Maura O'Connor, *The Romance of Italy and the English Imagination* (New York: St. Martin's Press, 1998), pp. 27–34.

18. Hosmer to Carr, April 23, 1854, quoted in Cornelia Carr, ed., *Harriet Hosmer: Letters and Memories* (New York: Moffatt, Yard and Co., 1912), pp. 26–27.

19. Sarah Foose Parrott, "Networking in Italy: Charlotte Cushman and 'The White Marmorean Flock,'" *Women's Studies* 14 (1988), pp. 314, 321; Sarah Foose Parrott, "Professionals and Expatriates: The Careers in Italy of Nineteenth-Century American Women Writers and Artists" (Ph.D. diss., George Washington University, 1988), p. 33 n. 20; and Sherwood, *Harriet Hosmer,* pp. 87, 90, 328.

20. Hosmer to Crow, December 1, 1852, in Carr, ed., *Harriet Hosmer,* pp. 22–23.

21. Benedict Read, *Victorian Sculpture* (New Haven: Yale University Press, 1982), pp. 32–33.

22. Taylor, *William Page,* pp. 124, 134.

23. Barrett Browning to Mary Russell Mitford, May 10, 1854, quoted in Sherwood, *Harriet Hosmer,* p. 97.

24. Grace Greenwood [Sarah Jane Clarke Lippincott], "Miss Hosmer's Progress," *Boston Transcript,* March 18, 1853, p. 1.

25. "Atelier," *Cosmopolitan Art Journal* 1 (March 1857), p. 90; ibid. (June 1857), p. 122.

26. Story to J. R. Lowell, February 11, 1853, quoted in James, *William Wetmore Story,* vol. 1, p. 255.

27. Nathaniel Hawthorne, *The Marble Faun* (1859; reprint, New York: Signet Classics, 1961), p. 47.

28. Story to J. R. Lowell, February 11, 1853, quoted in James, *William Wetmore Story,* vol. 1, pp. 256–57.

29. Vance, *America's Rome,* vol. 1, pp. 183, 193.

30. Thorp, *Literary Sculptors,* p. 87; James Hall, *Dictionary of Subjects and Symbols in Art* (New York: Harper and Row, 1974), pp. 28–29; and Thayer Tolles, ed., *American Sculpture in The Metropolitan Museum of Art, Volume I: A Catalogue of Works by Artists Born before 1865* (New York: The Metropolitan Museum of Art, 1999), p. 130.

31. Thanks to Gene Dwyer, my colleague at Kenyon College, for bringing to my attention the Severe-style figures at the Temple of Zeus at Olympia and their possible influence on Hosmer's work.

32. In 1854 Hiram Hosmer began to experience financial difficulties that forced him to withdraw support from his daughter in Rome. He had hoped she would return home to Watertown; instead she turned to her close friend and mentor, Wayman Crow. Hosmer gave this sculpture to Crow in return for his economic support. The bust *Daphne* would become the first of many works produced under Crow's sponsorship. Margaret Thorp, "Harriet Hosmer: Leader of the White Marmorean Flock," *Smith Alumni Quarterly* (spring 1975), p. 150; Sherwood, *Harriet Hosmer,* p. 81.

33. Hosmer to Crow, August 1854, Harriet Goodhue Hosmer Papers, Schlesinger Library, Radcliffe Institute for Advanced Study, Harvard University, Cambridge.

34. "Mere Mention," *Home Journal* (New York), November 21, 1857, p. 3.

35. Grace Greenwood [Sarah Jane Clarke Lippincott], *Haps and Mishaps of a Tour in Europe* (Boston: Ticknor, Reed and Fields, 1854), p. 222; and Vance, *America's Rome,* vol. 1, p. 211.

36. Gerdts, "The *Medusa* of Harriet Hosmer," pp. 100–102.

37. Read, *Victorian Sculpture,* pp. 53, 201. Janet Headley first noticed this resemblance.

38. Sherwood, *Harriet Hosmer,* p. 80; "Oenone," in Alfred Tennyson, *Poems and Plays* (New York: Oxford University Press, 1973), pp. 38–41.

39. Thomas Crawford to Louisa Crawford, July 5, 1854, Thomas Crawford Papers, Archives of American Art, Smithsonian Institution, Washington, D.C., microfilm reel D181, frame 783.

40. Barrett Browning to Ilsa Blagden, May 8, 1854, quoted in Sherwood, *Harriet Hosmer,* p. 91.

41. Vance, *America's Rome,* vol. 1, pp. 211–12; for a feminist analysis of *The Greek Slave,* see Joy S. Kasson, *Marble Queens and Captives: Women in Nineteenth-Century American Sculpture* (New Haven: Yale University Press, 1990), pp. 46–73.

42. Alicia Faxon, "Images of Women in Sculpture by Harriet Hosmer," *Woman's Art Journal,* spring–summer 1981, p. 27; Sherwood, *Harriet Hosmer,* pp. 119, 347 n. 11. For an interesting and detailed discussion of *Puck,* see H. Nichols B. Clark, *A Marble Quarry: The James H. Ricau Collection of Sculpture at the Chrysler Museum of Art* (New York: Hudson Hills Press in association with the Chrysler Museum of Art, 1997), pp. 217–20.

Joyce K. Schiller

Winged Victory, A Battle Lost: Augustus Saint-Gaudens's Intentions for the *Sherman Monument* Installation

In the late nineteenth century Augustus Saint-Gaudens (1848–1907) collaborated with other sculptors, studio assistants, and like-minded architects to create public monuments that were meant to be viewed within specifically constructed architectural and landscaped surroundings. These viewing enclaves were designed with careful consideration to spatial arrangements, color, edge, height, lighting, sound, and relationships to nearby urban features. Conceived as site specific within a larger environment, the monuments, by their very design, instructed visitors in how to approach the monumental experience. Unfortunately, none of Saint-Gaudens's monuments still stands in its environment as originally planned: landscape elements grow, change, and sometimes die; some of the sculptures have been relocated; and some installations have had their original forms modified.

In 1892, while negotiating the commission for a monument in New York City to honor Civil War hero William Tecumseh Sherman (1820–1891), Saint-Gaudens included provisions for mounting a figural group on an architect-designed pedestal and siting the piece within a collaboratively planned viewing environment "with all its appurtenances finished and complete . . ." (fig. 35).[1] Although "appurtenances" might be understood to refer to the sculptural monument's appointments, as Saint-Gaudens used the word it also meant the monument site's accoutrements, such as location and placement, which for a public monument were not typically stated within the contractual agreement. Saint-Gaudens's monumental commissions often included an implied responsibility for choosing or suggesting a location to the commissioning committee. In the case of the *Sherman Monument* the site was to be officially requested by the Sherman Statue Committee.

New York's policy on the location and erection of public monuments underwent a transformation during the last quarter of the nineteenth century. Before that time there had been rather informal arrangements between sculptors and their connections at City Hall or in the Parks Department. While the city's Central Park Commission did not itself order public monuments, they did have discretion in the use of public spaces.[2] Eventually the process became more regular, and the channels necessary for determining agreements expanded to include the parks commissioner, the Art Commission of the City of New York, and a specified municipal official. In addition to the many public park and traffic juncture locations potentially available as sites for monuments, Central Park sites were regularly requested by various groups offering statues to the city. Such requests were made despite a report on the inclusion of statues in the park, published in 1873 by the Parks Department, that clearly

Figure 35. Augustus Saint-Gaudens (American, 1848–1907) with Charles Follen McKim (American, 1847–1909). *Sherman Monument,* 1892–1903. Gilded bronze on granite base, Grand Army Plaza, New York. Photograph in Royal Cortissoz, *Augustus Saint-Gaudens* (Boston and New York: Houghton, Mifflin, 1907), p. 61. Thomas J. Watson Library, The Metropolitan Museum of Art, New York

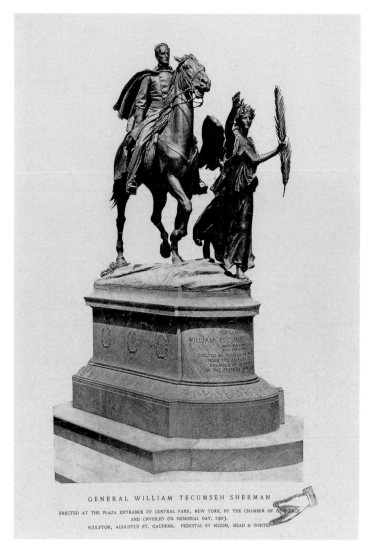

Figure 36. Photograph of the *Sherman Monument,* probably taken at the time of unveiling (May 1903). Avery Architectural and Fine Arts Library, Columbia University, New York

stated the park should be considered a park, first and foremost, and was in and of itself a work of art.[3] The park's board of commissioners approved public monuments on a case-by-case basis, but it rarely agreed to sites that necessitated changes to the park at the time the application was made.

The initial contractual agreement for the *Sherman Monument* stated that it would be "complete, and ready for unveiling on or before May 1st 1894" (fig. 36).[4] In fact, Saint-Gaudens did not commence concentrated work on the sculpture until early in 1897, the same year he relocated to Paris. The question of the monument's placement did not surface in Saint-Gaudens's correspondence until the beginning of March 1898. In a letter to Saint-Gaudens in Paris, architect Stanford White noted the lack of a decision: "The question as to the site for the Sherman statue is all at sea again, on account of Greater New York and Tammany being in power. The present President of the Park Board runs everything, and he is [a] very difficult and impossible man to deal with, so we are laying around to find out some Tammany channel through which to approach him."[5] "We" no doubt refers to the close circle of colleagues whom Saint-Gaudens and White had relied on for friendship, artistic camaraderie, and collaborative work for more than twenty years, including Charles Follen McKim and George Fletcher Babb.

The equestrian portion of the *Sherman Monument* was perhaps the least problematic aspect of the commission, in part because of Saint-Gaudens's reliance on preparatory studies and his portrait bust of Sherman, which he had modeled from life in 1888 (fig. 37). The only substantive change to the general's physiognomy was a modification of his hair. During sittings for the bust in 1888, Saint-Gaudens had requested that Sherman pose on a horse, but the general refused.[6] For the monument, Saint-Gaudens hired an Italian model with a similar body type to sit astride the horse. The equine model was produced by the animal specialist Alexander Phimister

Proctor, who had earlier sculpted the horse for Saint-Gaudens's *General John A. Logan Monument* (1894–97), in Chicago's Grant Park (fig. 38). Under Saint-Gaudens's supervision and criticism, Proctor modeled Sherman's steed from "the then famous jumper Ontario . . . [a] magnificent raw boned horse."[7]

The figure of *Victory* at the fore of the *Sherman Monument* (fig. 39) was constructed from a variety of sources: the body was modeled on the graceful and "Goddess-like" professional artist's model Harriette Eugenia Anderson, while the figure's face was modeled from Saint-Gaudens's longtime mistress, Davida Clark.[8] Compared with the face of Saint-Gaudens's bas-relief *Amor Caritas* (1880–98, The Metropolitan Museum of Art), which was also based on Clark, the face on *Victory* seems gentler, less pugnacious. This is partly a result of the clever way in which Saint-Gaudens accommodated Davida's strong chin and jaw. According to text fragments of manuscript papers for *The Reminiscences of Augustus Saint-Gaudens,* by the artist's son, Homer Saint-Gaudens, he "had cast for the living model a heavy plaster cap. She could pose only for a moment beneath it, but at that moment she carried her head at the proper angle, which banished her hated 'stuck-out' chin."[9] By the time Saint-Gaudens went to work finishing the *Victory* in Paris, he was experimenting with various drapery arrangements on four copies of the model.[10] He envisioned a convincing arrangement of *Victory*'s "flowing draperies" that would convey the forward motion of the group in much the same way the windswept drapery of the Victory of Samothrace (ca. 190 B.C.E., Musée du Louvre, Paris) conveys the motion of lift and flight.[11]

Saint-Gaudens's quest for excellence in the whole of the monument as well as in its constituent parts caused him to rework and recast many of the elements until the sculpture came together as an entirely satisfying composition. In a letter to Homer, he noted, "I've just remodeled the cloak over for the

Figure 37. Augustus Saint-Gaudens (American, 1848–1907). *General William Tecumseh Sherman,* 1888; this cast, 1910. Bronze, 31 ¼ x 21 ½ x 11 ½ in. (79.4 x 54.6 x 29.2 cm). The Metropolitan Museum of Art, New York; Gift by subscription through the Saint-Gaudens Memorial Committee, 1912 (12.76.2)

10000th time, and to-day it seems beautiful. Tomorrow it will probably appear hellish and so things go."[12] This obsessive attention to detail also led Saint-Gaudens—following his own dictum that things need not be modeled as they are so long as they appear to be what they seem—to skew the proportions of

Figure 38. Augustus Saint-Gaudens (American, 1848–1907) with Stanford White (American, 1853–1906). *General John A. Logan Monument,* 1894–97. Bronze on granite pedestal. Grant Park, Chicago

Victory until her extremities were overextended. The dimensions of *Victory*'s body parts and her idealized proportions could be deemed appropriate because the subject is allegorical. When the model of *Victory* was displayed in the Salon of 1899, it was celebrated. One French critic found it "proves there are no subjects used up and done with, and that Art far from having said its last word, ceases not from renewing itself at the call of genius...."[13] In July 1899 Saint-Gaudens modified his *Sherman Monument* model and considered any changes that might be necessary before delivering the finished work for placement, and a celebratory unveiling, in New York.

Figure 39. Augustus Saint-Gaudens (American, 1848–1907). *Victory,* 1892–1903; this cast, 1912 or after (by 1916). Bronze and gilt, 38 x 9½ x 18½ in. (96.5 x 24.1 x 47 cm). The Metropolitan Museum of Art, New York; Rogers Fund, 1917 (17.90.1)

Two years earlier Saint-Gaudens had proposed that his old friend Charles Follen McKim, a partner in the architectural firm McKim, Mead & White, collaborate with him as the designer of the pedestal.[14] Anticipating a conclusion to the discussion of the monument's site, Saint-Gaudens wrote to McKim in February 1900 urging him to begin work. He also promised that in a month's time drawings would arrive in New York indicating the form of the sculpture's plinth, so that McKim could adjust his design accordingly.[15]

The official *Sherman Monument* proposal, including drawings for a coveted Central Park site, had been made to the Sherman

Figure 40. Map of southern portion of Central Park. In Lewis I. Sharp, *New York City Public Sculpture by Nineteenth-Century American Artists* (The Metropolitan Museum of Art, 1974), p. 41. Thomas J. Watson Library, The Metropolitan Museum of Art, New York

Statue Committee in late spring or early summer of 1899. Writing to his wife, Saint-Gaudens said that he expected their chosen site for the *Sherman Monument* in Central Park was available.[16] Another friend of the collaborators, the architect Thomas Hastings, of the firm Carrère & Hastings, believed that his partner, a close friend of the president of the Central Park board, could see to it that Saint-Gaudens and McKim were awarded their preferred location: at the head of the Mall, an area that runs just east of the center of the park, from Sixty-sixth Street through Seventy-second Street.[17] Six months later, however, McKim expressed concern that he was unable to gauge the reaction to their proposal by the park's board or by the National

Sculpture Society, from whose ranks a committee advised the Parks Department on matters of new public monuments. McKim wrote Saint-Gaudens, "What opposition it will meet in the Park Board, I cannot say, nor how the Sculptor's Society (who I believe have something to say in Park matters) will view it. . . ."[18]

Saint-Gaudens and McKim had conceived of setting the *Sherman Monument* in a newly formed round plaza at the southern end of the Mall even though, as they acknowledged, that would entail altering the park's landscaping or possibly relocating nearby sculptures (fig. 40). That area of the park already had five significant pieces of sculpture, two of which were by John Quincy Adams

Perspectives on American Sculpture before 1925

Figure 41. Model for *Sherman Monument,* installation at Exposition Universelle, Paris, 1900. Photograph in Lorado Taft, "American Sculpture at the Exposition, II," *Brush and Pencil* 6 (August 1900), p. 215. Thomas J. Watson Library, The Metropolitan Museum of Art, New York

Ward. Ward's *Indian Hunter* (1866), the first piece of statuary placed in the park, was at the time one of the most popular public sculptures in New York. Saint-Gaudens also wanted to transplant or otherwise modify trees (through trimming or extreme reshaping) in order to open up viewing access or provide a foliage wall as a backdrop within the *Sherman*'s strong visual statement. In his correspondence he referred to the design consideration of placing a powerful image at the end of a vista in order to draw the pedestrian from one area to another.[19] In defense of the plan, Saint-Gaudens described the changes as minor modifications that would provide a strong focus to balance the far northern end: "The objection to this site is purely sentimental,

i.e. that nothing in the Park must be touched, trees, shrubs, stick or stone."[20]

Despite Saint-Gaudens's and McKim's optimism, negotiations about the site broke down, with objections to the Mall placement led by the park's landscape architect, Samuel Parsons.[21] The notion that they would casually suggest modifying the park, and moving monuments no less, caused great consternation. According to critic and artist William A. Coffin, "There was a great stew in New York over a site for the Sherman. McKim had evolved a plan for placing it at the South end of the Mall in Central Park and had worked it out, as McKim was sure to do, so that with certain changes in the Park made necessary if the statue should be seen in the sort of set-

Fig. 5.—Ground Plan of the Proposed Grant Monument, Riverside Drive.

Figure 42. John H. Duncan (American, 1854–1929). Ground plan for proposed *Grant Monument,* 1890, Riverside Park, New York. In Mariana Griswold Van Rensselaer, "The Grant Monument for Riverside Park," *Garden and Forest* 4 (January 21, 1891), pp. 27–28. Science, Industry and Business Library, The New York Public Library, Astor, Lenox and Tilden Foundations

ting it deserved. . . . This plan was advocated by Saint-Gaudens . . . as he thought if McKim's plan were carried out it would make the best site possible for the Sherman. Great opposition to it developed. . . ."[22]

Saint-Gaudens's correspondence of June 1900 records that the Parks Department had denied the Mall location. Coming on the heels of his great success in the 1900 Exposition Universelle in Paris, where he won the Grand Prix for the *Sherman Monument* model and for the rest of his work exhibited there (fig. 41), this turn of events was particularly galling to the sculptor. Saint-Gaudens felt that he was being forced to beg a site in his home city worthy of what had already been acclaimed as his best work.[23]

Another possible location—and to Saint-Gaudens, upon further reflection, a better site—was proximate to the tomb of Ulysses S. Grant on Riverside Drive (fig. 42). The area was clear and treeless, but it was also jealously guarded by Grant's supporters. Saint-Gaudens related to McKim that the president of the Grant Monument Association, General Horace Porter, who had been Grant's aide-de-camp, "thought 'it would interfere with the view of the tomb,' said there would be 'difficulty with the Grant trustees,' 'that it was a burial place'. . . . He was distinctly antagonistic, without a moment's reflection he expressed opposition as soon as I submitted the idea to him."[24] The notion that a monument to General

Perspectives on American Sculpture before 1925

Sherman would be placed below the tomb of President Grant and would appear to lead to Grant's site caused no end of dismay in Grant's circle (fig. 43). Some saw the potential placement as a symbolic slight against Grant, as though, even in death, Sherman led the way to Grant's victorious, albeit penultimate, status. A suggested alternative location was at the end of the viaduct behind and below Grant's Tomb, about which Saint-Gaudens wrote, "If they do not wish to give General Sherman the swellest position possible, they can put it where they please. I shall only raise a vigorous protest if it should be faced North or East, it must face South or West."[25] In the end, both Saint-Gaudens and Porter opposed that site suggestion as well.

Still in Paris, a rebuffed Saint-Gaudens focused on returning home and taking up the challenge of finding a proper location for the *Sherman* himself. To McKim he confided: "[I]f I cannot get a proper site I shall drop the matter and allow the Committee to take what action they please.... [William] Coffin who has been here suggested 'Long Acre' as a good site. Have you thought of that!"[26] Longacre Square was an earlier name for the northern end of Times Square, an area that would soon become known as the new center of the New York theater district but that in 1900 still had a residential and commercial focus. There was no further mention of that site.

Saint-Gaudens had not been well during his time in France, and in July 1900 he was diagnosed with colon cancer. He returned to the United States to undergo surgery, first in the summer and then again in November. Ill in body, Saint-Gaudens was also ill in spirit, feeling that the *Sherman Monument* situation was hopeless.[27] Casting about for potential locations, in January 1901 he remarked on the suggestion of a site at Park Avenue and Thirty-fourth Street.[28] Based on a disparaging comment in a letter the following month from Saint-Gaudens to McKim, there also must have been discussion of a site somewhere along West Seventy-second Street: "As to the Sherman, I distinctly agree with

Figure 43. John H. Duncan (American, 1854–1929). Grant's Tomb, 1890–97. Granite. Riverside Park, New York

you that the group should be a whole block north so that the nose of the horse should not be rammed into the 72nd Street houses at its head."[29]

Finally, in March 1902, the park's commissioners scheduled a hearing to determine the site of the *Sherman*. Saint-Gaudens continued to make cases for either the Central Park

Mall or the site in front of Grant's Tomb, which he still considered to be ideal.[30] McKim and William E. Dodge of the Sherman Statue Committee attended the March 14 hearing as Saint-Gaudens's representatives, since the sculptor was still recovering at his residence in Cornish, New Hampshire. After the hearing was over, McKim described the day to Saint-Gaudens in a long, colorful letter:

> The hearing wound up very well. . . . Powerful speeches were made by members of the West Side Association, who were interested in Sherman Park, and there followed much rhetoric by others, who represented themselves and the interests of other sections. Then Mr. Dodge arose, and, with his usual suavity, delivered himself in regard to the Grant site, with great moderation and effectiveness. . . . I confined myself to the discussion of the site as an architectural opportunity, most commanding and central in New York, facing South, etc., etc., . . . A man with a beak like an eagle then arose, and kept on rising, until he was surely eight feet above the floor, and spoke in support of the 99th Street site, for which an elaborate drawing had been prepared, showing Sherman gazing West at the setting sun over the North River! . . . Finally Mr. Babcock arose (in his 80th year), and said that so much history has elapsed since he had been Chairman of the Committee, that he would not pretend to speak with authority about its various chapters under the various administrations which had succeeded each other, but that this much he could remember, that all the sites proposed by the Committee had always been refused, and that he would charge the Commissioner of Parks with the imperative duty which devolved

upon him, of selecting a final and adequate resting place for the whole subject! After calling upon those assembled to say their say or for ever after hold their peace, Mr. Wilcox [the head of the commission] said that he would reserve his decision, but expected to be in a position within a week to inform the Committee.[31]

Anticipating a final decision, Saint-Gaudens expressed his initial thoughts about a site at Fifty-ninth Street and Fifth Avenue, at the entrance to Central Park, that had been proposed by the park's landscape architect, Samuel Parsons. In a letter to an unidentified recipient, Saint-Gaudens clearly indicated his reservations about the spatial constraints of the site and the changes to it that would be necessitated in order to accommodate the *Sherman*:

> The best distance to see the work on the whole is between 65 and 70 feet from the pedestal, from that as you approach to 55 feet it is seen fairly well. Any nearer than 55 feet the work loses rapidly until within 40 feet, this is the shortest limit at which the monument can possibly be seen without great disadvantage. The circle at 59th Street is about 114 feet in diameter, this would make a distance of only 55 feet from the pedestal to the Curbstone.
>
> If that site were determined on, in order that it should be at all practical the outer grass plot would have to be eliminated, graded or paved so that the spectator could have that space to stand upon and the circle enlarged at least 10 feet.[32]

Saint-Gaudens tested the specifications for this proposed plaza circle at his property in Cornish, where he could view the plaster cast (fig. 44), and later the finished monument—

Figure 44. Photograph of the plaster cast of the *Sherman Monument* in Saint-Gaudens's "Large Studio" at Cornish, New Hampshire, 1901. U.S. Department of the Interior, National Park Service, Saint-Gaudens National Historic Site, Cornish, New Hampshire

which was installed there so that its surface could be gilded—from an adequate distance. The preference for providing at least fifty-five feet of clearance around a monument in order to view it reflects the sculptor's admonishment to his studio assistants to continually move away from a work a considerable distance to allow for sufficient contemplation.[33] That Saint-Gaudens took into account elements of the streetscape in his designs is evident in a maquette he made while working on the

Charles S. Parnell Monument (1903–7) for the O'Connell Street Square in Dublin (fig. 45), which was based on photographs and measurements of the square and its various facades. Saint-Gaudens's placement of the monument clearly reflects a consideration of the primary access to the square and the movement of traffic through the space. Likewise, one factor in Saint-Gaudens's decision to gild the monumental *Sherman* figures was to combat the potential "invisibility" of the bronze sculpture

when viewed against the trees of Central Park and the busy streetscape nearby. According to Homer Saint-Gaudens, his father explained that he was attempting to protect the surface from eventual pitting, and besides, he was "sick of seeing statues look like stove-pipes."[34]

The final decision on the placement of the *Sherman Monument* was made later in March. It would stand at the southeast corner of Central Park to serve as a grand entrance. Saint-Gaudens wrote Daniel Chester French, a member of the National Sculpture Society advisory committee to the Parks Department, that he considered the choice, albeit with some reservation, "a most honorable and beautiful location," but he nevertheless vented his frustrations about the site and urged the society or other sculptors to help him win approval for the necessary modifications. He mentioned the possible necessity of moving some trees and requested French's committee's support in the matter:

> At 59th Street it will be very much hidden by the trees and unless the circle is increased 15 or 20 feet in diameter the work cannot be seen to advantage without stepping off the curb into the driveway 27 and 30 steps. About 65 feet from the pedestal is the proper distance for viewing the work. . . .
>
> It is absolutely essential that the Circle be extended and the grass plots eliminated in order that the spectator may be free to move at will around the monument. It will also be necessary to make some redisposition of the trees but I cannot say how without further study.[35]

The extent of Saint-Gaudens's panic over the site and its viewing area is also revealed in a hurried note he wrote to McKim in September 1902 in which he requests that the architect lower the height of the pedestal considerably in order to accommodate the limited viewing space.

Facing a clash with the city's Parks Department, a situation he had endured twenty years earlier over the installation of fenced-off grass plots around the base of his *Farragut Monument* in Madison Square Park (which he opposed), Saint-Gaudens, along with McKim, decided to head off another confrontation with William R. Willcox and the Central Park board of commissioners. They issued a joint memorandum on the subject of the *Sherman*'s base and proposed a set of solutions, including replacing the grass plots with sidewalk, laying grillwork in the pavement around the bases of the remaining trees, and acquiring new, "more appropriate" lampposts.[36] Saint-Gaudens also began to press Willcox on the elimination of some of the trees on the site to facilitate viewing. Prior to the sculptor's official request to have some of the trees removed, an article was published in the March 7, 1903, *Evening Post* titled "The Sacredness of the Tree." Although not attributed, the text is a litany of Saint-Gaudens's complaints:

> So to the Plaza the Sherman is to go. It is an honorable site—though the great height of the buildings which partially surround it is somewhat of a drawback; a site which might satisfy any artist were it properly prepared for the statue. Ah, but there are the trees! There are trees in the Plaza, and they [are] . . . not [to] be sacrificed. It is true that the statue will never be properly seen—but what of that? It is true that the man who should propose to plant trees in rows either side the Colleoni at Venice would be thought a lunatic—but the trees are here, and the statue shall be set between them, because it is held inconceivable that they should be disturbed. It is true that these are not particularly fine trees, and that far finer ones could be grown in fifty years. It is true that the Sherman group is not merely a work of art, but such a splendid and

Figure 45. Photograph of maquette (now lost) for the O'Connell Street Square installation of the *Charles S. Parnell Monument* (1903–7, Dublin, Ireland) by Augustus Saint-Gaudens with Henry Bacon (American, 1866–1924). Sculpture: bronze and granite. Photograph: American Academy of Arts and Letters, New York

consummate work of art as has not, perhaps, been produced in four hundred years. What then? The Tree is sacred and must not be touched. The statue may suffer—the whole effect of the square may suffer—but the tree, like the American flag, must never come down.[37]

Saint-Gaudens wrote to Willcox soon thereafter stating that there were too many trees within the monument circle, not including those behind it in the park, and that a minimum of four elms needed to be removed.[38] Willcox responded testily with an interesting comparison between the various proposed *Sherman* sites and their relative abundance of trees. He wrote pointedly that it made no sense for the landscape to be unacceptable in one locale and not in another:

> When the question of locating the Sherman Monument was first brought to my attention, the one argument for placing it on the Mall was that trees were there, and the statue must have trees near it. When, however, I gave the hearing in the Chamber of Commerce, and Mr. McKim appeared, the only argument

Figure 46. Letter from Augustus Saint-Gaudens to Mr. Bliss, with drawing of grass plots, November 28, 1903. Augustus Saint-Gaudens Papers, Dartmouth College Library, Hanover, New Hampshire

he made was that the statue should be placed three hundred feet in front of Grant's Tomb. Here was a site where there were no trees, and you can appreciate how confused I am when the argument made in favor of the Mall was that the statue must have trees, and later, Mr. McKim talked in favor of placing the statue at a point where there were no trees.

Inasmuch as you enclose an editorial from The Evening Post on the "Sacredness of the Tree," I assume that this is part of your letter and that you agree with its

deductions. I entirely dissent from the views expressed in that editorial. A feeling exists among a good many people, that Central Park would be much improved if a great deal of the statuary was replaced by trees, and personally I am not much impressed with the argument set forth in the editorial which you enclosed. We are all, of course, anxious to get the best possible setting for the Sherman Statue, but we must also remember that park features are entitled to consideration, and we must not forget that the

Perspectives on American Sculpture before 1925

Figure 47. Fifth Avenue and Sixtieth Street looking south to Grand Army Plaza, New York. Gelatin silver print, n.d. Museum of the City of New York

parks are not made for statues, but that the placing of the statues within the parks is an incidental feature.[39]

Saint-Gaudens's reply was to the point:

The first impression of a monument is an all important one. I agree with you as to the general inadvisability of statues in the park and had there been any other suitable place offered should have advised against this one because of the location of the trees, otherwise it is a superb

site. . . . Trees <u>behind</u> a statue of this importance, like the avenue in the mall forming a procession, are very fine, not otherwise.[40]

Willcox ultimately agreed to remove two elms immediately in front of the statue. Nevertheless, a week before the monument's unveiling Saint-Gaudens was still waiting for their removal, and for the resulting clear line of sight. To speed the action along he had his assistant Gaeton Ardisson quietly trim the trees as much as possible during installation. Saint-Gaudens described the action in a letter to French:

After promising Mr. McKim that the two trees in front would come down, I suppose Wilcox [*sic*] became frightened, and did nothing, and then seeing the way the green came down over the front of the statue (notwithstanding surreptitious cutting of the branches under his hand by Ardisson while erecting the scaffold) became bold again and [Willcox then] sent a boss with two men to trim off the concealing limbs. Ardisson plied them with whiskey and they became enthusiastic in their cutting, (alas, not enthusiastic enough)....[41]

The *Sherman Monument* was unveiled to great spectacle on May 30, 1903, Memorial Day. McKim's pink Bradford granite pedestal still stands atop three low-rise steps; the seat-formed base of the inscribed and laurel-bedecked plinth provides a fitting anchor for the heroic group that resolutely and perpetually moves forward. Throughout the following autumn Saint-Gaudens wrote numerous letters attempting to persuade Willcox and the board of commissioners to remove the areas of grass within the *Sherman Monument* viewing space as well as more offending trees.[42] To that end he wrote to a Mr. Bliss, the new chairman of the Sherman Statue Committee, begging some assistance. On the bottom of the third page of that letter, Saint-Gaudens included a handwritten note about the grass plots and a drawing to illustrate his point (fig. 46). He noted, "They are situated so that the public is restricted to strips on the SE and SW (the important views) so narrow and near the group that in spite of the low pedestal the belly of the horse is too obtrusive and the object of the Sherman is defeated" (fig. 47).[43]

Still in a fury over Willcox's refusal to pave or modify the area, Saint-Gaudens sent a letter to the editors of the *New York Sun* airing his grievances. The sculptor even quoted from Willcox's correspondence:

[H]e led me to believe that they would be removed, he now refuses to remove them, saying—"I gave the matter a great deal of consideration when the statue was erected and finally came to the conclusion that the grassplots added much to the attractiveness of the circle and did not to any appreciable extent prevent a proper view of the statue." And he concludes—"I am further convinced from the fact that although the grass plots have existed for several months around the memorial, visitors have not found it necessary to stand upon them for a satisfactory view."

How Mr. Wilcox [*sic*] arrives at this conclusion is difficult to understand, for the spectator views the statue from where he may find footing and the ever vigilant policeman is prompt to hustle him off the grassplots, while the passing horses and vehicles prevent his standing in the roadway beyond.[44]

After reading the letter, the sculptor's wife quipped that if Willcox was still in charge of the board, Saint-Gaudens should expect "more grass plots rather than less...."[45]

In February 1904 Saint-Gaudens was still lobbying to widen the apron of the monument site and to finish it with pavers or pavement, reiterating his arguments in a letter to the new Parks Commissioner, John J. Pallas.[46] Only in 1906, the year before his death, did Saint-Gaudens become philosophical about the legacy a sculptor of public monuments might leave behind, writing to Henry James: "The strange thing about us sculptors is our presumption in the face of our knowledge that no matter how offensive or inane our productions may be, there they are in the public place to stick and stick for centuries, while men pass away. A bad picture gets into the garret, a book is forgotten, but our things

Figure 48. *Sherman Monument,* ca. 1998–99

remain to irritate, amuse or shame the populace and perpetuate our various idiocies."[47]

POSTSCRIPT

In 1913 the *Sherman Monument* and its viewing area were moved sixteen feet south of their original site to accommodate the planned installation of Karl Bitter's *Pulitzer Fountain* (1912–16), designed in relation to Saint-Gaudens's *Sherman* and to architect Thomas Hastings's master plan for Grand Army Plaza. Although the monument's space is now larger than at the original site, the grass plots are still there, and so are the trees (fig. 48).

1. Contract for *Sherman Monument,* March 1, 1892, Augustus Saint-Gaudens Papers, Dartmouth College Library, Hanover, New Hampshire (hereafter cited as Saint-Gaudens Papers), microfilm reel 36, frame 66.

2. See Joyce K. Schiller, "The Artistic Collaboration of Augustus Saint-Gaudens and Stanford White" (Ph.D. diss., Washington University, St. Louis, 1997), esp. pp. 62–166.

3. Theodora Kimball and Frederick Law Olmsted Jr., eds., *Forty Years of Landscape Architecture,* "Report of the Committee on Statues in the Park," Department of Public Parks, Office of Design and Superintendence, New York, April 25, 1873. Printed as doc. no. 46, July 17, 1873. Karen Lemmey, formerly Monuments Coordinator, Art and Antiquities, City of New York Department of Parks and Recreation, kindly brought this material to my attention.

4. Contract from Sherman Statue Committee to Saint-Gaudens, May 21, 1891, Saint-Gaudens Papers, microfilm reel 12, frames 850–51. Parts of this document deteriorated before its preservation on microfilm.

5. White to Saint-Gaudens, March 2, 1898, Stanford White Correspondence Copy Books, Drawings and Archives, Avery Architectural and Fine Arts Library, Columbia University, New York, vol. 19, pp. 397–98.

6. "The General refuses point blank to get on a horse. He got through doing that twenty years ago he says. Otherwise he is as amiable as possible." Saint-Gaudens to Mr. [Henry?] Adams, January 25, 1888, manuscript fragment from Homer Saint-Gaudens, ed., *Reminiscences of Augustus Saint-Gaudens,* Saint-Gaudens Papers, microfilm reel 49, frame 17.

7. Augustus Saint-Gaudens, "Reminiscences of an Idiot," Saint-Gaudens Papers, microfilm reel 36, frame 594.

8. William E. Hagans, "Saint-Gaudens, Zorn, and the Goddesslike Miss Anderson," *American Art* 16, no. 2 (summer 2002), pp. 66–89.

9. Manuscript fragment from Homer Saint-Gaudens, ed., *Reminiscences,* microfilm reel 50, frame 628.

10. Saint-Gaudens to Abbott Handerson Thayer, September 5, 1905, Saint-Gaudens Papers, microfilm reel 13, frame 200:

> After many trials I found my first and simplest way the best. Most of the muslin calicoes, etc., that you would very likely try for your purpose have a little starch in them I have found that after wetting and laying over the model, they remain very well, <u>if I pin them here and there</u> . . . That is the way the drapery on the Sherman Victory was done. After it is dry, in order to make assurance doubly sure, I go over it all, (using the greatest care) with shellac with a very delicate brush piece by piece, doing first the hollows to strengthen the rest as you proceed. Another good way is to dip the cloth in a mixture of modeling clay and water of about the consistency of a very watery mush. That holds pretty well when dry and on this, if you wish, use shellac as explained above.

11. Saint-Gaudens commented on this in a letter to his niece Rose Nichols. Quoted in Homer Saint-Gaudens, ed., *The Reminiscences of Augustus Saint-Gaudens* (New York: Century Co., 1913), vol. 2, p. 134.

12. Saint-Gaudens to Homer Saint-Gaudens, undated [spring 1899], Saint-Gaudens Papers, microfilm reel 23, frame 30.

13. Louis St. Gaudens, translation of an unidentified clipping, "Les Salons de 1899," p. 556, Saint-Gaudens Papers, microfilm reel 25, frame 300.

14. McKim to Saint-Gaudens, June 18, 1897, Saint-Gaudens Papers, microfilm reel 10, frame 16.

15. Saint-Gaudens to McKim, February 19, 1900, Saint-Gaudens Papers, microfilm reel 10, frame 27.

16. Saint-Gaudens to Augusta Saint-Gaudens, July 8, 1899, Saint-Gaudens Papers, microfilm reel 21, frames 380–81.

17. Ibid.

18. McKim to Augustus Saint-Gaudens, December 13, 1899, Saint-Gaudens Papers, microfilm reel 2, frame 55.

19. Ibid. "An objection made to the Mall site was that the monument would conceal the vista. A glance at the drawings would show in an instant the error of this. The idea probably arose from the idea that the monument would be a bulky structure, whereas it will only be about the size of the Statue of Washington [by Henry Kirke Brown; 1851–56] in Union Square and quite similar to that in proportion."

20. Saint-Gaudens to unidentified recipient, March 14, 1902, Saint-Gaudens Papers, microfilm reel 12, frames 774–75.

21. Coffin, quoted in typed manuscript of "Reminiscences of Augustus Saint-Gaudens," Saint-Gaudens Papers, microfilm reel 36, frame 141.

22. Michele H. Bogart, *Public Sculpture and the Civic Ideal in New York City, 1890–1930* (Chicago and London: University of Chicago Press, 1989), p. 86.

23. Saint-Gaudens to McKim, June 2, 1900, Saint-Gaudens Papers, microfilm reel 10, frames 28–29. "The turn things have taken with regard to the site for the Sherman has made me sick and I have not the stomach to go around begging for a place to put my work."

24. Saint-Gaudens to McKim, June 24, 1900, Saint-Gaudens Papers, microfilm reel 10, frame 30.

25. Saint-Gaudens to McKim, June 2, 1900, Saint-Gaudens Papers, microfilm reel 10, frames 28–29.

26. Saint-Gaudens to McKim, June 24, 1900, Saint-Gaudens Papers, microfilm reel 10, frame 30.

27. Saint-Gaudens to Augusta Saint-Gaudens, undated ["Monday"], Saint-Gaudens Papers, microfilm reel 21, frame 508. "I have passed the day yesterday to White's and all day today with McKim at the hopeless Sherman Mont. Business."

28. Saint-Gaudens to McKim, January 5, 1901, Saint-Gaudens Papers, microfilm reel 12, frame 770.

29. Saint-Gaudens to McKim, February 3, 1901, Saint-Gaudens Papers, microfilm reel 12, frame 771.

30. Saint-Gaudens to unidentified recipient, March 14, 1902, Saint-Gaudens Papers, microfilm reel 12, frames

774–75. "It seems to be the unanimous opinion among those not interested in the controversies of the Grand Army Societies that the site in front of the Grant Tomb, (which is superb) offers a singularly appropriate opportunity for the poetic bringing together of the two men. If this site is not selected, the only other adequate one is that at the southern end of the Mall."

31. McKim to Saint-Gaudens, March 14, 1902, Saint-Gaudens Papers, microfilm reel 12, frames 855–56. Samuel D. Babcock had been one of the contract-signing members of the Sherman Statue Committee.

32. Saint-Gaudens to unidentified recipient, March 17, 1902, Saint-Gaudens Papers, microfilm reel 12, frames 778–79.

33. Homer Saint-Gaudens, ed., *Reminiscences,* vol. 2, p. 293. "I am going to invent a machine to make you all good sculptors. It will have hooks for the back of your necks, and strong springs. Every thirty seconds it will jerk you fifty feet away from your work, and hold you there for five minutes' contemplation."

34. Manuscript fragment from Homer Saint-Gaudens, ed., *Reminiscences,* microfilm reel 50, frame 637.

35. Saint-Gaudens to Daniel Chester French, March 19, 1902, Saint-Gaudens Papers, microfilm reel 12, frames 776–77.

36. Saint-Gaudens and McKim, Mead & White Office, undated memorandum, McKim, Mead & White Collection, Department of Prints, Photographs and Architectural Drawings, New-York Historical Society, folder M-8E.

37. "The Sacredness of the Tree," *New York Evening Post,* March 7, 1903, p. 4, clipping in the Saint-Gaudens Papers, folder ML4: 18–16.

38. Saint-Gaudens to William R. Willcox, March 17, 1903, Saint-Gaudens Papers, microfilm reel 12, frame 801. "Now that the work on the pedestal for the Sherman is started, you will excuse me if I return again to the subject of the trees that will surround the statue. It is absolutely essential, if the monument of such importance increases enormously in its impressiveness by having a clear space around it and is not narrowed down or hemmed in by trees. I know that the impressiveness of this monument to Sherman will be greatly enhanced by what I propose or will be greatly diminished by allowing the trees to remain in the circle."

39. Willcox to Saint-Gaudens, March 20, 1903, Saint-Gaudens Papers, microfilm reel 12, frames 886, 888.

40. Saint-Gaudens to Willcox, March 24, 1903, Saint-Gaudens Papers, microfilm reel 12, frame 891.

41. Saint-Gaudens to French, May 21, 1903, quoted in manuscript fragments from Homer Saint-Gaudens, ed., *Reminiscences,* microfilm reel 50, frame 399.

42. Saint-Gaudens to Alexander Phimister Proctor, June 13, 1903, quoted in manuscript fragments from Homer Saint-Gaudens, ed., *Reminiscences,* microfilm reel 50, frame 86. "One thing, however, that I hope your Committee will insist on, that is before giving the final decision it be required that the scheme for the laying out of the ground in the immediate vicinity of the monument and the approaches be submitted to them, as that forms part of the monument. That will be an excellent precedent against the dropping of monument[s] around without rhyme or reason at the whim of some official Know Nothing."

43. Saint-Gaudens to Mr. Bliss, November 28, 1903 (draft), Saint-Gaudens Papers, microfilm reel 12, frames 811–13.

44. Saint-Gaudens to the editor of the *New York Sun,* November 30, 1903 (draft), Saint-Gaudens Papers, microfilm reel 12, frames 819–21. The actual letter was published in the *Sun* as "The Sherman Monument—A Statement by Mr. Saint-Gaudens," December 4, 1903, p. 5.

45. Augusta Saint-Gaudens to Augustus Saint-Gaudens, December 22, 1903, Saint-Gaudens Papers, microfilm reel 20, frame 566.

46. Saint-Gaudens to John J. Pallas, February 3, 1904, Saint-Gaudens Papers, microfilm reel 12, frames 826–28.

47. Saint-Gaudens to Henry James, February 8, 1906, Saint-Gaudens Papers, microfilm reel 12, frames 834–35.

Thayer Tolles

"In a Class by Themselves": Polychrome Portraits by Herbert Adams

"The 'fetishism of the white' is not necessarily everlasting because it is strong."

George Henry Payne, 1898[1]

In recent years scholars of nineteenth- and early-twentieth-century European sculpture have focused study on the rich topic of color in relation to sculpted form, yet this interest has extended only in passing to American art of the same period.[2] Although a certain finger may be pointed at the comparatively less-developed state of scholarship on American sculpture, perhaps part of the reason for this lack of attention to date can be attributed to the attitudes and practices of American sculptors themselves. While in Europe the practice of polychromy flourished, albeit with controversy, American sculptors infrequently and inconsistently explored the expressive potential of color.[3] Americans were not uninterested in the topic, however. Beginning in the mid-nineteenth century, publications and correspondence document many ongoing debates: Does color take precedence over form, or does form precede color? Does color clarify form, or is it an embellishment that masks inherent structural deficiencies? Does color heighten or lower sculpture's dignity, thus manifesting as an aspect of either high or popular art? Is colored sculpture the product of the artist or of the artisan?

These were among the questions surrounding sculpture and color when Herbert Adams (1858–1945) began *Primavera* (fig. 49) in 1890; indeed, they were questions that had been deliberated in Europe for centuries. With golden brown hair, a red-gold bandeau edged with black, a hairnet stippled with red accents, gray-brown eyes, and a blue dress trimmed with gold decorative motifs, Adams's directly colored marble bust became a signature image in his oeuvre. *Primavera* not only broke ground in American sculpture by returning to the artistic practices of Renaissance Italy and, by extension, to those of ancient Greece, it also responded to the current vogue for polychrome sculpture in France and was a showpiece for Adams's Parisian academic training and cosmopolitanism.

Primavera belongs to a group of Adams's innovative portraits of women that two writers pronounced in 1902 and 1904, respectively, "as forming a class apart" and "stand[ing] in a class by themselves."[4] Adams created some fifteen of these portrait busts, including both polychrome and multi-material works, with greatest frequency during the 1890s and sporadically thereafter through the early 1920s. Although they represent only a small portion of his diverse oeuvre, these heads in marble, plaster, terracotta, and bronze constitute the largest identifiable body of such work in American sculpture. This essay assesses the meaning and function of Adams's busts in the context of the history of color in American sculpture, American attitudes toward color in sculpture, and the coalescing interest in color during the American Aesthetic movement.

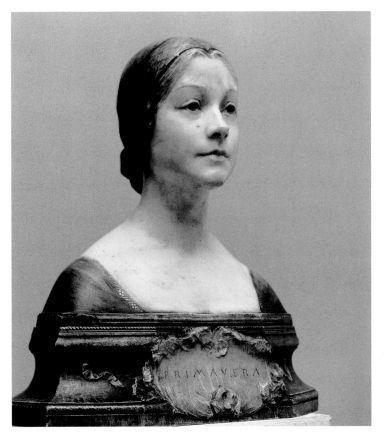

Figure 49. Herbert Adams (American, 1858–1945). *Primavera,* 1890–93. Polychrome marble, 21½ x 19¼ x 10 in. (54.6 x 48.9 x 25.4 cm). The Corcoran Gallery of Art, Washington, D.C.; Gift of Mrs. Herbert Adams

Adams's colored busts—always of female sitters—were admired for their conscious allusion to Italian Renaissance art and for their technical excellence, yet they had almost no precedence in this country and were little imitated. "Forming a class apart" was a compliment, but was it also a dubious distinction? A sentiment of sculptural "chromaphobia"— "the fear of corruption through colour," as it has recently been defined[5]—was engrained in the American artistic and cultural psyche. Although many sculptors expressed interest in color in theory, they were reluctant to explore it in practice. In this context, Russell Sturgis— architect, critic, and partisan of ancient colored sculpture—observed in 1904 that modern color works were "looked upon as vagaries, as pleasant whims of an able man taking his

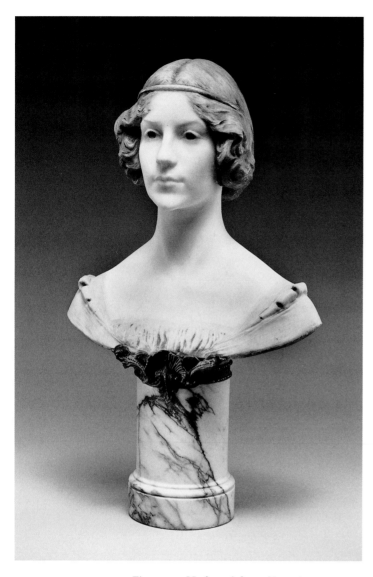

Figure 50. Herbert Adams (American, 1858–1945). *Portrait of a Young Lady*, 1894. Polychrome marble with bronze mounts, 28½ x 18½ in. (72.4 x 47 cm). The Detroit Institute of Arts, Michigan; Founders Society Purchase, Beatrice W. Rogers Fund (1987.77.A)

pleasure, and they do not weigh with our generally accepted views about sculpture."[6]

Born in West Concord, Vermont, Adams underwent an extended and varied course of artistic training in the United States.[7] Between 1878 and 1883 he enrolled in classes at the Massachusetts Normal Art School, Boston (now the Massachusetts College of Art), while also teaching drawing in public schools. He then served as an instructor in modeling at the Maryland Institute of Industrial and Fine Arts in Baltimore for two years. When he went abroad in 1885, Adams was thus well familiar with the gallicized pedagogical practices of American art academies. In Paris his experience as an aspiring sculptor was typical, if not predictable. He trained first at the Académie Julian and then at the École des Beaux-Arts. He worked in the atelier of Antonin Mercié, a highly decorated academic sculptor who is best known for his *néo-florentin David* (1869–72, Musée du Louvre, Paris) and who was an influential mentor to Adams and other Americans, including Augustus Saint-Gaudens and Frederick William MacMonnies. Adams sought inspiration in contemporary French sculpture and visited the Louvre to study its vast holdings of paintings and sculpture, particularly the work of such quattrocento Italians as Mino da Fiesole, Benedetto da Maiano, Francesco Laurana, Donatello, and the della Robbia family.[8] Adams proved his mettle against an international coterie of sculptors by exhibiting works in plaster and marble in the prestigious Salons each year between 1886 and 1890. In his transition from student to professional artist, he established his own Parisian studio in 1888 and earned his first significant commission: a bronze fountain of two boys playing with turtles (1888–89) for his boyhood town of Fitchburg, Massachusetts.

Adams's earliest sculptures were very much informed by who he knew and by what he studied and assimilated in Paris. Technically, his modeling style reflects the example of his French mentors in the fusion

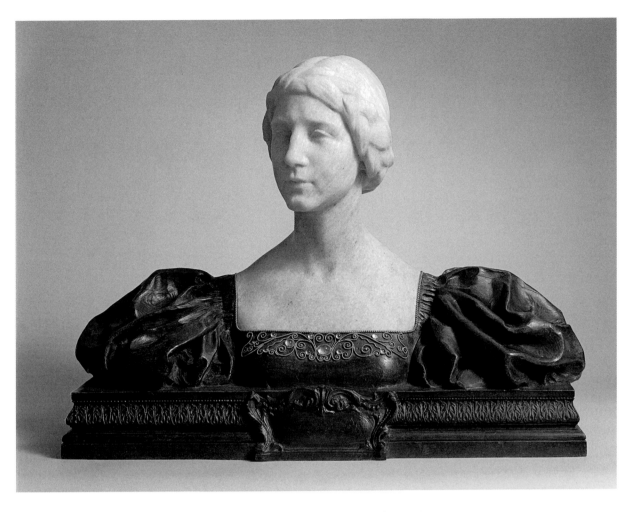

Figure 51. Herbert Adams (American, 1858–1945). *La Jeunesse,* ca. 1894; this version, ca. 1899–1900. Applewood, marble, paste jewels, and twisted wire, 22¾ x 31 x 10¾ in. (57.8 x 78.7 x 27.3 cm). The Metropolitan Museum of Art, New York; Rogers Fund, 1911 (11.41)

of delicate but spontaneous handling of form with a firm command of anatomical structure. His first pieces, which demonstrate this training and incorporate color, were completed in New York in the early 1890s and seem to have been executed primarily for pleasure, experimentation, and speculation.[9] They were frequently exhibited and widely discussed in the contemporaneous literature on Adams. The marble *Portrait of a Young Lady* (Linda Malinson) (fig. 50) has a golden fillet adorning her brown hair and is set upon a columnar base of yellow-green Numidian marble. The two parts are joined together by a decorative, green-tinted bronze collar that echoes the coloration of the base. Unlike most of Adams's other busts, this one still retains distinct color on the lips. Adams modeled *La Jeunesse* (fig. 51), another signature work, about 1894. He exhibited it on several

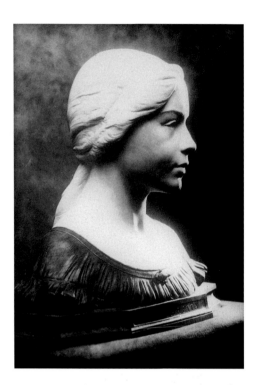

Figure 52. Herbert Adams (American, 1858–1945). *Portrait Bust of a Young Woman (Margaretta du Pont),* 1919. Walnut, maple, lapis lazuli, and twisted wire, 18 x 19 x 10 in. (45.7 x 48.3 x 25.4 cm). Private collection

(1899, Chesterwood, Stockbridge, Mass.) to his New York neighbor, the sculptor Daniel Chester French, but he disliked the results and ordered the rest destroyed.[11]

About 1910 Adams began a second group of portraits, privately commissioned, that are not as well documented; most, in fact, are unlocated. Stylistically these half dozen busts recapitulate the earlier pieces. What may have been innovative in 1893, however, appeared *retardataire* in the years following the Armory Show in 1913. Adams, who spoke out stridently against the advances of modernism,[12] produced these conservative works even as his Beaux-Arts style and idealized conception of feminine beauty were becoming outmoded. He continued to employ a variety of materials: a fetching portrait of young Margaretta du Pont (fig. 52) comprises a head of toned marble set into a shoulders and base of French walnut, with a lapis lazuli brooch and gold-toned fillets concealing the joint. The directly colored plaster *Mariannina* (fig. 53) is decorated with soft rose, blue, and gray pigments. Adams's interest in color is seen consistently in his reliefs and ideal figures as well, for instance in a compositional excerpt from *The Orchid,* a plaster bas-relief of a seated woman (1894, private collection) and the bronze statuette *The Debutante* (1914, Museum of Fine Arts, Boston).

Adams's first widely publicized success in Paris was a likeness of his future wife, Adeline Valentine Pond (fig. 54), who was also studying sculpture there and whom he married in 1889. He submitted the bust in plaster to the Salon of 1888, earning an honorable mention, and showed it again at the Salon of 1889, this time in marble, which he carved himself. After Adams returned to the United States he exhibited the portrait frequently, including at the 1893 World's Columbian Exposition in Chicago. Like *Primavera* and *La Jeunesse,* it became emblematic of his oeuvre and announced what quickly became his trademark specialty: elegant portrait busts of attractive women. Although this bust is not colored in the traditional sense, it served to

occasions during the 1890s to critical appreciation while continuing to refine the composition. The final version of about 1899–1900, which The Metropolitan Museum of Art acquired from the sculptor in 1911,[10] is a multimaterial composition of applewood and Italian pink marble with applied ornaments of twisted wire and topaz-colored stones. Adams also experimented with terracotta versions of *La Jeunesse* using green, blue, and yellow glazes. He gave one

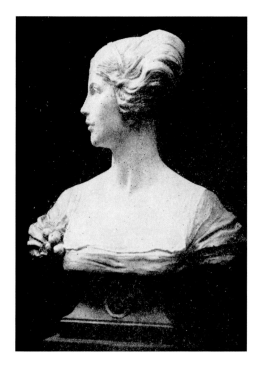

Figure 53. Herbert Adams (American, 1858–1945). *Mariannina,* 1923. Polychrome plaster. Photograph in Adeline Adams, "Sculpture: Is It among the House-Broken Arts?" *House Beautiful* 55 (January 1924), p. 18. Thomas J. Watson Library, The Metropolitan Museum of Art, New York

Figure 54. Herbert Adams (American, 1858–1945). *Adeline Valentine Pond Adams,* 1887–89. Marble, 27¼ x 20 in. (69.2 x 50.8 cm). The Hispanic Society of America, New York

ally Adams with a pictorial as well as a sculptural tradition. Critics eagerly seized on the sculptor's atmospheric technique, which emphasized flickering and incidental light over pronounced structure, and whose nimble touch and broad, stroke-like handling of form, especially in the filmy shawl, recalled painting. Clarence Cook wrote in 1891, "In Mr. Adams' hand the movement of the chisel is like that of the brush and makes us think of painting, and of a very beautiful and sympa-

thetic kind of painting, too."[13] When the portrait was shown at the Society of American Artists in 1892, one writer observed that it appeared unfinished, in the manner of French master Auguste Rodin: "It was odd to see the broad handling in painting . . . reflected in sculpture; but a parallel movement exists in statuary although the public is slow to grant it favor."[14] The impressionistic technique of *Adeline Valentine Pond Adams* was novel because it disregarded a long-held, long-argued

formal boundary between painting as color and sculpture as form. This crumbling division had been a topic of heated discussion in American art circles for several decades, though it had tempered by the 1890s. Nevertheless, the marble portrait of Adeline Adams and the sculptor's works that incorporate color were regarded as groundbreaking.

Most earlier sculptors—European and American—working in a Neoclassical aesthetic heralded the whiteness of marble for its symbolic purity and spirituality. As the midcentury medium of choice—or, more accurately, convention—white marble presented form without color, emphasizing outline and surface, and thereby abstracting what the human eye beholds in nature. Some sculptors, however, did make attempts at realism through the manipulation of light, tacitly acknowledging marble's inherent artifice. A well-known example was the German sculptor Johann Heinrich von Dannecker's *Ariadne on a Panther* (1812–14, Städtische Galerie Liebieghaus, Museum alter Plastik, Frankfurt), which at the time was housed in the Bethmann Museum. Installed on a rotating pedestal, the marble was lit by a window of colored glass that variously tinted the sculpture rose, pink, or purple and offered the illusion of human flesh.[15] Likewise, when Erastus Dow Palmer displayed *The White Captive* (1857–59, The Metropolitan Museum of Art) in an 1859 one-artist exhibition at the New York gallery of William Schaus, the lifesize nude female was illuminated by gaslight filtered through paper to confer a warm, fleshlike tone on the marble surface.[16] These efforts at heightened reality were achieved indirectly: that is, they did not alter or compromise the actual marble surface.

In the wake of late-eighteenth-century archaeological excavations offering irrefutable evidence that the ancient Greeks colored their marbles and bronzes, such influential sculptors as Antonio Canova began experimental applications of color to surface. It was the British Neoclassicist John Gibson, however, who familiarized audiences with

directly colored sculpture. His efforts were not among the earliest to emulate the practices of the ancient Greeks, nor were they extreme, but they were notorious. Gibson's most celebrated work, *The Tinted Venus* (fig. 55), was completed in Rome and exhibited at the International Exposition in London in 1862 in a pavilion designed by Owen Jones. The skin was probably colored with a thin layer of paint mixed with wax, while pigment was applied to the lips, eyes, and hair, pomegranate, drape, and turtle.[17] Gibson had articulated his rationale for introducing color to sculpture in 1855, invoking not only archaeological exactitude and living reality but decorative potential as well:

> if you see a white statue in a room
> that is hung with coloured curtains
> and furniture, and surrounded by
> objects all having colour in them,
> how poor, and cold, and lifeless it
> looks; but if you introduce a faint
> tint on the flesh and drapery, it then
> becomes a part of the suit . . . adds
> to the harmony of the whole room,
> and is more consonant with our
> habits and feelings.[18]

Expatriate American Neoclassicists in Rome did not follow Gibson's example, with the documented, but unlocated, exceptions of Joseph Mozier, who colored the clothing and legs of a version of his full-length figure *The Wept of Wish-ton-Wish* (ca. 1857–58), and Harriet Hosmer, Gibson's protégée, who lightly colored some of her marbles, including a version of the ambitious *Zenobia in Chains* (1859).[19]

In the main, the coloring of sculpture, even by noninvasive means such as tinted glass or light-filtered paper, was a practice devalued by most Western artists of the mid-nineteenth century largely because it overturned the long-held belief that marble, in its whiteness, represented the highest sculptural achievement of the ancient Greeks. Some defenders of established Neoclassical conven-

tions reacted to color with hostility or outrage, perceiving its introduction—or, more properly, reinstatement—to three-dimensional form as vulgar or sensual. The indignation the topic was capable of inspiring is evident in an excerpt from a letter written by expatriate American sculptor Hiram Powers and published in 1854 in the New York journal *The Albion*:

> The painter can do nothing without form; the sculptor can do every-thing in his legitimate art without colour. The painter, then *needs* form; but does the sculptor need colour? . . . When Sculpture calls upon her sister Painting for aid, she acknowledges her weakness, drops her chisel, takes up the palette, and pursues a mongrel art, half sculpture half painting. . . . When I look upon a well-executed and expressive statue I do not feel that anything is wanting in it. It seems full and com-plete. The bare idea of colouring it is offensive to my taste.[20]

As the Neoclassical aesthetic waned dur-ing the 1870s, American attitudes toward color and sculpture began to broaden from an elusive quest to simulate lifelike reality to an expression of decorative potential. With American sculptors now opting for Parisian academic training and at the same time familiarizing themselves with Rodin's expres-sive modeling and carving techniques, the symbolism and potential of both marble and colored sculpture changed dramatically. Sculptors in Europe had for several decades been incorporating color in their works, and their compelling efforts provided technical precedence for Americans. In the late 1850s the French orientalist sculptor Charles Cordier revived the tradition of contrasting various materials to accentuate the scientific realism of his "ethnographique" busts. Jean-Léon Gérôme, a popular and influential teacher to Americans, colored sculptures in

Figure 55. John Gibson (British, 1790–1866). *The Tinted Venus,* ca. 1851–56. Tinted marble, H. 68⅞ in. (174.9 cm). Walker Art Gallery, Liverpool

the name of archaeological re-creation, both accenting surfaces and juxtaposing materials. His *Tanagra* (1890, Musée d'Orsay, Paris), a seated female personification of the city of Boeotia, has colored eyes, hair, and skin and holds Gérôme's *Hoop Dancer,* an imitation Tanagra figurine.[21] Jean Dampt and Théodore-Auguste-Louis Rivière, among others, continued to experiment with sculpture's decorative possibilities through their innovative groupings of such contrasting materials as bronze, ivory, and wood, textured and variegated marble, and jewel-encrusted surfaces.

If colored sculptures by European artists were a familiar presence in the annual Salon exhibitions, they also commanded notice in New York. In 1891, for instance, Schaus & Co. displayed a replica of Johannes Bonk's *Klytia,* a female nude in marble, with her girdle, drapery, flowers, and other ornamental elements in bronze.[22] American artists and architects trained in Paris's academies and ateliers recognized the potential of polychrome and mixed-media sculpture, which could synchronize visually with the decorative programs of contemporary public and domestic structures while at the same time referencing the Italian Renaissance past. One of the earliest examples to do so was Augustus Saint-Gaudens's colored reredos of kneeling angels executed in Paris in 1877 for the chancel of Saint Thomas Church in New York (destroyed by fire, 1905). Saint-Gaudens cast the eight alto-relief panels in cement composition material and painted them with the assistance of Will H. Low. They were installed in Saint Thomas between large encaustic canvases by John La Farge and flanked a central gilded Latin cross set above the altar. In his letters from Paris, Saint-Gaudens fretted about the reaction the color might provoke, even advising La Farge to repaint the reliefs one tone "if too ugly 'pour le bourgeois.'"[23] In the early 1880s La Farge involved Saint-Gaudens in the lavish interior program for the mansion of Cornelius Vanderbilt II in New York. The sculptor

modeled panels for the dining room after designs by La Farge, themselves based on Classical and Renaissance prototypes. Set into the ceiling, the mahogany panels of mythological subjects were inlaid with marble, bronze, coral, mother-of-pearl, ivory, and other rich materials (fig. 56). Colored sculptures such as these affirmed the Aesthetic movement mantras of artistic interdependence, cross-fertilization, and aesthetic harmony. They are significant when seen in relation to Adams's work because their decorative and representative functions were accorded equal weight.

The controversy about decoration versus subject, color versus form, was further enflamed by sketch-style paintings and sculptures exhibited at American venues beginning in the late 1870s. Previously restricted to the academy classroom, these sculptures were at first greeted equivocally by advocates of the precise contours and smooth surfaces of Neoclassical productions. But by the late 1880s, this sketchy pictorial style was condoned, even anticipated, in sculpture, especially in Saint-Gaudens's innovative, freely modeled bronze bas-reliefs such as *Rodman de Kay Gilder* (1879, The Metropolitan Museum of Art). At the same time, New York–based American sculptors began to experiment with coloring their work. Jonathan Scott Hartley, a portrait specialist, applied single hues, such as a faint pink, on the surfaces of some of his busts.[24] Daniel Chester French delicately tinted the hair auburn, the roses pink, and the dress green in his plaster portrait of his cousin Elizabeth Richardson French (fig. 57), following the example of the polychrome sculptures that he would have seen in Paris in 1886–87. He displayed it at the Society of American Artists in the spring of 1890,[25] just as Adams himself was commencing his own explorations with color.

Before we return to Adams, the debate over the practice of coloring in ancient Greek sculpture must be acknowledged. Although Americans were less exercised than their European counterparts in terms of the

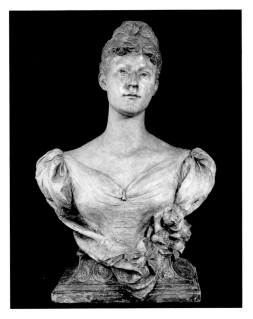

Figure 56 (left). Augustus Saint-Gaudens (American, 1848–1907). *Ceres,* 1881–83. Mahogany, holly wood, bronze, ivory, mother-of-pearl, and marble, 62¾ x 25¼ in. (159.4 x 64.1 cm). United States Department of the Interior, National Park Service, Saint-Gaudens National Historic Site, Cornish, New Hampshire

Figure 57 (above). Daniel Chester French (American, 1850–1931). *Miss Elizabeth Richardson French,* 1888. Polychrome plaster, 31⅝ x 22 x 13⅛ in. (80.3 x 55.9 x 33.3 cm). Chesterwood, A National Trust Historic Site, Stockbridge, Massachusetts

degree and scope of the controversy, it was a subject contested in American newspapers and journals from the midcentury onward, particularly among purists who associated color with decadence and cautioned against a modern revival of the practice.[26] Attention was brought to the topic afresh following the discovery of vividly colored sculptures on the Athenian Acropolis in the mid-1880s, which

was, not insignificantly, shortly before Adams began coloring his busts.

In January 1890 the New York studio of Adams's colleague Daniel Chester French was the site of a lecture by Edward Robinson on the topic of color in Greek sculpture that was attended by some forty artists.[27] Robinson, a curator at the Museum of Fine Arts, Boston, led a crusade to educate the general

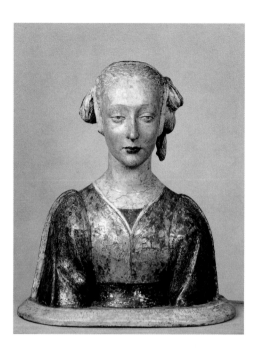

Figure 58. Italian School, bust of an unknown woman called La Belle Florentine, third quarter of the 15th century. Polychrome wood, 21¾ x 16⅛ x 9⅛ in. (55.2 x 41 x 23.2 cm). Musée du Louvre, Paris

commissioned from the French artist Émile Gillieron that accurately recorded the appearance of the excavated statues from the Acropolis.[29] One of the questions posed in connection with these experiments was what effect they would have on American sculptors of the day. Robinson asked, "[W]ill our sculptors correct the error made by their predecessors; or does the sentiment regarding the essential separation of form from color in sculpture now rest upon such firm ground that we shall ignore the authority of the Greeks . . . and continue on our own way?"[30] He concluded that it was up to contemporary sculptors—the likes of Saint-Gaudens, French, or Adams—to resolve the matter, in essence to determine the future course of colored sculpture.[31]

Despite the timeliness of these investigations, nationalistic critics assessing Adams's work avoided analogies to ancient painted sculpture. To them, the color of his busts more usefully substantiated a lineal descent from Italian Renaissance portrait sculptures the artist had studied, for example, La Belle Florentine (fig. 58), acquired by the Louvre in 1888. Writers repeatedly championed the quattrocento flavor of Adams's work as evidence of American cultural advancement, just as they did for other cosmopolitan sculptors, painters, and architects. However, in doing so they asserted that he was not merely a formal imitator of, but an inspired successor to these master painters and sculptors. The title *Primavera,* of course, alluded to Botticelli's painting of the same name (ca. 1481, Galleria degli Uffizi, Florence). The portrait of Adeline Pond Adams recalled Francesco Laurana's *Femme Inconnue* (before 1502, Musée du Louvre, Paris), a similarly uncolored marble bust widely admired by late-nineteenth-century Americans.[32] The sloping shoulders, auburn hair, and green dress of the colored-plaster *St. Agnes' Eve* (ca. 1892, unlocated) offered to one writer "a suggestion of Florentine sculpture."[33] Other portraits by Adams, in their timeless costumes and ornament, tasteful craftsmanship, and pictorial

public about color in sculpture and to reform and redress its misperceptions. He and other colleagues from the Museum of Fine Arts and the Art Institute of Chicago supervised artists in coloring plaster copies after ancient Greek sculptures in order to re-create their original appearances. These mimetic experiments, which emulated ones already carried out in Europe, resulted in well-publicized exhibitions in Boston in 1891 and Chicago in 1892. The latter, held at the Art Institute, featured fifty-seven works, including recently colored copies, original ancient sculptures with traces of polychromy, and, significantly, two pieces colored by French, whose brother William was then the Art Institute's director.[28] Also included were drawings that New York critic and collector Russell Sturgis

treatment of surface, were affiliated more generally with the glorified artistic tradition of the Italian Renaissance.

If the inspiration of the past was encoded in Adams's female portraits, so, too, was the notion of artistic and cultural progress: the idea that these works constituted an innovative new genre of American art set within the history of Western art. One comment from 1904 speaks for many: "His art is reminiscent of Renaissance Italy and 'the fragrance of the fifteenth century,'—yet dominated by the spirit of his own time, and expressing modern feeling with unusual grace and tenderness."[34] This supposed resolution of Renaissance tradition with American modernity in Adams's female heads was also perceived in academic mural and easel painting of the day.[35] Indeed, Adams's busts drew comparisons to decorative paintings by the likes of George de Forest Brush, Thomas Dewing, and Abbott Henderson Thayer, Adams's summer neighbors in New Hampshire. Thayer's *Virgin Enthroned* (fig. 59) and Adams's *Primavera,* for instance, were shown at the Society of American Artists in 1892 and their resemblance did not go unnoticed.[36] Both works draw on Renaissance compositional and decorative elements to invite comparison with Renaissance art: *Virgin Enthroned* in its dignified frontality and pyramidal arrangement of form; *Primavera* in its similar orientation as well as the beribboned cartouche and decorative base. And both, as their titles suggest, reaffirm their young subjects' chastity and moral innocence.

Adams's portraits, like paintings by Thayer and others, also reaffirmed current ideals of feminine beauty and the sanctity of genteel American womanhood.[37] By interweaving reality and imaginative idealism, objectivity and subjectivity, Adams literally and figuratively put his women on a pedestal. A photograph taken (or more correctly, staged) by C. J. Berg at the National Sculpture Society exhibition in 1898 visually reinforces this concept (fig. 60). In this aes-

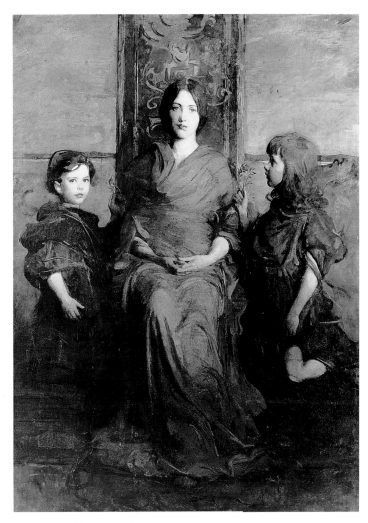

Figure 59. Abbott Henderson Thayer (American, 1849–1921). *Virgin Enthroned,* 1891. Oil on canvas, 72⅝ x 52½ in. (184.5 x 133.4 cm). Smithsonian American Art Museum, Washington, D.C.; Gift of John Gellatly (1929.6.131)

theticized mise-en-scène, complete with an iconic peacock, a model in an old-time costume is posed in a verdant Italian garden setting and gazes reverently at a terracotta version of *La Jeunesse.* Although Adams's early busts are portraits on an elemental level, they are foremost three-dimensional representations of feminized abstract ideals or temporal

Figure 60. Model posing with Herbert Adams's *La Jeunesse*. Photograph in "The Exhibition of the National Sculpture Society, II," *Brush and Pencil* 2 (July 1898), p. 154. Thomas J. Watson Library, The Metropolitan Museum of Art, New York

allegories, as affirmed by such titles as *Primavera, La Jeunesse,* and *Meditation* (1905, enameled bronze, private collection). When *Primavera* was sold to the Corcoran Gallery of Art in 1946, Adeline Adams noted that the model had been a beautiful American girl studying in Paris. From an initial study of this

individual, who may be identified as Florence Keller,[38] Adams over several years "purified" (Mrs. Adams's word) her delicate features into what his widow described as "typifying young American Maidenhood."[39] When sculptor and writer Lorado Taft reviewed Adams's polychrome plaster portrait of

Shakespearean actress Julia Marlowe (1898, Museum of the City of New York), he called it "a radiant presentation of our popular actress—an impression of her as she appears upon the stage, rather than a close rendering of her features. The artist—being an artist—has chosen the better part and made of his portrait something delightful."[40]

Neither paintings nor sculptures (in the purest sense), Adams's colored portraits blurred distinctions between fine and decorative arts. It is in this context that Adams's own reasons for coloring his work must be examined. Although we will never know the extent to which the theory and science of color impacted Adams, his works and surviving writings offer little evidence that he was driven by influential chromatic theoreticians of the time or by a desire to precisely replicate the effect of ancient polychrome statuary. If anything, Adams's philosophy must be seen in the context of the turn-of-the-century concept of the harmonious interior. In 1898, in one of his few utterances on the topic, the sculptor declared: "Bronze is so hard for a woman . . . and marble has no place with parlor furniture."[41] His primary motivation for coloring domestic-scale portraits, it seems, was to make them decorative so that they would blend more pleasingly than stark white marbles, which appeared incongruous in a color-filled space. Adams selected his colors for their overall emotive and visual potential; in concert with the youthful beauties they adorned, the colors were intended as prescriptions for taste and morality. Adams's technical processes warrant further study, but if one considers the range of colors that he selected for his portraits, they reveal a traditional palette of primary and secondary hues delicate in intensity, combined with browns, golds, blacks, and other subtler, neutralized colors. Color then, to Adams, represented a fusion of naturalism and aestheticism.

Adams's concern for the assimilation of sculpture into domestic surroundings recalls part of John Gibson's rationale, quoted above,

for the introduction of color to his works. Because little remains of Adams's personal writings, we must glean more of his philosophy through his wife, Adeline, who was herself a prolific writer on the arts and who shared her husband's aesthetic viewpoints. In *The Spirit of American Sculpture,* published in 1923, Mrs. Adams noted that "the pure white marble bust looks ill at ease in the warm precincts of the modern home; it is a thing of the past." She wondered how "our elders bore it so long."[42] As an example, one must look at the crowded and lavish interiors into which white Neoclassical sculpture was installed in the 1870s and 1880s. Hamilton Fish's New York drawing room (fig. 61), seen in a photograph reproduced in *Artistic Houses* (1883–84), offers the perfect foil to what the Adamses advocated as the most complimentary setting for sculpture. In contrast, a simply decorated, lightly colored interior in the Colonial Revival mold (fig. 62) was illustrated as a model of good taste in an article Mrs. Adams published in *House Beautiful* in 1924, "Sculpture in the House: Is It among the House-Broken Arts?" Not surprisingly, to Mrs. Adams the type of sculpture that was most tasteful—or housebroken—was colored, toned, gilded, or patinated. Adams's polychrome plaster *Mariannina* was also illustrated and described as "a twentieth century girl masquerading as an eighteenth century marquise," its color scheme after the pastels of La Tour.[43] Mrs. Adams noted that the successful incorporation of color in sculpture is "the right way . . . toward beauty, harmony, permanence."[44] Her husband's genteel busts represented, by insinuation, the paradigm.

As noted earlier, artists and critics continuously sanctioned Adams's work as individual, refined, and tasteful. Lorado Taft observed that other sculptors responded positively to Adams's application of color: "In Mr. Herbert Adams the whole fraternity recognizes a master almost unequalled in a certain form of sculpture as rare as it is exquisite—the creation of beautiful busts of women. . . . [I]n these female heads he tran-

Figure 61. *Hon. Hamilton Fish's Drawing-Room*. Photograph in *Artistic Houses* (New York, 1883–84). Thomas J. Watson Library, The Metropolitan Museum of Art, New York

Figure 62. *Will Foster's Apartment*. Photograph in Adeline Adams, "Sculpture in the House: Is It among the House-Broken Arts?" *House Beautiful* 55 (January 1924), p. 19. Thomas J. Watson Library, The Metropolitan Museum of Art, New York

scends almost every one we know in modern sculpture, not only being without rivals in this country, but being unsurpassed in France."[45] This widespread respect of Adams's unmatched skill is exemplified by his coloring a wax version of Augustus Saint-Gaudens's portrait of the late Louise Adele Gould (ca. 1894, unlocated) at the request of Saint-Gaudens himself.[46] But if imitation is the sincerest form of flattery, then why was Adams's practice of coloring portraits not more widely followed? Why were others of his generation content to let him "paint the lady's face" alone? Taft later acknowledged an underlying prejudice, submitting that "the practice of coloring sculpture . . . is not regarded with favor by artists or sculptors. But Adams's effective use of this color work is favorably received."[47] The question remains, however: why were artists, while admiring Adams's work, either unwilling or unable to follow suit?

Several factors have contributed to the dearth of American polychrome works from this period, including the long-held stigma associated with decorative or manual work versus the more "elevated" fine or creative arts. To many, decorative sculpture represented a less serious pursuit, or something one turned to in the early years of a career out of financial necessity. Adeline Adams saw this as a basic hypocrisy. Acknowledging that a mastery of craftsmanship is fundamental to successful results in polychromy, she wrote: "[T]he sculptor in no wise belittles himself or his calling when creating sculpture that can be lived with. . . . But in such creating, the artist must turn artisan also, and not shamefacedly, but glorying in it."[48] When sculptor Adolph Alexander Weinman gave a commemorative tribute to Adams following his death in 1945,

he recognized Adams's love of "experimentation with the various media of his art, the results of which he always delighted in making known to his colleagues."[49]

Another factor involves cost and changing turn-of-the-century aesthetics. Adams's works—mainly marbles and plasters—were either unique or sparingly duplicated, each individualized through the extra effort of the coloring process. Surface coloring or mixing of media was labor-intensive. Adams's practice of further embellishing his female portraits cannot be considered time-effective, especially for an artist who managed both a busy studio and more remunerative public commissions. They generated limited income and had a narrow clientele. In contrast, bronze, which by the 1890s had eclipsed marble as the preferred sculptural medium, could be replicated in large editions and in a wide range of patinas—from chemically treated "antique" green to resplendent gilding. Bronze, also the medium of choice for the modern industrial age, offered extensive possibilities for commercial sale, as attested by the early-twentieth-century popularity of small statuettes for domestic and garden adornment. Thus, those early-twentieth-century artists who were fascinated with the expressive potential of color in bronze—the likes of Frederic Remington, Paul Manship, and C. Paul Jennewein—may have avoided the decorative brand of color represented by Adams's marble portraits, but they were not "chromaphobic." They embraced color with form in the name of technical experimentation and individuality, but in an aesthetic and a medium that acknowledged the changing times and the impending and permanent rupture of boundaries between painting and sculpture.

1. George Henry Payne, "Herbert Adams," *Criterion* 18 (May 28, 1898), p. 17.

2. See, most significantly, Andreas Blühm et al., *The Colour of Sculpture, 1840–1910,* exh. cat. (Zwolle: Waanders Uitgevers, 1996), which accompanied an exhibition at the Van Gogh Museum, Amsterdam, and the Henry Moore Institute, Leeds.

3. Although not complete with respect to Americans, the impressive listing in *The Colour of Sculpture, 1840–1910* (pp. 271–72) of 275 nineteenth-century artists who created polychrome sculpture includes just eight who were American-born or worked in this country for a significant portion of their careers.

4. Russell Sturgis, "Sculpture," *Forum* 34 (October–December 1902), p. 253; George Julian Zolnay, entries in *Illustrations of Selected Works in the Various National Sections of the Department of Art . . . Universal Exposition, St. Louis, 1904* (St. Louis: Official Catalogue Co., 1904), p. 357.

5. David Batchelor, "Chromaphobia: Ancient and Modern, and a Few Notable Exceptions" (1997), pamphlet for The Centre for the Study of Sculpture, Henry Moore Institute, Leeds.

6. Sturgis, *The Appreciation of Sculpture: A Handbook* (New York: Baker & Taylor Co., 1904), p. 14.

7. On Adams, see Katherine Derry Holler, "Herbert Adams: American Sculptor" (master's thesis, University of Delaware, 1971); Rebecca Ann Gay Reynolds, "Herbert Adams (1858–1945): A Leading Spirit of American Sculpture," in *Fitchburg's Golden Age: Industry and Philanthropy, 1863–1923* (Fitchburg, Mass.: Fitchburg Historical Society, 1995), pp. 36–56; and Marilyn Gage Hyson, "Profile of Herbert Adams, 1858–1945: Sculptor," unpublished manuscript, 2000.

8. Charles H. Caffin, *American Masters of Sculpture; Being Brief Appreciations of Some American Sculptors and Some Phases of Sculpture in America* (New York: Doubleday, Page & Co., 1903), p. 100: "During these years, too, he studied in the galleries and frequented the Louvre, not only for the sculpture, but also for the paintings."

9. One early work is known to have sold: the polychrome plaster *St. Agnes' Eve* (ca. 1892, unlocated) was exhibited and purchased at the World's Columbian Exposition in 1893. See *Collector* 5 (November 15, 1893), p. 27. Both *St. Agnes' Eve* and *Primavera* were priced at $1,000. See *Revisiting the White City: American Art at the 1893 World's Fair,* exh. cat. (Washington, D.C.: National Museum of American Art and National Portrait Gallery, 1993), p. 356.

10. Daniel Chester French, chairman of the Metropolitan Museum's trustees' committee on sculpture, advocated the purchase of *La Jeunesse:* "This bust has received the endorsement of the whole fraternity of sculptors and painters in New York as well as in some other places and no sort of criticism could be made in regard to its acquisition for the museum. It ought to be there." See French to Frederick S. Wait, March 25, 1907, Daniel Chester French Family Papers, Manuscript Division, Library of Congress, Washington, D.C. (hereafter cited as Daniel Chester French Family Papers), microfilm reel 1, frame 598. *La Jeunesse* was Adams's only colored bust to enter a public collection during his lifetime. See Thayer Tolles, ed., *American Sculpture in The Metropolitan Museum of Art, Volume I: A Catalogue of Works by Artists Born before 1865* (New York: The Metropolitan Museum of Art, 1999), pp. 362–64.

11. Notes of a telephone conversation with Adams, January 6, 1933, object catalogue cards, Department of American Paintings and Sculpture, The Metropolitan Museum of Art. A second terracotta survived and is privately owned.

12. See, for instance, Adams, "Aspects of Present-Day Sculpture in America," *American Magazine of Art* 12 (October 1921), p. 335, where he finds among the "new-born European art of the twentieth century . . . work by perverts, fakirs, and peasants . . . one is inclined at times to discount the whole movement as a huge farce."

13. [Clarence Cook], "The Society of American Artists of New York. Thirteenth Annual Exhibition," *Studio* 6 (May 2, 1891), p. 213.

14. "Monthly Record of American Art," *Magazine of Art* 16 (1893), p. v. Likewise, in his *History of American Sculpture,* Lorado Taft observed: "this bust has an air of unusual spontaneity and seems to have been the result of mere toying with the clay." See Taft, *The History of American Sculpture* (New York: Macmillan, 1903), p. 387.

15. William H. Gerdts, "Marble and Nudity," *Art in America* 59 (May–June 1971), pp. 60, 62. See also Ellen Kemp, *Ariadne auf dem Panther,* exh. cat. (Frankfurt: Liebieghaus, Museum alter Plastik, 1979). The sculpture was seriously damaged during World War II; conservation treatment was completed in 1978.

16. See "Fine Arts in New York," *Boston Evening Transcript,* November 7, 1859, p. 2; and J. Carson Webster, *Erastus D. Palmer* (Newark: University of Delaware Press, 1983), p. 29.

17. Blühm et al., *Colour of Sculpture,* p. 122.

18. Unidentified newspaper clipping, September 5, 1855, National Library of Wales, 4915D, quoted in Elisabeth S. Darby, "John Gibson, Queen Victoria, and the Idea of Sculptural Polychromy," *Art History* 4 (March 1981), p. 46.

19. On Mozier, see Anne Brewster, "American Artists in Rome," *Lippincott's Magazine* 3 (February 1869), p. 197, and Gerdts, "Marble and Nudity," p. 62; for Hosmer, see Dolly Sherwood, *Harriet Hosmer: American Sculptor, 1830–1908* (Columbia: University of Missouri Press, 1991), pp. 216, 354 n. 12.

20. Quoted in "Fine Arts," *Albion* 13 (January 21, 1854), p. 33.

21. Gerald M. Ackerman, *The Life and Work of Jean-Léon Gérôme, with a Catalogue Raisonné* (New York: Sotheby's Publications, 1986), pp. 136, 314–15.

22. "How Statues Are Made," *New York Times,* January 25, 1891, p. 14.

23. Saint-Gaudens to La Farge, September 10, 1877, quoted in Homer Saint-Gaudens, ed., *The Reminiscences of Augustus Saint-Gaudens* (New York: Century Co., 1913), vol. 1, p. 196. A photograph of the St. Thomas chancel is illustrated in Kathryn Greenthal, *Augustus Saint-Gaudens: Master Sculptor,* exh. cat. (New York: The Metropolitan Museum of Art, 1985), p. 85.

24. "How Statues Are Made," p. 14.

25. That the sculpture was tinted about the time of execution is documented by "The Exhibition of the Society of American Artists: Second Notice," *New York Sun,* May 4, 1890, p. 15.

26. See, for instance, "Foreign Art Gossip," *Crayon* 1 (April 18, 1855), pp. 251–52, which proclaims the "strong and repeated objections to the coloring of statues" held by editors (William J. Stillman and John Durand).

27. Daniel Chester French to William M. R. French, February 9, 1890, Daniel Chester French Family Papers, microfilm reel 41, frame 196.

28. For Boston, see Greta [pseud.], "Art in Boston," *Art Amateur* 24 (May 1891), p. 142. For Chicago, see *Catalogue of a Polychrome Exhibition Illustrating the Use of Color Particularly in Graeco-Roman Sculpture* (Chicago: Art Institute of Chicago, 1892); and "News and Notes: Art in Chicago," *Art Amateur* 26 (February 1892), p. 83.

29. "Colored Greek Statues: Pictures of Some Recent Discoveries of Artistic Value," *New York Times,* September 26, 1887, p. 8.

30. Robinson, "Did the Greeks Paint Their Sculptures?" *Century Magazine* 43 (April 1892), p. 869.

31. See Robinson's letter, May 25, 1892, quoted in "Colored Sculpture: Mr. Robinson Is Dealing with What He Believes to Be Facts," *New York Times,* June 13, 1892, p. 9.

32. See, for instance, W. Lewis Fraser, "American Artist Series: Carl Marr, J. H. Dolph, and Herbert Adams," *Century Magazine* 44 (May 1892), p. 103: "one instinctively thinks of that other in the Louvre, the delight of the artist, the despair of the copyist, and the puzzle of the Philistine, 'La Femme Inconnue.'"

33. "Works by Sculptors at the Society," *New York Times,* May 12, 1892, p. 4. *St. Agnes' Eve* is illustrated in *Revisiting the White City,* p. 356.

34. Edwina Spencer, "American Sculptors and Their Art: Contemporary New York Sculptors," *Chautauquan* 39 (March 1904), p. 46.

35. On this topic, see Lois Marie Fink, "The Innovation of Tradition in Late Nineteenth-Century American Art," *American Art Journal* 10 (November 1978), pp. 63–71.

36. See, for instance, "Society of American Artists: First Notice," *New York Evening Post,* May 4, 1892, p. 7.

37. For further discussion, see Bailey Van Hook, *Angels of Art: Women and Art in American Society, 1876–1914* (University Park: Pennsylvania State University Press, 1996).

38. Hyson, "Profile of Herbert Adams," p. 21. Adams's photograph of a study for *Primavera* is illustrated (opp. p. 15).

39. Adeline Adams to C. Powell Minnigerode, Director, The Corcoran Gallery of Art, July 20, 1946, curatorial files, The Corcoran Gallery of Art, Washington, D.C.

40. Lorado Taft, "The Exhibition of the National Sculpture Society," *Brush and Pencil* 2 (June 1898), p. 125.

41. Payne, "Herbert Adams," p. 17.

42. Adeline Adams, *The Spirit of American Sculpture* (New York: National Sculpture Society, 1923), p. 120.

43. Adeline Adams, "Sculpture in the House: Is It among the House-Broken Arts?" *House Beautiful* 55 (January 1924), p. 18.

44. Ibid., p. 19.

45. Taft, *History of American Sculpture,* pp. 385–86.

46. Charles Gould to Mabel McIlvaine, Office of the Secretary, The Metropolitan Museum of Art, January 15, 1908, Archives, The Metropolitan Museum of Art. Saint-Gaudens was "greatly pleased" by the result. The Metropolitan Museum of Art has an uncolored marble version. See Tolles, ed., *American Sculpture in The Metropolitan Museum of Art, Volume I,* p. 323.

47. [Lorado Taft], "Herbert Adams," *Bulletin* (Pan American Union) 45 (April 1917), p. 104.

48. Adams, "Sculpture in the House," p. 19.

49. Adolph A. Weinman, "Herbert Adams, 1858–1945," in *Commemorative Tributes of the American Academy of Arts and Letters, 1942–1951* (New York: American Academy of Arts and Letters, 1951), p. 41.

Thomas P. Somma

Sculpture as Craft: Two Female Torsos by Paul Wayland Bartlett

Paul Wayland Bartlett (1865–1925) was one of many American artists in the last quarter of the nineteenth century who turned for inspiration to French art and for instruction to the art schools of Paris. In fact, Bartlett, more than any other American sculptor of his generation, developed particularly close ties with France. Bartlett's father—the art educator, critic, and historian Truman Howe Bartlett (1835–1922)—moved his family to France from New Haven, Connecticut, in 1869, when Paul was only four years old. By age fifteen the precocious young sculptor had already exhibited his first work in the Paris Salon,[1] and in 1880 he entered the École des Beaux-Arts as a pupil of Pierre-Jules Cavelier. Bartlett also studied animal sculpture at the Jardin des Plantes with Emmanuel Frémiet, and he eventually completed his training during the 1890s as an assistant in the studio of Auguste Rodin. His relationship with Rodin was particularly significant in light of the French master's close professional contact with Truman Bartlett, who in the late 1880s had conducted extensive interviews with Rodin that resulted in a series of ten articles published in 1889 in *American Architect and Building News*. As Ruth Butler has noted, when Truman's study appeared it "was the longest, most detailed, most accurate discussion of Rodin's work in any language."[2]

Today Paul Bartlett is largely remembered for his ethnological statues, monumental architectural sculpture, and bronze historical portraits. Prominent examples include *Bohemian Bear Tamer* (fig. 63); the House pediment for the United States Capitol (1908–16); the pediment for the New York Stock Exchange (1901–4), a collaboration with his American mentor, John Quincy Adams Ward; his statue *Michelangelo* for the Library of Congress (fig. 64); and what would become the centerpiece of his career, the *Equestrian Statue of Lafayette* (fig. 65), America's gift to France in response to Frédéric-Auguste Bartholdi's Statue of Liberty.[3]

Despite such public and often grand international successes, during Bartlett's own lifetime he often drew his greatest praise as a sculptor-craftsman. This reputation was based on an impressive series of exquisitely cast and delicately colored small bronze animal pieces, intimate torsos, and other statuettes that he produced throughout the 1890s. These carefully crafted objets d'art represented the fruits of extensive experiments in patination and cire-perdue bronze casting (lost-wax technique) that Bartlett conducted at his own foundry, which he built next to his studio in Paris about 1892. This study focuses on two of Bartlett's best torsos from the 1890s, one seated and one standing, both originally modeled about 1895. The Metropolitan Museum of Art owns casts of each work; both were purchased directly from the sculptor, both came into the collection in 1909, and both were almost certainly cast and patinated by Bartlett himself (figs. 66, 67). Other casts of these torsos that have been located are probably posthumous.[4]

The essential influence on Bartlett with respect to the torsos was Rodin: his expressive use, and abuse, of anatomy through selec-

Figure 63. Paul Wayland Bartlett (American, 1865–1925). *Bohemian Bear Tamer*, 1885–87; this cast, 1888. Bronze, 69⅜ x 33 x 45½ in. (176.2 x 83.8 x 115.6 cm). The Metropolitan Museum of Art, New York; Gift of an Association of Gentlemen, 1891 (91.14)

Figure 64. Paul Wayland Bartlett (American, 1865–1925). *Michelangelo*, 1894–97; this cast, 1898. Bronze, H. approx. 85–90 in. (215.9–228.6 cm). Main Reading Room, Library of Congress, Washington, D.C. Photograph in Charles V. Wheeler, "Bartlett (1865–1925)," *American Magazine of Art* 16 (November 1925), p. 577

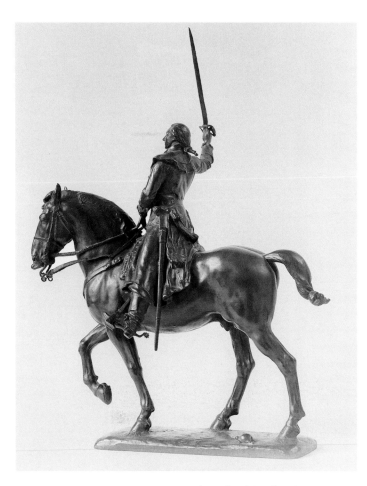

Figure 65. Paul Wayland Bartlett (American, 1865–1925). *Equestrian Statue of Lafayette*, reduced replica of second version, 1900–1907. Bronze, 16¼ x 15¼ x 9½ in. (41.3 x 38.7 x 24.1 cm). The Corcoran Gallery of Art, Washington, D.C.; Gift of Mrs. Armistead Peter III, 1958

tions. Perhaps most important, Bartlett's torsos are beautifully hand-crafted objects whose formal purity and decorative character contrast sharply with the traditional "high-art" concepts of allegory, personification, and portraiture and whose entire process of manufacture was subject to the individual touch and complete control of the sculptor. In these respects Bartlett's small bronzes are linked to the contemporary rise of craft modernism in France and the Arts and Crafts movement in America.

Bartlett's decision to do his own casting and his intense interest in the coloration of cire-perdue bronzes were inspired by contemporary achievements in the decorative arts, especially among French sculptor-ceramicists such as Jean Carriès.[5] Carriès, whose own recent experiments with lost-wax bronze casting and Japanese glazing techniques were prominently exhibited in Paris in 1889 and 1892, encouraged and probably advised Bartlett in the pursuit of his technical studies. Another motivation for Bartlett to produce his own bronzes was his dissatisfaction with the quality of the work produced by the various French foundries he had relied on throughout the late 1880s and early 1890s. Bartlett ended all such arrangements in 1892 in order to assume full control over the entire manufacturing process. For Bartlett, as Michael Shapiro explains:

> the question was not simply learning to cast, but creating his own models, casting them to his satisfaction, and then perfecting the patination. . . . Bartlett gave up contractual arrangements with expert foundries in preference to the handmade *facture* of his own casting. The casting and patination of Bartlett's small bronzes were dependent upon his touch, in the same way in which a painter must apply his own paint. . . . Bartlett's experiments harmoniously blended craft and artistic decisions into a single process. . . .[6]

tive distortion, fragmentation, and patination; his embrace of the partial figure and nude fragment as valid motifs for "serious" art; and his appropriation, as inspired by Michelangelo, of ancient art and the resulting romantic transformation of the academic tradition. Bartlett's torsos also reflect elements of Art Nouveau style in their sinuous, organic design and slender Rococo-inspired propor-

Figure 66. Paul Wayland Bartlett (American, 1865–1925). *Seated Torso of a Woman*, ca. 1895; this cast, ca. 1909. Bronze, 14 x 5 x 7 in. (35.6 x 12.7 x 17.8 cm). The Metropolitan Museum of Art, New York; Rogers Fund, 1909 (09.88.2)

Figure 67. Paul Wayland Bartlett (American, 1865–1925). *Standing Torso of a Woman,* ca. 1894–95; this cast, ca. 1909. Bronze, 18⅛ x 7 x 5 in. (46 x 17.8 x 12.7 cm). The Metropolitan Museum of Art, New York; Rogers Fund, 1909 (09.88.1)

Figure 68. Anders Zorn (Swedish, 1860–1920). *Nymph and Faun*, 1894–95; this cast, 1896. Bronze, H. 11⅞ in. (30.2 cm). Private collection

Bartlett credited his special success in cire-perdue to his rediscovery, through trial and error, of a mold material previously known only to the Japanese. This distinctive material was fine and supple enough when wet to capture the most delicate details of the wax model to be cast, but it was also firm enough when baked to receive the white-hot liquid bronze without expanding or contracting.[7] Characteristically, Bartlett never identified this material, remaining secretive concerning all his procedures for casting and patination. One of his notebooks survives, however, among the Bartlett Papers at the Library of Congress, and fortunately it records much of the wealth of practical information on casting, alloys, patination, and glazing that Bartlett developed during the course of his investigations.[8]

In the years that Bartlett actively operated his foundry, he cast in bronze the works of at least one other artist, Anders Zorn. Best known for his brilliant etchings, Zorn, who was Swedish, became interested in sculpture about 1894 while living in Paris. He had recently developed a close friendship with Bartlett, which was undoubtedly one of the factors that led him to experiment with the medium. One of Zorn's sculptures, *Nymph and Faun* (fig. 68), modeled during the winter of 1894–95, was cast by Bartlett using the lost-wax method sometime the following year.[9] Zorn included the sculpture in *Self-Portrait with Faun and Nymph* (1895, Riddersberg Collection, Sweden), suggesting the significance he himself invested in the piece.[10]

General sources for Bartlett's small cire-perdue bronzes from the 1890s are many and varied. His animal pieces recall similar works from the Paduan Renaissance modeled after or cast from nature; a typical example is *Box in the Form of a Crab* (late 15th or early 16th century, National Gallery of Art, Washington, D.C.).[11] They also evoke the distinctive naturalistic pottery of the great sixteenth-century French ceramist-artist-naturalist Bernard Palissy. Bartlett's *Frog and Snake* and *Frog on a*

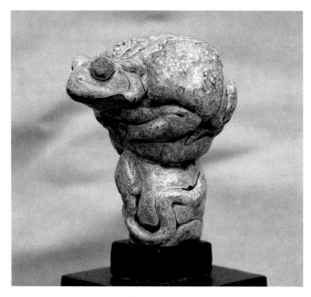

Figure 69. Paul Wayland Bartlett (American, 1865–1925). *Frog and Snake*, 1893. Glazed ceramic, 3 x 3⅜ x 4¼ in. (7.6 x 8.6 x 10.8 cm). Tudor Place Historic House and Garden, Washington, D.C. (6346.01)

Figure 70. Paul Wayland Bartlett (American, 1865–1925). *Frog on a Turtle*, ca. 1895; this cast, ca. 1927. Bronze, 3 x 3⅜ x 4¼ in. (7.6 x 8.6 x 10.8 cm). Tudor Place Historic House and Garden, Washington, D.C. (6135.01)

Turtle (figs. 69, 70), for example, clearly rival a typical Palissy rustic basin (fig. 71) in their heightened realism and matchless blend of aestheticism and the natural sciences. Cast from life and glazed in vivid, translucent colors in imitation of nature, Palissy's rustic earthenware platters could reach extraordinary levels of naturalism. They were greatly admired and much copied into the nineteenth century, especially in France and England (fig. 72). By 1850 Palissy was so famous that he had become "the object of cult worship" by generations of European imitators known as the Palissystes, and at the end of the century he was being hailed as "the French Leonardo da Vinci."[12] Bartlett's animal bronzes are clearly related to the nineteenth-century Palissy revival in France in their Renaissance craftsmanlike commitment to the detailed observation and recording of nature.

In America, Bartlett's animal sculptures from the 1890s may aptly be compared with the small decorative ceramic-bronzes of Maria Longworth Nichols, founder of Rookwood Pottery in Cincinnati,[13] and with the gemlike ceramic glazes of late-nineteenth-century American Art Nouveau pottery in general. Interestingly enough, both Nichols and Bartlett showed their bronzes to great acclaim at the 1900 Exposition Universelle in Paris, an international venue that highlighted Art Nouveau in all its applied, decorative, and architectural manifestations.[14] Bartlett's small bronze torsos of the 1890s belong to a late-nineteenth-century revival of the popular Renaissance tradition of the bronze statuette, which in turn can be traced back to ancient Greek and Roman precedents. Rodin, of course, was the key figure in establishing the partial figure as a primary vehicle for sculptural expression. Albert Elsen and others have

Figure 71. Bernard Palissy (French, 1510–1590). *Rustic Basin— Textured Oval Platter with Garden Snakes, Crawfish, Turtles, Lizards, Frogs, Fish, Eels and Shells*, 1556–90. Lead and tin-glazed ceramic, 15 x 14⅝ in. (38 x 37 cm). Musée du Louvre, Paris

Rodin's monumental portrait statues through its expressionistic power and a distinctive authority that was no longer dependent on academic formulas.

The work-oriented, progressive-minded character of Bartlett's statue easily allied itself, as did his small bronzes of the period, with the broadly popular Arts and Crafts movement. In response to the growing threats of industrialization and predatory capitalism to the security of the common worker, the Arts and Crafts movement celebrated individual human achievement and valued the hand-made over the factory-produced object. The significance of Bartlett's *Michelangelo* to Arts and Crafts ideology is perhaps best illustrated by the case of Elbert Hubbard, a nationally prominent publisher and founder of the Community of the Roycrofters in East Aurora, New York, and the leading spokesman for the movement in America. Upon seeing *Michelangelo,* Hubbard not only wrote and published a short essay on the statue, he contacted Bartlett personally to arrange for a full-scale bronze replica to be made and shipped to East Aurora for erection on the Roycroft Community grounds.[16]

While designating direct sources for Bartlett's two female torsos seems unnecessary (Rodin's influence on these pieces is essentially generic), his seated figure does bear a close resemblance to Rodin's *Kneeling Female Faun* (fig. 73), one of two female fauns on *The Gates of Hell.* Truman Bartlett, in his 1889 study of Rodin, described the figure as follows:

> The central figure of this part of the panel [the left side of the lintel] is a kneeling female satyr clasping her hands behind her head. She personifies sensual passion, and expresses in her position the consciousness of her condition and readiness to accept the coming punishment.[17]

Without negating the relaxed sensuality and feminine beauty implicit in the torso, Bartlett's

traced Rodin's preoccupation with the partial figure to his early and sustained practice— which he shared with Michelangelo—of drawing from plaster casts of ancient fragments and other "ruined" sculptures. Rodin himself took great satisfaction in the fact that his researches into the anatomical fragment had introduced intelligent artists of his time "into the environment of Michelangelo and the Antique."[15] Bartlett was not the only late-nineteenth-century sculptor to lay claim to this particular artistic heritage (Rodin-Michelangelo-Antiquity), but he did have more opportunities than most to proclaim himself a rightful heir. For example, following the installation of his *Michelangelo* in the Main Reading Room of the Library of Congress in late December 1898, the work was soon hailed by many as a genuine American masterpiece. An homage, both personal and national, to the great Italian artist, Bartlett's *Michelangelo* likewise pays tribute to

Figure 72. Georges Pull (French, 19th century). *Round Basin with Lizards, a Snake and Insects,* 1859–63. Lead-glazed ceramic, 19⅜ x 15¾ x 2⅛ in. (49.2 x 40 x 5.4 cm). Musée des Arts Décoratifs, Paris

elimination of the head and limbs effectively avoids both the animalistic sexuality and ambivalent pathos thematically inherent in Rodin's faun.[18] At the same time, the "damaged" or "corrosive" nature of the antique patina that Bartlett gave his bronze—one of the piece's more compelling characteristics—endows the torso with a fragile and surprisingly human sense of loss and vulnerability.

Unlike the *Seated Torso of a Woman,* which was probably conceived as a partial figure right from the start, the *Standing Torso of a Woman* began "life" with a full complement of appendages. Bartlett originally modeled the figure in connection with a private commission from Senator William A. Clark of Montana, the eventual benefactor of the Corcoran Gallery of Art. The senator had engaged Bartlett in April 1894 to design the bronze doorway of a mausoleum for his recently deceased wife, Katherine, that he was preparing to build in New York's Woodlawn

Cemetery (fig. 74).[19] Bartlett delayed getting started on the project, but by the autumn of 1897 he was ready to put the final touches on the full-size clay model for the door.

The bas-relief sculpture (fig. 75) depicts a slender, spectral woman who is dressed in ample, flowing garments and gestures passively for visitors to approach and enter the tomb. A border of poppies surrounds the relief on three sides. To more effectively realize a heavily draped figure in extremely low relief, Bartlett first modeled in the round a small female nude in the same pose. He must have been pleased with the statuette, for soon after he cast the figure's torso in bronze (*Standing Torso of a Woman*), applying a characteristic mottled antique patina in the manner of his *Seated Torso of a Woman.* Incidentally, the Clark door was modeled in Paris and cast in New York in 1898 by the Henry-Bonnard Bronze Company. According to Michael Shapiro, the border for the doorway is the earliest known lost-wax

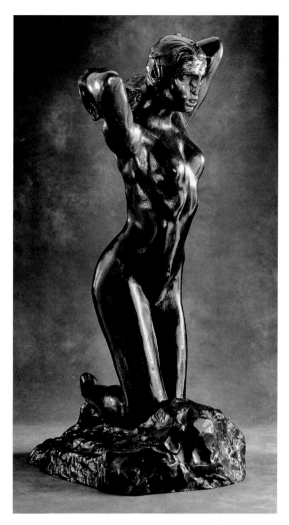

Figure 73. Auguste Rodin (French, 1840–1917). *The Kneeling Female Faun*, ca. 1884–86; this cast, 1966. Bronze, 21 ¼ x 8 ¼ x 11 ¼ in. (54 x 21 x 28.6 cm). Los Angeles County Museum of Art; Gift of B. Gerald Cantor Art Foundation (M.73.108.9)

casting by Henry-Bonnard and may have been the first ever cast in the United States.[20]

As noted earlier, Bartlett's small pieces from the 1890s are related to contemporary craft modernism in France, a movement that attempted to forge a new, vital French idiom out of the decorative and craft traditions of the eighteenth century. Craft modernism, in turn, must be viewed against the backdrop of France's deteriorating industrial and technological base within the rapidly developing international economy of the late nineteenth century. During the final decade of the nineteenth century, France lost its ability to compete in a world market suddenly transformed by the tremendous increase in German and American industrial power. By the early 1890s it was already clear that the national dream of an ascendant France built on the massive industrialization and technology prefigured at the 1889 Exposition Universelle was simply beyond the country's capacity to realize. In response, many key French officials and cultural figures—such as Marius Vachon, author of *Les Musées et les écoles d'art industrielle en Europe* (1890), an extensive report on the applied-arts institutions of France's European competitors, and Georges Berger, who had served as deputy commissioner of the 1889 exposition— turned to cherished eighteenth-century artistic traditions and to the work of the contemporary French artisan, rather than to industrial technology, as "the basis for French economic invincibility."[21]

As Debora L. Silverman explains in *Art Nouveau in Fin-de-Siècle France*:

> If France had to acknowledge other nations as the champions of heavy industrial output . . . how was France to maintain its position as a healthy competitor in the world market? Some members of the republican elite responded: by countering industrial rivalry with traditions of quality. . . . With its national resources of elegance and its reputation as the mecca of taste, fashion, and luxury, France would compensate for industrial deceleration with civilizing graces. . . . the *objet bien fait* would assure for France an exclusive and profitable corner of the competitive world market.[22]

Figure 74. Clark Mausoleum, 1898. Woodlawn Cemetery, New York.
Photograph in Edward F. Bergman, *Woodlawn Remembers: Cemetery of
American History* (Utica, N.Y.: North Country Books, 1988), p. 41.

Figure 75. Paul Wayland Bartlett (American,
1865–1925). Door from the Clark
Mausoleum (*The Vision*), 1894–98. Bronze,
Woodlawn Cemetery, New York

Figure 76. *La Parisienne*, 1900, from the Porte Binet, Exposition Universelle, Paris

Figure 77. Paul Wayland Bartlett (American, 1865–1925). *La Parisienne*, ca. 1900. Plaster, 13⅝ x 9½ x 5⅛ in. (34.6 x 24.1 x 13 cm). Tudor Place Historic House and Garden, Washington, D.C. (6225.01)

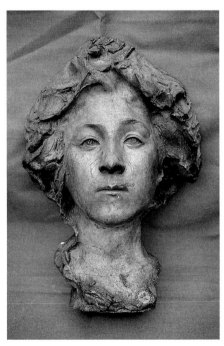

"Elevating taste by presenting objects of superior craftsmanship in the institutions of high art," Silverman further notes, led to an unprecedented unity of the arts in France during the 1890s, with furniture, jewelry, and ceramics recovering "the position beside painting and sculpture that they [had] enjoyed in the Old Regime."[23] Bartlett's conscious blending of high-art intentions with an artisan's devotion to the handmade object and to technical aspects of artistic production were clearly part of this larger, state-sponsored movement in France during the 1890s to promote the crafts as a primary means for reinstating French cultural hegemony and commercial viability.

The 1900 Exposition Universelle in Paris represented the culmination of the craft modern style "as the essence of France."[24] The official reintegration of art and craft was boldly featured in the fair's grand entrance-way, the Porte Binet, which replaced the Eiffel Tower from the 1889 fair as the "main attraction." Atop the Porte Binet perched *La Parisienne* (fig. 76), an elaborately decorated female figure that symbolized "the triumph of modern decoration"; it also highlighted the feminine, organic, and nationalistic principles that lie at the heart of craft modernism and Art Nouveau.[25] Bartlett, evidently captivated by the figure, created a female mask that he named after the statue (fig. 77). Beautifully modeled in a style reminiscent of Rodin, yet reflecting an allegiance to the craft ideal,

Bartlett's *La Parisienne* epitomized his approach to sculpture as craft and acknowledged the significance of craft modernism to his artistic production throughout the previous decade.[26]

The 1900 fair also marked a dramatic change of course in Bartlett's career. The new direction was heralded by his *Equestrian Statue of Lafayette,* the first version of which was unveiled with great pomp and ceremony in the gardens of the Louvre on July 4— United States Day.[27] The success of the *Lafayette,* and that of the *Michelangelo* less than two years earlier, encouraged Bartlett to shift his artistic energies to the production of monumental historical portraits and architectural sculpture. Throughout the remainder of his career, Bartlett would occasionally cast a piece of sculpture in bronze himself, but he did not actively operate his Paris foundry after 1900. His expertise as an international maker of public monuments would largely supplant his personal experimentation in casting and patination. Still, while mostly monumental successes lay ahead as Bartlett's career progressed beyond 1900, one can easily imagine, as Jean Carriès noted, that whenever Bartlett's "mind [became] fatigued with working at some grand piece of sculpture, he [would seek] relief in modelling curious small objects of art."[28] In the end, these "curious small objects of art," rather than any "grand piece of sculpture," may well be Bartlett's most compelling contribution to the history of American sculpture.

1. Bartlett exhibited a plaster portrait bust of his grandmother in the 1880 Paris Salon under the title *Vieille Femme*. See Société des Artistes Français, *Explication des Ouvrages de Peinture, Sculpture . . .*, Salon de 1880 (Paris: Imprimerie Nationale, 1880), p. 563, no. 6081.

2. Ruth Butler, *Rodin: The Shape of Genius* (New Haven and London: Yale University Press, 1993), p. 398. For a reprint of the articles, published in *American Architect and Building News* from January 19 to June 15, 1889, see T. H. Bartlett, "Auguste Rodin: Sculptor," in Albert E. Elsen, ed., *Auguste Rodin: Readings on His Life and Work* (Englewood Cliffs, N.J.: Prentice-Hall, 1965), pp. 13–109.

3. On these Bartlett works, see the following publications by Thomas P. Somma, "The Myth of Bohemia and the Savage Other: Paul Wayland Bartlett's *Bear Tamer* and *Indian Ghost Dancer*," *American Art* 6, no. 3 (summer 1992), pp. 15–35; *"The Apotheosis of Democracy," 1908–1916: The Pediment for the House Wing of the United States Capitol* (Newark: University of Delaware Press, 1995); "The Sculptural Program for the Library of Congress," in *The Library of Congress: The Art and Architecture of the Thomas Jefferson Building,* eds. John Y. Cole and Henry Hope Reed (New York and London: W. W. Norton and Company in association with the Library of Congress, 1997), pp. 227–51; and "The Hand Obedient to the Intellect": Paul Wayland Bartlett's *Michelangelo* for the Main Reading Room of the Library of Congress" (to be published in a forthcoming volume of essays, Ohio University Press in association with the United States Capitol Historical Society).

4. See Thayer Tolles, ed., *American Sculpture in The Metropolitan Museum of Art, Volume II: A Catalogue of Works by Artists Born between 1865 and 1885* (New York: The Metropolitan Museum of Art, 2001), pp. 457–60. Additional casts of each torso are located at the Musée d'Orsay, Paris; the Smithsonian American Art Museum, Washington, D.C.; and the Westmoreland Museum of American Art, Greensburg, Pennsylvania. The Corcoran Gallery of Art, Washington, D.C., also has a cast of *Seated Torso of a Woman*; another *Standing Torso of a Woman* is at the Yale University Art Gallery, New Haven.

5. Carriès was best known for his adoption of Japanese glazing techniques and for a series of portrait busts that were cast in bronze by Pierre Bingen (1842–after 1906), one of the leading lost-wax founders in France during the 1880s and 1890s. Bartlett could have seen examples of Carriès's cire-perdue bronzes when fourteen of them were exhibited at the Salon of the Champs de Mars in 1892; he probably already knew Bingen, who had served as Rodin's lost-wax founder in the 1880s. See Michael Edward Shapiro, *Bronze Casting and American Sculpture, 1850–1900* (Newark: University of Delaware Press; London and Toronto: Associated University Presses, 1985), p. 124, p. 190 n. 16.

6. See Shapiro, *Bronze Casting,* p. 125. For Carriès's comments on Bartlett's cire-perdue bronzes, see

Lorado Taft, *The History of American Sculpture* (New York and London: Macmillan, 1903), pp. 376–77. On Bartlett as craftsman, see also Katharine Elise Chapman, "A Sculptor Who Is Also a Craftsman," *Craftsman* 16 (July 1909), p. 437; and *Dictionary of American Biography,* s. v. "Bartlett, Paul Wayland."

7. "'Lost Wax': A Visit to Paul Bartlett's Studio," *New York Daily Tribune,* September 15, 1895, p. 23.

8. See Paul Wayland Bartlett, "Notebook on the Coloration of Bronzes, Alloys, and Methods of Casting," ca. 1890–95, Paul Wayland Bartlett Papers, Manuscript Division, Library of Congress, Washington, D.C. See also Shapiro, *Bronze Casting,* pp. 125–26.

9. Gerda Boëthius, *Anders Zorn, an International Swedish Artist: His Life and Work* (Stockholm: Nordisk Rotogravyr, 1954), p. 61. See also "Lost Wax," p. 23.

10. As subsequent events seem to bear out, it appears that Zorn became romantically involved with Bartlett's wife, Emily, shortly before the summer of 1896, when Zorn and his wife left Paris abruptly to settle in Mora, Sweden. While the affair did not cause an immediate breakup of the Bartletts' marriage, within two years Emily had filed for divorce; a decree of divorce was issued in Paris in early 1899. Truman Bartlett to Paul Bartlett, February 17, 1899, Paul Wayland Bartlett Papers, Tudor Place Historic House and Garden, Washington, D.C.; Boëthius, *Anders Zorn,* pp. 48, 51–52.

11. Other characteristic examples from the Paduan Renaissance (all by unknown artists) include *Toad with a Tiny Toad on Its Back* (early 16th century), also at the National Gallery of Art, Washington, D.C., and *Toad* (ca. 1500–1525) and *Lobster* (ca. 1500–1520), both in the Cleveland Museum of Art.

12. Leonard N. Amico, *Bernard Palissy: In Search of Earthly Paradise* (Paris and New York: Flammarion, 1996), pp. 6, 7, 9, 189. On Palissy, see also T. Clifford Allbutt, *Palissy, Bacon and the Revival of Natural Science* (London: H. Milford, Oxford University Press, 1914); and Marshall P. Katz, *Nineteenth-Century French Followers of Palissy: A History of Nineteenth-Century French Ceramists from Avisseau to Renoleau* (Pittsburgh: M. P. Katz, 1994).

13. A representative selection of Nichols's pieces is in the collection of the Cincinnati Art Museum.

14. For a recent study on Art Nouveau, see Paul Greenhalgh, ed., *Art Nouveau, 1890–1914,* exh. cat. (New York: Harry N. Abrams, 2000); see pp. 204, 256, and 259 for specific references to Nichols, Rookwood Pottery, and Bartlett. A basic bibliography on Nichols and Rookwood Pottery includes Kenneth R. Trapp, *Ode to Nature: Flowers and Landscapes of the Rookwood Pottery, 1880–1940,* exh. cat. (New York: Jordan-Volpe Gallery, 1980); and Robert C. Vitz, *The Queen and the Arts: Cultural Life in Nineteenth-Century Cincinnati* (Kent, Ohio: Kent State University Press, 1989).

15. Rodin is quoted in Judith Cladel, *Auguste Rodin:*

L'Homme et l'Oeuvre (Brussels: Van Oest, 1908), p. 97. See also Albert E. Elsen, *The Partial Figure in Modern Sculpture, from Rodin to 1969,* exh. cat. (Baltimore: Baltimore Museum of Art, 1969), p. 26.

16. On Hubbard and the Roycrofters, see Elbert Hubbard, *The Roycroft Shop: Being a History* (East Aurora, N.Y.: The Roycrofters, 1908). Original copies of Hubbard's essay entitled "He Faces the East" are in the Bartlett Papers at the Library of Congress and in the Records of the Architect of the Capitol, United States Capitol.

17. See Elsen, ed., *Auguste Rodin,* p. 74. See also John L. Tancock, *The Sculpture of Auguste Rodin* (Philadelphia: Philadelphia Museum of Art, 1976), p. 171.

18. Rodin's kneeling fauness proved to be a very adaptable figure throughout the late nineteenth century. He produced several variants in different media, including one that he used in 1888 to illustrate a copy of Baudelaire's *Les Fleurs du Mal.* Even Edvard Munch created a 1902 print version of Rodin's alluring, dangerous, and yet curiously pathetic creature. See Tancock, *Auguste Rodin,* pp. 168, 170–71, figs. 11-1–5.

19. For the Clark Mausoleum and Bartlett's bronze door, see C[harles] de Kay, "A Bronze Door by Bartlett," *New York Times,* November 7, 1897, magazine section, p. 12; Shapiro, *Bronze Casting,* pp. 128–30, figs. 137, 138; and Edward F. Bergman, *Woodlawn Remembers: Cemetery of American History* (Utica, N.Y.: North Country Books, 1988), pp. 40–41. Besides being a U.S. senator, Clark was an extremely wealthy businessman. As director of the United Verde Copper Company, he was known popularly as the "Copper King of Montana." At the time of its erection in 1898–99 at an estimated cost of $150,000, the Clark Mausoleum was probably the most expensive tomb at Woodlawn. See "Costly Tombs for Rich New Yorkers Now Adorn Woodlawn Cemetery," *New York World,* May 7, 1899, p. 5.

20. Shapiro, *Bronze Casting,* p. 129. For a discussion of Bartlett's relationship with Henry-Bonnard, Clark's acquisition of the foundry, and the expansion of the company into a more modern facility—the Gorham Manufacturing Company, built by Clark in 1906 at Mount Vernon, New York—see Shapiro, *Bronze Casting,* pp. 129–32.

21. Debora L. Silverman, *Art Nouveau in Fin-de-Siècle France: Politics, Psychology, and Style* (Berkeley, Los Angeles, and Oxford: University of California Press, 1989), pp. 52–55. Silverman provides an excellent discussion of technology and craft modernism in France.

22. Ibid., p. 53.

23. Ibid., p. 62.

24. Ibid., p. 284.

25. Ibid., pp. 291–93.

26. There is a bronze cast of *La Parisienne* in the collection of the Smithsonian American Art Museum, Washington, D.C.

27. After countless revisions to the original plaster model and a long and difficult casting process by the lost-wax method, the final bronze *Equestrian Statue of Lafayette* was hoisted onto its pedestal in the Louvre's Cour Napoléon in late June 1908. The statue remained at its original site until July 1984, when it was removed to the Cours la Reine, between the Grand Palais and the Seine, to allow for the archaeological excavations that preceded the construction of I. M. Pei's glass pyramid.

28. Taft, *History of American Sculpture,* pp. 376–77.

Andrew J. Walker

The Aesthetics of Extinction: Art and Science in the Indian Sculptures of Hermon Atkins MacNeil

This essay focuses on two bronze sculptures by Hermon Atkins MacNeil (1866–1947) that bracket the artist's early career in Chicago. MacNeil moved to Chicago in 1893 to work on the decorations for the Electricity building at the World's Columbian Exposition and eventually became widely known as the city's most "serious student of the American Indian."[1] *The Vow of Vengeance* (fig. 78), a 16¾-inch-tall statuette, was modeled and cast in 1894. This small work was his first attempt at representing an Indian ritual in sculptural form. Although the specific ethnographic context of the ritual has proved elusive, MacNeil later described it as a youth "taking his oath of allegiance to his tribe, so with the hope of becoming a warrior . . . proving his prowess by throwing the arrow directly in the face of the sun."[2] That description was partly in reference to *The Sun Vow* (fig. 79), a composition completed by the artist in 1899 while in Rome studying on a William H. Rinehart Scholarship, and perhaps MacNeil's best-known lifesize sculpture. When finished, both pieces attracted the interest of Chicago

patrons. The first bronze cast of *The Sun Vow* was purchased in 1901 by Howard Van Doren Shaw, an architect and an influential trustee at the Art Institute of Chicago. Shaw placed the sculpture in front of Ragdale, the name he had given his Arts and Crafts house in Lake Forest, Illinois.[3] The two located casts of *The Vow of Vengeance* went to Chicago purchasers, one of whom was the real estate developer Arthur Alidis, whose brother Owen had commissioned MacNeil in 1895 to make four bronze reliefs for the Marquette Building in the city's burgeoning business district.[4]

Although these sculptures are separated by nearly five years and were designed on vastly different scales, a comparison of the two reveals a strong visual relationship. Both portray an elder chieftain with his legs crossed and a naked male youth in a serpentine pose stretching out to shoot an arrow from a bow. The sinuous bodies of the subjects intersect, as though they were modeled to underscore the continuity of generations, and both sets of figures intently gaze upward, watching the arrow's path and awaiting the outcome of the initiation ceremony. The correspondences between the two works were not lost on critics at the turn of the twentieth century. After MacNeil completed the larger plaster in 1899, a writer for a Chicago art journal reminded readers of a "small bronze which appeared some few years ago, and which created attention for its good modeling, [and] the picturesque and sculptural treatment of the Indian."[5] Since that time, art historians have tended to view *The Vow of Vengeance* (if they knew of it) as a kind of sketch for the larger work.

This is a simple explanation, however, which overlooks the sculptures' dramatic differences. In *The Sun Vow,* the war bonnet, which MacNeil had earlier rendered with

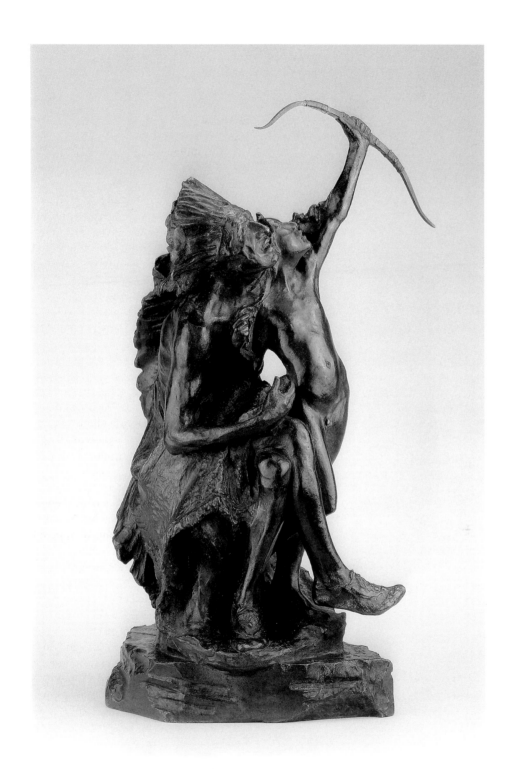

Figure 78. Hermon Atkins MacNeil (American, 1866–1947). *The Vow of Vengeance,* 1894. Bronze, 16¾ x 7¾ x 8½ in. (42.5 x 19.7 x 21.6 cm). The Art Institute of Chicago; Restricted Gift of Wesley M. Dixon, Jr. (2001.435)

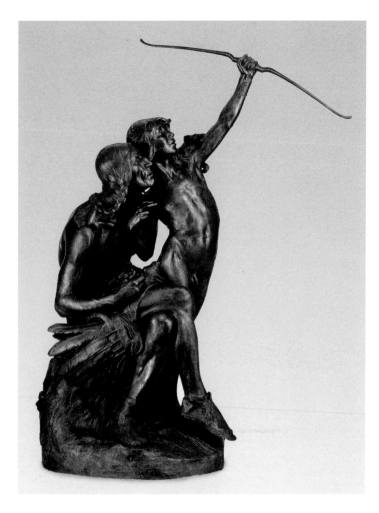

Figure 79. Hermon Atkins MacNeil
(American, 1866–1947). *The Sun Vow,* 1899;
this cast, 1901. Bronze, H. 69½ in. (176.5 cm).
The Art Institute of Chicago; Bequest of
Howard Van Doren Shaw (1926.1503)

calligraphic dexterity, now rests in the elder's lap, crumpled and hidden. The arrow that the chief once held so prominently in his right hand has completely disappeared. MacNeil's most dramatic transformations, however, relate to the facial features. The exaggerated noses, eyes, and mouths of the figures in *The Vow of Vengeance* are tempered in *The Sun Vow,* almost as if the artist had replaced racial caricature with a type of ethnographic realism. The later version, as one critic noted in 1906, was not a "cigar store Indian nor 'Wild West Show' specimen." Rather, it represented a "genuine savage" that derived its authenticity from the fact that MacNeil "went to them—to the tribes of the Northwest and to the Moquis and Zunis."[6] Evidently the five years between *The Vow of Vengeance* and *The Sun Vow* marked a considerable change not only in MacNeil's technical ability but in his approach to the Indian as subject matter. In my view, MacNeil's developing artistic conception paralleled similar changes in social policy and anthropological inquiry toward this "vanishing race" and reflected his experience among the artists, patrons, and institution builders of Chicago.

In the glowing aftermath of the 1893 World's Columbian Exposition, Chicago stood on the brink of an unprecedented opportunity to become a cultural as well as an economic crossroads of the United States. The city's cultural prosperity, however, depended on a symbiotic relationship between its artists and civic leaders. "Our history, which we are making so hastily," wrote the editor of *The Arts,* Chicago's principal art magazine, "will have no fair representation unless our artists take the work in hand and put it into permanent form. There is work for us all and time is fleeting. Each year should represent a volume of art bound by the ties of Americanism."[7] Part of that "Americanism" turned on the unique themes available in the West, including Indian subjects, which would emerge as a defining interest shared by MacNeil and Chicago's cultural leaders.

Figure 80. *Hermon Atkins MacNeil.*
Photograph in *Arts* 3 (October 1894), p. 101.
The Art Institute of Chicago

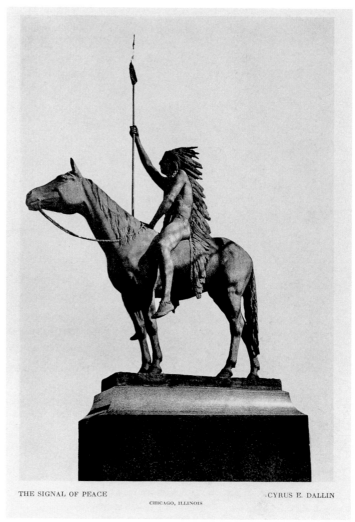

THE SIGNAL OF PEACE

CHICAGO, ILLINOIS

·CYRUS E. DALLIN

MacNeil (fig. 80) openly acknowledged
that his studious interest in Indian subject
matter arose while he was working at the
Chicago world's fair: "The Indian caught my
fancy as it had with many a young sculptor."[8]
Native American themes were pervasive,
from the impressive works of art to the dis-
plays of artifacts organized by Frederick W.
Putnam and his team of anthropologists. In
the Fine Arts building, for instance, MacNeil
would have encountered Cyrus Dallin's
The Signal of Peace (fig. 81).[9] The over-lifesize
bronze depicts an incident that Dallin claimed
to recall from his boyhood in Utah: a Sioux
chief on horseback pointing a spear upward
in a gesture of peace at the moment of first
contact with white explorers.[10] Judge
Lambert Tree purchased the sculpture and
offered it to Chicago as a "fit memorial of

Figure 81. Cyrus Dallin (American,
1861–1944). *The Signal of Peace,* 1890; this
cast, 1894. Bronze. Chicago Park District,
Lincoln Park. Photograph in Katherine
Thayer Hodges, "Dallin: The Sculptor,"
American Magazine of Art 15 (October 1924),
p. 523. Thomas J. Watson Library, The
Metropolitan Museum of Art, New York

the Aboriginal Americans."[11] In a letter to the commissioners of Lincoln Park, where *The Signal of Peace* was unveiled in June 1894, Judge Tree made a stirring statement, laced with regret:

> I fear the time is not distant when our descendants will only know through the chisel and brush of the artist these simple, untutored children of nature who were, little more than a century ago, the sole human occupants and proprietors of the vast Northwestern empire, of which Chicago is now the proud metropolis.[12]

Dallin's sculpture romantically evoked the rituals and customs of an era that had passed as it also aesthetically reinforced the prevailing idea put forth in the fair's various ethnological displays, some of which were organized by the Smithsonian Institution and others by Putnam and his chief assistant, Franz Boas. In 1890, after the government officially declared the American frontier closed forever, the "Indian Problem" resolved into a scenario of eventual cultural extinction that demanded a permanent record be made before the project of Anglo-American assimilation was complete. As a consequence, organizers of the fair's anthropological displays focused primarily on artifacts unique to native peoples. "Objects traded to the natives by whites," wrote Putnam, "are of no importance, and are not desired; the plan being to secure such a complete collection from each tribe as will illustrate the condition and mode of life of the tribe before contact with Europeans."[13]

MacNeil, thus inspired by the broad themes encountered at the fair, and installed as an instructor at the School of the Art Institute of Chicago, completed *The Vow of Vengeance*. The staid, arrested action of MacNeil's initiation ritual—presented as a generational rite of passage—aligned with the views of those scientists and artists who regarded the Indians and their ceremonials as unbroken links to an ancient past. But the

statuette makes a strong statement in a different, more pejorative, sense by underscoring the dramatic "savagery" of the figures. The war bonnet worn and the arrow held by the chieftain signify the idea of Indian aggression so central to current popular versions of the winning of the West. Even the title puts an emphasis on retaliation. Only the small ceramic pot at the sculpture's base appears to qualify the primitive violence of the composition. Anthropologists generally regarded the invention of pottery as an evolutionary marker for a racial group (a midpoint in the development from savagery through barbarism to civilization), and MacNeil would have seen abundant examples of such crafts at the fair's ethnographic displays.[14]

Nowhere did MacNeil proclaim his Indian subject's "primitive savagery" more clearly than in the figures' physiognomies. The large wide faces, prominent chins, and hooded eyes of Native Americans were seen by physical anthropologists at the time as biological evidence of their retarded evolutionary state. This theory was literally on display at the Columbian Exposition: Franz Boas set up an anthropometry lab in the physical anthropology division to measure the crania and facial features of members of various Indian tribes who had traveled to Chicago to take part in fair events. As the assistant chief of anthropology, Boas displayed the results in the form of diagrams and charts that defined a racial hierarchy and reinforced the "primitive" condition of the North American Indians.[15] Perhaps using the outcome of such investigations as a touchstone, MacNeil consciously exaggerated those features then attributed to the Indians' arrested evolution.

Costume, title, and the conscious exaggeration of facial features together made a conclusive statement about the desultory future of the Indian. They also underscored the belief that the impending extinction of the Indian peoples was an unfortunate but inevitable consequence of the march of Western culture across the American conti-

nent. In a sense, *The Vow of Vengeance* reflects the narrative of Indian demise propagated in Buffalo Bill's Wild West show, which played to great acclaim in a stadium outside of the Columbian Exposition fairgrounds. As historian Richard White has observed, in Buffalo Bill's version of frontier conquest the continent "teemed with murderous Indian enemies" frozen in a savage state of evolutionary development.[16] MacNeil certainly visited the Wild West show and, later in his life, even confirmed that the model for his early Indian sculptures—a Sioux named Black Pipe—had been a member of Buffalo Bill's troupe.[17] *The Vow of Vengeance* would appear then to relegate the Indian to what the artist Frederic Remington described as "the scrap heap of departing races."[18]

Although *The Vow of Vengeance* seems to uphold certain stereotypes, it should not be viewed as an end point in the young sculptor's embrace of Indian subject matter. The Sioux who remained in Chicago after the fair certainly offered MacNeil the chance to base his subjects on studies from life, but Black Pipe's abject poverty underscored the paradox of Indian survival under the daunting pressure of modernization—a condition not portrayed in the Wild West show. In fact, during the 1890s Chicago's cultural leaders, the founders of the city's museums and libraries, decisively opposed the "Wild West" version of frontier conquest and Indian extinction, a point of view they considered nostalgic and aggressively romantic. Rather, their social perspective, backed by current scientific reasoning, viewed the "primitive" Indian race as having played a positive role within the development of an Anglo-dominated civilization. The end of the Indian wars and the permanent establishment of the reservation allotment system in 1884 simply clarified that the future of the Indian was more an issue of assimilation than extinction.

No cultural leader better exemplified this perspective than Edward Everett Ayer. Like other wealthy businessmen responsible for building Chicago's institutional infrastructure, Ayer, who had made his vast fortune in the 1860s selling wood ties to the westward-pushing railroads, recognized the role his class had played in the inevitable threat to the Indian way of life. In 1892 he authored a short tract entitled *The North American Indian and Their Condition* that acknowledged the paradox of extinction:

> I don't think any one hated an Indian worse than I. Since I have commenced to read about them, and put myself in their place, my views have changed very materially. We have simply destroyed a great race of human beings, in many of the virtues our superiors, and when you look back and see the great men each part of the country has produced on all occasions, it only makes our regret the greater that we have not given them a better show.[19]

Ayer certainly accepted that the various tribes were "vanishing," but for him those aspects of native culture that were approaching extinction were less a function of actual numbers of people than the disappearance of customs and rituals. To counter the problem, Ayer, together with other powerful Chicago businessmen, founded the Field Columbian Museum and helped to formulate its commitment to collecting and preserving Indian culture. Housing the ethnological displays created for the World's Columbian Exposition, the Field and its professional staff, with the assistance of patrons such as Ayer, continued to collect related objects and to display them in innovative ways. Foremost among these were the lifesize sculpted mannequins dressed in native clothing and displayed within environments showing Indians working together at a specific industry or ritual (fig. 82).[20] Also, echoing George Catlin's display technique from earlier in the nineteenth century—which combined actual native artifacts with representations of tribal customs—the

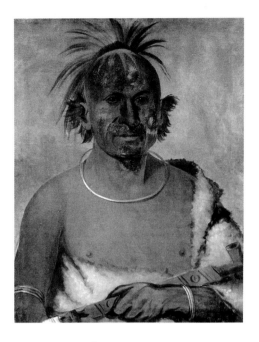

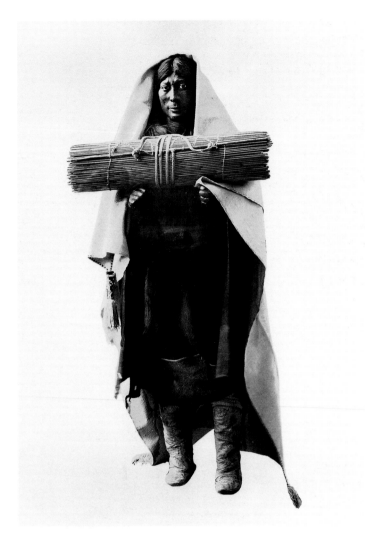

Figure 82. Hopi bride figure model for diorama, reconstruction by H. R. Voth. On display at the Field Columbian Museum, 1894 (photographed ca. 1902). Field Museum of Natural History, Chicago

Figure 83. George Catlin (American, 1796–1872). *Little Stabbing Chief, the Younger,* 1832. Oil on canvas, 28 x 23 in. (71.1 x 58.4 cm). Field Museum of Natural History, Chicago; Museum Purchase, 1894

museum's curators would often install works of art alongside various Indian relics.[21]

In 1894 Ayer worked with Harlow Higginbotham to procure for the Field Museum a significant collection of thirty-five paintings by George Catlin made between 1831 and 1837, when the artist was living and painting among the tribes of the West. The group was offered to the Field by Emily O'Fallon, a grandniece of General William Clark (of Lewis and Clark fame), and comprised mostly portraits of Sioux, Fox, Mandan, and Blackfoot Indians.[22] The portrait *Little Stabbing Chief, the Younger* (fig. 83), for example, captured the distinctive hairstyles, wardrobes, and ornamentation that anthropologists and collectors such as Ayer wanted to record and preserve. In fact, when the Catlin paintings were first exhibited in Chicago, it was their ethnographic accuracy that captured the attention of the local press.[23] Science and art, so it seemed, were together salvaging that which was becoming extinct among the diverse Indian tribes.

Ayer and his like-minded contemporaries demanded a realism that was both ethnographic and aesthetic, priorities that had

a commanding influence within Chicago's art community, in which MacNeil played a major role. The sculptor allied himself closely with three important artists: author Hamlin Garland; sculptor Lorado Taft; and painter Charles Francis Browne, with whom he had an especially close friendship. Browne, Taft, and MacNeil taught at the School of the Art Institute and, along with Garland, served as the core group who began the bohemian summer art colony in Oregon, Illinois, known as Eagle's Nest. They also frequently attended informal evening salons with Chicago's art set. On one memorable occasion MacNeil, Browne, and Taft showed up at the studio of the sculptor Richard Bock dressed "in Indian costumes."[24] All four men were active members in the city's most influential arts organizations, including the Cosmopolitan Art Club and the larger Central Art Association (CAA). These groups strongly supported exhibitions in Chicago and throughout the Midwest (eventually extending to California) that promoted the idea of a homegrown American art.[25]

As the CAA's president and most articulate spokesman, Garland consistently called for the revitalization of national art. He himself practiced a literary realism that conflated hard facts with strong emotions, and he applied similar standards to the visual arts. "Hold the Western artist," he wrote, "to a rigidly high standard, but do not make the fatal mistake of substituting tradition for vitality, imitation for originality, dead canvas for nature. The creative artist should be held accountable only to truth. His method should be convincing, simple, sincere—being sincere it will grow to be spontaneous and individual."[26] As their ambitions took shape around these compelling themes, it became clear to Garland and his cohorts that they had to test themselves beyond the city, in the West, where they were sure of finding sources for authentic American art. The reservation Indian, still possessing his customs and rituals, became a dominant subject that was "America" itself. But to be "sincere," as it

was often labeled, required firsthand experience, and to that end MacNeil, Garland, and Browne set off in the summer of 1895 for the Indian reservations in the North and Southwest. Anticipating that they would help to make the "West famous" through their art, the trio secured funds to cover their railway passage from Chicago to San Francisco and back. Garland, who had traveled to Colorado the year before, served as the group's de facto guide. Neither Browne nor MacNeil had ever been west of the Mississippi River, and Garland somewhat humorously described them as Easterners who wanted to "see the red people" and collect "Wild West" material.[27] They traveled on the Santa Fe Railroad through South Dakota and Colorado south to the Arizona Territory, where they observed the changes taking place in the lifestyles of the Pueblo Indians as they adapted to the reservation system that had been forced upon them.[28] They spent the majority of the summer visiting the Isleta Pueblo, near Albuquerque, and lived for a period among the Hopi in Winslow, Arizona, where they met with noted anthropologists Walter Fewkes and Frederick Hodge. The climax of their trip came when they attended the most sacred and, for the anthropologists, the most popular ritual of the day: the Snake Dance ceremony at Walpi on First Mesa.[29] Although all three found the experience stimulating, it had a particularly significant impact on MacNeil. "Every artist," he later recalled, "has at various times very strong impressions that he longs to express. The sensation received by me from this dance was without doubt the deepest I had received. There was an abandon and fury and sincerity."[30]

Back in Chicago, MacNeil and Browne publicized their expedition by establishing a joint studio in the Marquette Building and holding a reception for the city's art set. They embellished the studio with various artifacts and souvenirs, as at least one local critic noted with a touch of humor: "The rooms are fitted up with Indian trappings gathered during their sojourn in New Mexico and Arizona,

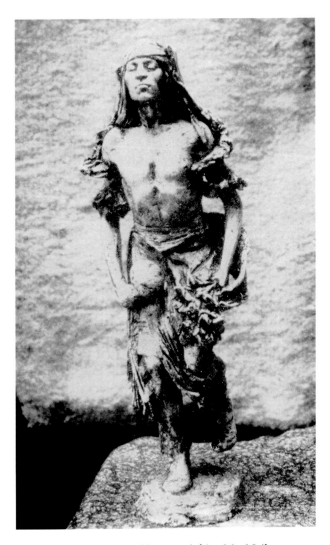

Figure 84. Hermon Atkins MacNeil
(American, 1866–1947). *Acoma Dancer,*
ca. 1896. Plaster, H. 13 in. (33 cm).
Photograph in *Arts for America* 5 (April 1896),
p. 98. The Art Institute of Chicago

pieces treated Native American subjects,
including the 13-inch-tall plaster statuette
Acoma Dancer (fig. 84), inspired by the Hopi
Snake Dance that MacNeil and his friends had
witnessed in Arizona.

Acoma Dancer departs from the caricature
and stereotype glimpsed in its predecessor,
The Vow of Vengeance; instead, a level of ethno-
graphic detail signaled audiences to the
authenticity of the artist's experience. The
costume and facial features of the work cor-
respond to accounts and illustrations of Hopi
religious rituals that anthropologists such as
John Gregory Bourke had published as early
as 1884, thus conforming to critical expecta-
tions for authenticity.[33] When MacNeil
debuted six other works at the Art Institute's
annual American art exhibition in 1895, one
reviewer praised the sculptor's realism:

> In sculpture those fresh, spirited
> Indians, by H. A. MacNeil, are so
> strong and full of vigor that they
> command at once one's admiration
> and respect. The strongly developed
> and "straight-as-an-arrow" style
> surely marks the Indian as nature's
> nobleman. MacNeil knows just how
> to bring out their striking charac-
> teristics, and even on a small scale
> the work is grandly conceived.[34]

Collectors, too, showed their approval: all six
of the sculptures shown at the exhibition sold
immediately to local patrons, bringing
MacNeil an unprecedented endorsement, if
not financial reward (each plaster was priced
at twenty dollars).[35] A few months later, in
April 1896, when *Acoma Dancer* was on dis-
play at the Cosmopolitan Art Club's exhibi-
tion, a contributor to *Arts for America*
described MacNeil's work as "sincere" and
"wonderfully true to Indian life."[36]

The greatest confirmation of MacNeil's
achievement as both authentic and preserva-
tionist, came in the patronage of Edward
Everett Ayer. At the time of the Art Institute
exhibitions, in 1895 and 1896, respectively,

and looks more like 'Big Chief's Wigwam'
than an artist's retreat."[31] But such studio
arrangements were only one means through
which MacNeil promoted his Western experi-
ence. In 1896 he also exhibited six Indian
subjects in the Cosmopolitan Art Club's exhi-
bition held at the Art Institute.[32] Except for
one work depicting a cowboy, all of MacNeil's

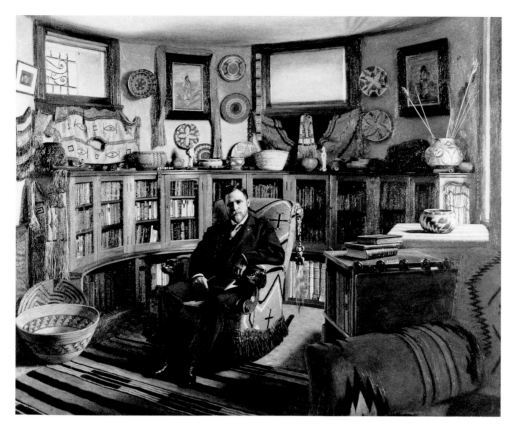

Figure 85. Elbridge Ayer Burbank (American, 1858–1949). *Edward Everett Ayer in His Study,* 1897. Oil on fabric, 25 x 32 in. (63.5 x 81.3 cm). Edward E. Ayer Collection, The Newberry Library, Chicago

Ayer was serving as president of the Field Columbian Museum's board of trustees and had donated most of his collection of Indian artifacts to that institution, making it an essential national center for the study and preservation of Native American culture. Ayer considered his own identity as a scholar and collector of Indian relics and books of paramount importance, and the portrait he commissioned from his nephew, Elbridge Ayer Burbank, served to reinforce these associations (fig. 85). The portrait is set in Ayer's study, where he sits in a large rocking armchair upholstered in a brilliant scarlet Navajo blanket. Half-height bookcases line the alcove behind him, the volumes' yellow, gold, blue,

and red bindings adding touches of color. Displayed atop the bookcases and hanging on the wall above are Hopi and Pima woven baskets and trays as well as framed portraits of Indian warriors by Catlin. Among the objects framing Ayer are two of MacNeil's plasters: *Water Carrier, Zuni* and *Nai-u-cgum Chief Priest of the Bow,* which were made from the sculptor's Arizona studies and shown at the 1895 Art Institute exhibition.[37]

Ayer's patronage of MacNeil validated the sculptor's combined artistic and ethnographic relevance; the sculptures were scientifically accurate in the details of costume and aesthetically picturesque in that they preserved a fast-disappearing part of

Indian culture. As such, MacNeil's post-Arizona sculptures easily moved from the art environment of the Art Institute to the more scientific environment of the collector's research library. This was an important early endorsement, but even more consequentially, Ayer continued to champion the artist even after he left Chicago early in 1896 to take up residence in Rome as one of the first recipients of the prestigious William H. Rinehart Scholarship, established to subsidize European study for young American sculptors.

The decision to leave Chicago did not come easily to MacNeil, who worried about abandoning the supportive environment of his patrons and artist friends. As MacNeil later recalled, Hamlin Garland and Charles Francis Browne both feared that he would lose his "Americanism by associating with the old European Art."[38] As it turned out, the Rinehart Scholarship provided MacNeil with an exceptional opportunity to increase his national reputation. Installed in the luxurious Villa dell'Aurora, MacNeil—perhaps in answer to his friends' concerns—refused to abandon the work he had begun in Chicago and continued to explore Indian subject matter.[39] In 1896 he completed the first notable sculpture of his residency, The Moqui Runner (The Moqui Prayer for Rain—The Returning of the Snakes) (fig. 86). This bronze depicts a moment from the last day of the Hopi Snake Dance, when the chief priest runs with a handful of serpents from the high mesa to the plains so that the reptiles can carry the prayer for rain to the Rainmakers beneath the earth. In contrast to the earlier Acoma Dancer, which renders arrested motion in a static, photographic manner, The Moqui Runner employs more sophisticated means to capture the priest's intense physical activity. This new direction was as much an experiment with the sculptural representation of movement as it was an attempt to accurately depict the Hopi ritual.

Ayer, who was visiting Rome that summer on a book-buying trip for Chicago's Newberry Library, saw the finished model and immediately convinced MacNeil to commission ten bronze casts, for which he promised to find purchasers. He must have fulfilled his promise, for in December 1898 his nephew Elbridge congratulated him: "Am glad to hear that you have sold 7 running Indians by MacNeil. It is a fine thing."[40] At least one of these casts went to a private collection in Lake Geneva, Wisconsin, and another to the Museum of Natural History in New York.[41] Of the two casts that Ayer kept, one went on long-term loan to the Art Institute of Chicago and the other went to the Newberry Library, institutionally reinforcing the Moqui Runner's credentials as both a work of fine art and an ethnographic artifact.[42]

There were limitations to the Moqui Runner's double purpose that MacNeil himself recognized and which are suggested by a comparison between his sculpture and his friend Elbridge Ayer Burbank's portrait Ko-pe-li, the Snake Dance Priest (1898, Field Museum of Natural History, Chicago). Burbank painted Ko-pe-li in 1898 while living among the Hopi, with Ayer's financial support, in what proved to be a deeply meaningful experience in the Southwest. Distressed by the imminent cultural extinction that he observed at almost every Indian reservation he visited, Burbank committed himself to recording the few religious rituals that remained.[43] Like MacNeil two years earlier, he discovered rich material for his paintbrush in the Snake Dance. Burbank was granted access to the sacred kiva rite (held in a subterranean ceremonial chamber) before the official ceremony and was determined to paint as many aspects of the ritual as he could. "The head Chief named Ko-pe-li of the Snake dance is to sit for me and I am not going to leave here until have painted most of the principal costumes. Am working on my 19th picture now."[44]

The strength of Burbank's finished portrait of Ko-pe-li lies in his precise depiction of the details of costume and body paint, all of which had specific meaning within the ritual. When the group of Burbank's Hopi

Figure 86. Hermon Atkins MacNeil (American, 1866–1947). *The Moqui Runner (The Moqui Prayer for Rain—The Returning of the Snakes),* 1896; this cast, ca. 1897. Bronze, 25 x 11 x 22½ in. (63.5 x 27.9 x 57.2 cm). The Art Institute of Chicago; Gift of Edward E. Ayer (1924.1350)

KO·PE·LEY.
MOQUI.

Figure 87. Elbridge Ayer Burbank
(American, 1858–1949). *Ko-pe-li, Snake Chief
at Walpi,* 1898. Color lithograph. In *Brush and
Pencil* 4 (June 1899), opposite p. 148. Thomas
J. Watson Library, The Metropolitan Museum
of Art, New York

tume, lent scientific authority to Burbank's
lithograph; at the same time, the aesthetic
nature of the periodical suggested that the
print was also suitable for framing and display
in the home.

At this unique cultural moment both
Burbank's paintings and MacNeil's sculptures
could move with relative ease between insti-
tutional venues dedicated to either science or
art. But a comparison between MacNeil's
Moqui Runner and Burbank's *Ko-pe-li* demon-
strates that the boundaries would not remain
so fluid. Charles Francis Browne, who praised
Burbank's work in a laudatory article for
Brush and Pencil, hinted at the artists' different
approaches to the Snake Dance. "Ko-pe-li is
represented [by Burbank] with all his cere-
monial costume," he wrote, "and this is the
first time he has ever been painted in his
sacred character. It took a deal of persuasion,
I am sure, to win over Ko-pe-li's prejudices.
MacNeil and I were unable to do it two
years before."[47] Between the lines, Browne
admired the artist's initiative and dedication
more than the aesthetic qualities of his work.
Burbank's paintings edged toward the
scientific end of the continuum of realism,
while MacNeil's work tended toward the
ideal. And if institutional placement stands as
a marker of an object's cultural status, it soon
became evident which direction would pre-
vail as the dominant visual language for
modern renderings of the American West.

In 1901 Ayer received requests to lend
both MacNeil's *Moqui Runner* and a selection
of Burbank's paintings to the Pan-American
Exposition in Buffalo. William A. Coffin, the
exposition's director of fine arts, asked
MacNeil to submit work for the main art
display. Busy with a commission to model
sculptures for the exposition's Anthropology
building, the artist turned to Ayer for assis-
tance: "I have no more of that pet Indian
Runner left and here at the Buffalo Exhibit
Mr. Coffin has asked if it is not possible to
secure one for the Fine Arts Exhibit."[48] Ayer
appeared more than willing to accommodate
the request and instructed his secretary to

portraits was exhibited in 1898 at the
Thurber Art Galleries in Chicago, the cata-
logue's entries explained the symbolic impor-
tance of almost all of the carefully rendered
elements.[45] Furthermore, the June 1899 issue
of the art journal *Brush and Pencil* published a
lithograph of Ko-pe-li (fig. 87) accompanied
by a profile of the famed holy man written
by Walter Fewkes, the distinguished
Smithsonian anthropologist who had wit-
nessed the same performance of the Snake
Dance as MacNeil.[46] Fewkes's account of the
Snake Chief, which included a detailed
analysis of his ceremonial makeup and cos-

send the sculpture to Buffalo.[49] A few days later, A. L. Benedict, organizer of the exposition's anthropology display, wrote to Ayer requesting a loan of Burbank's Indian portraits. In addition to the usual collection of artifacts arranged geographically, Benedict planned to show oil paintings of various racial types set against a colorful, abstract backdrop.[50] As Benedict explained to Ayer:

> The department of Ethnology and Archaeology of the Pan-American Exposition has set aside an Art Gallery entirely distinct from the main Art Building of the Exposition for the purpose of presenting painted portraits and photographs of typical Indians and works of art reproducing, as faithfully as possible, the modes of life, costumes and occupation of the aborigines. A number of well-known artists have already signified their willingness to contribute to this branch of the department of Ethnology and Archaeology and it is desired that others should do so.[51]

Ayer fully supported the idea and again instructed his secretary to make a selection of twenty representative Indian portraits by Burbank.[52]

Several years later, when deciding how to disburse portions of his collection among Chicago institutions, Ayer viewed a natural history museum as the appropriate setting for Burbank's art work. In 1907 he promised a group of eight portraits relating to the Hopi Snake Dance to the Field Museum. However, he later rescinded the gift and instead sold the works in 1909 to Stanley McCormick, who had sponsored an important anthropological expedition to study the Hopi tribe.[53] Ultimately McCormick donated them to the Field Museum for display in the Hopi Room.

Although Burbank continued to produce work in this vein well into the twentieth century, MacNeil became dissatisfied

with documentary accuracy as an index of value. During his time in Rome, he had come under the influence of a wide circle of sculptors and a rich variety of Classical artistic sources, and he increasingly felt the need to reach beyond the merely representational. Charles Caffin, one of America's more prolific art critics, expressed the challenge MacNeil discovered in Rome. Caffin called for every artist, but especially sculptors, to use imagination to dig beneath the superficial trappings of realism toward some greater ideal, though this did not necessarily imply idealized subject matter. "We have a right to expect in the artist," he stated, "that degree of imagination which can penetrate beyond the outer integument of his subject, and find inside the tailor-made or millinery outworks the man or woman, the revelation in the flesh, however infinitesimally fractional, whether divine or devilish, of infinity."[54]

MacNeil and his one-time colleague took increasingly different views. From Burbank's perspective, MacNeil's exit to Europe—and, by extension, his formal and imaginative experimentation—could only diminish the ethnographic sincerity of his sculpture. In an 1898 letter to Ayer, Burbank expressed his concern over MacNeil's European pilgrimage as part of a defense of his own project:

> Suppose you have seen MacNeil. What in the world kind of Indian sculpture does he want to do at least 5000 miles away from his models? He ought to be here this very minute with the Indians. I have no patience with American Artists who go to Europe for natives to paint when in our own country we have natives that can not be equaled in color in composition any other place in the world. But then I am glad it is just as it is as I have the whole splendid field to myself and inside of two years it won't be worth while to paint the Indians as

he will be the same as a white man.
All his Indian clothes will be gone.
It is that way now with the majority
of Indians.[55]

MacNeil, for his part, suspected that art dedi-
cated solely to "salvage ethnology" was des-
tined to be relegated to a frozen past in the
natural history museum. He increasingly held
a higher, more idealistic goal for his sculp-
ture. Even his *Moqui Runner,* successful as it
was in the patronage and institutional orbit of
Chicago, had distinct limitations. No matter
how many national exhibitions he sent it to,
MacNeil had to take seriously his trusted
friend Lorado Taft's criticism of the piece. "Its
beauty is that of good construction and fine
modeling," Taft observed in 1903. "While
poetically delinquent and void of ideality," he
continued, "the figure might also possess an
ethnological interest if it bore the character-
istics of the race it purports to represent."[56]
MacNeil's sculpture failed on two fronts: it
was neither painstakingly real in its ethno-
graphic details nor sufficiently idealized to
secure broad aesthetic appeal. Moreover, Taft
seemed to imply, if the sculpture merely
referred to the ritual that it represented as an
index of meaning, it could not convey a
more universal message.

Perhaps Taft's comments motivated
MacNeil, who in 1904 transformed *The
Moqui Runner*'s central imagery by removing
the snakes, adding a spear and charging
buffalo, and enlarging the work to monu-
mental size. Modeled in his new studio in
College Point, New York, and now called
Physical Liberty, the 16-foot-tall cement
sculpture (fig. 88) was part of MacNeil's
contribution to the 1904 Louisiana Purchase
Exposition in St. Louis. Distanced from the
conventions of a specific ethnographic ritual,
the sculpture emphasized physical strength,
a positive social value that linked "primitive"
Indian lifestyles to contemporary Anglo-
American culture. Critics by and large
recognized the effectiveness of MacNeil's
translation. "Having an active imagination,"

wrote Harriet Warner Chapin, "MacNeil
owes much of his successful work to Indian
motives . . . *Physical Liberty* [is] a group
intensely ideal as well as realistic."[57]

No work by MacNeil was better posi-
tioned to bridge the real and the ideal than
The Sun Vow, especially as exhibited at the
1904 St. Louis world's fair. In the final project
required by the Rinehart Scholarship,
MacNeil had returned to the conception of
his first Indian project in Chicago, *The Vow of
Vengeance.* He premiered the original plaster
of *The Sun Vow,* along with a bronze cast of
The Moqui Runner, at the 1900 Exposition
Universelle in Paris, where it won a silver
medal. Shipped back to the United States,
The Sun Vow became something of an exhibi-
tion piece that impressed audiences in
Chicago in 1901, where Howard Van Doren
Shaw acquired the first bronze, cast in New
York by Roman Bronze Works. (It also
appeared that year in the Pan-American
Exposition in Buffalo, where again it was
exhibited along with *The Moqui Runner,* lent
by Ayer.) Chicago audiences responded to
The Sun Vow with enthusiasm and pride, feel-
ing responsible for MacNeil's professional
advent. Shaw loaned his cast of *The Sun Vow*
to the Art Institute for much of 1901 and
1902, at which point director William French
convinced him to make a promised gift of
the work.[58] French's brother, the accom-
plished sculptor Daniel Chester French,
claimed in 1917 that the work was "one of
the very finest things ever done by an
American sculptor."[59] In his capacity as a
trustee of The Metropolitan Museum of Art,
he also commissioned a full-size bronze cast
of *The Sun Vow* from MacNeil in 1919.

The growing popularity of *The Sun Vow*
during the early twentieth century, leading
up to its exhibition in 1904 in St. Louis,
belied the quandary over the precise subject
of the work. Some who knew MacNeil
insisted that it was a Sioux ceremony, others a
Zuni, and still others just a general rite of
passage without a specific Indian referent.
Indeed, MacNeil added to the confusion

Figure 88. Hermon Atkins MacNeil (American, 1866–1947). *Physical Liberty,* modeled 1903. Cement, H. 16 ft. (4.9 m). Photograph in "Sculpture for the St. Louis World's Fair," *Brush and Pencil* 13 (December 1903), p. 229. Thomas J. Watson Library, The Metropolitan Museum of Art, New York

years later by suggesting that perhaps the anthropologist Frederick Hodge had told him of this ritual, or maybe he (MacNeil) had just made it up. "Primarily," MacNeil said, "my interest was in the contrast of closing age and opening youth, and that I believe is what (unconsciously) interests most people."[60]

MacNeil's insistence that perhaps the most appropriate reading was universal—focusing on the exchange between generations—did not exempt it from the social and political issues relating to the Indian in 1904. The Native American displays in St. Louis, particularly those mounted by the anthropology department, offered broad-ranging views not only of the ethnographic past but also of

the contemporary Indian in a state of civic transformation. William J. McGee, the fair's head anthropologist, designed the display as a mock-up of Western reservation lands. Representatives of various tribes lived at the base of a raised hillock in simulated dwellings, such as the Pawnee mud hut. These dwellings were only a shadow of an ethnographic past, however. At the top of the hill, spatially and symbolically above the simulated reservation, was the United States Indian School (fig. 89). After all, school was where much of the hard work of "Americanization" took place, through the imposition of Anglo clothing and hairstyles on the younger generation. "The school

UNITED STATES INDIAN SCHOOL BUILDING FOR EXHIBITS OF INDIAN INDUSTRIES.

Figure 89. *United States Indian School Building for Exhibits of Indian Industries*. Photograph in Mark Bennitt, ed., *History of the Louisiana Purchase Exposition* (St. Louis: Universal Exposition Publishing Co., 1905), p. 672. General Research Division, The New York Public Library, Astor, Lenox and Tilden Foundations

tells a living narrative," wrote McGee, "the race narrative of savages made, by American methods, into civilized workers."[61]

The prevalence of this theory of assimilation suggests a new interpretation of the "schooling" depicted in *The Sun Vow*. The exchange of knowledge between elder and youth could now be read as a two-way street. Basic elements of native ritual are preserved in the work's ethnographic narrative; at the same time, as the anthropologist Charles Carson observed more generally, the sculpture demonstrates that "the way to win the confidence of those untutored Indians was through their little children."[62] The absorption process enacted by education, for Indians or the foreign-born alike, exerted social pressures in more ways than just clothing and customs.

Texts in social anthropology, such as John Common's 1904 study *Races and Immigrants in America,* used photographs to reinforce the idea that a dominating Anglo environment would inevitably cause physiological change as well. Oronhyatekha, a Mohawk who was the first academically accredited Native American medical doctor (fig. 90), was singled out in Common's book as having had an education that followed the model necessary for assimilation. After attending a reservation industrial school, he matriculated at Kenyon College in Ohio before finally studying medicine at the University of Toronto. When *Races and Immigrants in America* was published, Dr. Oronhyatekha had already founded an orphans' home and fought against discrimination through his office as supreme chief

DR. ORONHYATEKHA
MOHAWK INDIAN, LATE CHIEF OF ORDER OF FORESTERS

Figure 90. *Dr. Oronhyatekha, Mohawk Indian, Late Chief of Order of Foresters.* Photograph in John R. Commons, *Races and Immigrants in America* (New York and London: Macmillan, 1907). General Research Division, The New York Public Library, Astor, Lenox and Tilden Foundations

Figure 91. Hermon Atkins MacNeil (American, 1866–1947). Christmas card, 1922. Hermon Atkins MacNeil Papers, 1885–1947, Archives of American Art, Smithsonian Institution, Washington, D.C.

ranger of the Independent Order of Foresters. One photograph in the book portrays this distinguished civic leader not as a "savage" dressed in native costume but as a well-coiffed gentleman.

Whereas in *The Vow of Vengeance* physiognomy signified savagery, the faces in *The Sun Vow* (like the photograph of Dr. Oronhyatekha) seem to suggest a more "evolved" state. Critical responses to the sculpture, both before and after the St. Louis fair, made a point to praise this work as a "fine representation of essential idealism" that was "distinctly American," a quality that could be found most noticeably in "faces of this group."[63] The tribal elder who so lovingly embraces his young protégé has features that follow the then accepted racial standards for the Indian: wide forehead and chin, and a large flat nose. Although the youth's features also appear "Indian," his more finely pointed chin and aquiline nose are distinctly Anglicized. MacNeil had long made a point of the impact that seeing antiquities in Rome had had on his work, and *The Sun Vow*'s perplexing visual effect may be partly a result. But it is hard not to see in this gradual physiological change—cast in bronze, placed

in major urban art collections, and later transformed by MacNeil into a folksy Christmas card (fig. 91)—an effort to demonstrate that the Indian had not vanished, rather he had simply become more like every other white American. Just before MacNeil had his patron in Chicago (Howard Van Doren Shaw) send *The Sun Vow* to St. Louis, Lorado Taft made a provocative statement that seems a suitable conclusion: "The expressions of the two faces are remarkably good, the old man's earnest squinting in the light being extremely realistic; while the pose of the youth, savage though he be, has in it something very winning."[64]

The author is indebted to numerous individuals for their assistance in writing this essay, especially Judith Barter, Janis Conner, Jennifer Downs, Alice Duncan, Janet Headley, Paula Lupkin, Joel Rosenkranz, and Britt Salvesen. A portion of this essay appears in modified form in Judith A. Barter, *Window on the West: Chicago and the Art of the New Frontier, 1890–1940,* exh. cat. (The Art Institute of Chicago, 2003).

1. Charles Francis Browne, "H. A. MacNeil," *Arts* 3 (October 1894), p. 102.

2. MacNeil to Miss Barton, May 3, 1937, MacNeil file, Conner-Rosenkranz, New York.

3. Alice Ayes and Susan Moon, *Ragdale: A History and Guide* (Berkeley, Calif.: Open Books, 1990), p. 29.

4. Christie's, New York, sale cat., December 4, 1987, no. 154. The Art Institute's cast of *The Vow of Vengeance* was owned by a collector in Winnetka, Illinois.

5. "Some Recent Work by H. A. MacNeil," *Brush and Pencil* 5 (November 1899), p. 68.

6. Jean Stansbury Holden, "The Sculptors MacNeil: The Varied Work of Mr. Hermon A. MacNeil and Mrs. Carol Brooks MacNeil," *World's Work* 14 (October 1907), p. 9409.

7. Browne, "H. A. MacNeil," p. 125.

8. MacNeil, "Autobiographical Sketch," quoted in Erwin Millard Breithaupt Jr., "The Life and Works of Hermon Atkins MacNeil" (master's thesis, Ohio State University, 1947), p. 50.

9. William A. Coffin, "The Columbian Exposition. I. Fine Art: French and American Sculpture," *Nation* 57 (August 3, 1893), p. 81.

10. James L. Riedy, *Chicago Sculpture* (Urbana: University of Illinois Press, 1981), p. 34.

11. William Howe Downes, "Cyrus E. Dallin: Sculptor," *Brush and Pencil* 5 (October 1899), p. 11.

12. Tree, quoted in ibid., p. 12.

13. *History of the World's Columbian Exposition* (New York: D. Appleton and Co., 1897), p. 319.

14. The relationship of craft to evolutionary development was most widely promoted by Lewis Henry Morgan, the father of modern anthropology. For a discussion of this theory in relation to the fine arts, see Thomas P. Somma, "The Myth of Bohemia and the Savage Other: Paul Wayland Bartlett's *Bear Tamer* and *Indian Ghost Dancer*," *American Art* 6, no. 3 (summer 1992), p. 26.

15. Rossiter Johnson, ed., *The History of the World's Columbian Exposition Held in Chicago in 1893* (New York: D. Appleton and Co., 1897), vol. 2, p. 349.

16. Richard White, "Frederick Jackson Turner and Buffalo Bill," in *The Frontier in American Culture,* ed. James R. Grossman, exh. cat. (Chicago: Newberry Library, 1994), p. 29.

17. MacNeil, quoted in J. Walker McSpadden, *Famous Sculptors of America* (New York: Dodd, Mead and Co., 1924), p. 312.

18. Frederic Remington, *John Ermine of the Yellowstone* (New York and London: Macmillan Co., 1902; reprint, Ridgewood, N.J.: Gregg Press, 1968), p. 112, quoted in Alexander Nemerov, *Frederic Remington and Turn-of-the-Century America* (New Haven: Yale University Press, 1995), p. 10.

19. Edward E. Ayer, "North American Indians and Their Treatment," typescript, Edward E. Ayer Papers, The Newberry Library, Chicago (hereafter cited as Ayer Papers), folder 53.

20. The Hopi bride life group was part of the Field Columbian Museum's concentrated study of Hopi life and culture during the early twentieth century that resulted in a series of exhibitions overseen by the anthropologists George Dorsey and H. R. Voth. For a description of these, see Barton Wright, *Hopi Material Culture: Artifacts Gathered by H. R. Voth in the Fred Harvey Collection* (Flagstaff, Ariz.: Northland Press and the Heard Museum, 1979), pp. 4–5.

21. Susanne Belovari, "Invisible in the White Field: The Chicago Field Museum's Construction of Native Americans, 1893–1996, and Native American Critiques of and Alternatives to Such Representations" (Ph.D. diss., University of Illinois at Urbana-Champaign, 1997), p. 54.

22. For a brief history of the acquisition of this group of paintings, see George I. Quimby, *Indians of the Western Frontier: Paintings of George Catlin* (Chicago: Natural History Museum, 1954), pp. 6–7.

23. "Famous Painters of Indians: National Individuality Expressed in Art," *Chicago Times Herald,* March 15, 1896, p. 5.

24. Richard Bock, *Memoirs of an American Artist: Sculptor Richard W. Bock,* ed. Dorathi Bock Pierre (Los Angeles, Calif.: C. C. Publishing Co., 1989), p. 51.

25. William M. R. French, "Art of the Year: Record of the Exhibitions and Achievements—Chicago's Possibilities," *Chicago Record Herald,* January 1, 1896, p. 3.

26. Hamlin Garland, "Art Conditions in Chicago," in

The United Annual Exhibition: The Palette Club and the Cosmopolitan Art Club (Chicago: Art Institute of Chicago, 1895), p. 9.

27. Hamlin Garland, quoted in Lonnie E. Underhill and Daniel F. Littlefield Jr., "Introductory Survey of Garland's Writings on the American Indian," in *Hamlin Garland's Observations on the American Indian, 1895–1905* (Tucson: University of Arizona Press, 1976), p. 12.

28. Ibid., p. 13.

29. Ibid., p. 14.

30. MacNeil, "Autobiographical Sketch," cited in Breithaupt, "Hermon Atkins MacNeil," p. 52.

31. "Local Tone," *Arts* 4 (December 1895), p. 152.

32. *Catalogue: Fifth Annual Exhibition of the Cosmopolitan Art Club,* exh. cat. (Chicago: Art Institute of Chicago, 1896), p. 62. The works that MacNeil exhibited included *Cowboy* (no. 9), *Quong* (no. 10), *Acoma Dancer* (no. 11), *Indian Bust* (no. 12), *An Ute Madonna* (no. 13), and *Manuelito* (no. 14).

33. For the first influential scientific study of the Hopi Snake Dance, see John Gregory Bourke, *The Snake-Dance of the Moquis of Arizona* (New York: Charles Scribner's Sons, 1884).

34. "Sculptors at the American Art Exhibition," *Arts* 4 (November 1895), p. 150.

35. "Local Tone," p. 186.

36. "Cosmopolitan Art Club," *Arts for America* 5 (April 1896), p. 91.

37. *A Catalogue of Furniture and Decorative Art Objects Formerly the Property of Mr. Edward E. Ayer* (Chicago: Grant Art Galleries, 1934), nos. 990, 991.

38. MacNeil, "Autobiographical Sketch," cited in Breithaupt, "Hermon Atkins MacNeil," p. 52.

39. Breithaupt, "Hermon Atkins MacNeil," p. 14.

40. Burbank to Ayer, December 21, 1898, Ayer Manuscript 120, The Newberry Library, Chicago, box 1, folder 14.

41. For the provenance of the *Moqui Runner* in Lake Geneva, Wisconsin, see Sotheby's, New York, sale cat., May 25, 1994, no. 40. The Metropolitan Museum of Art also owns a cast, titled *The Moqui Prayer for Rain* (1978.513.6).

42. The loan of *Moqui Runner* to the Art Institute was made permanent in 1924, when Ayer presented it as a year-end gift.

43. For the most complete study of Burbank's career, see M. Melissa Wolfe, *American Indian Portraits: Elbridge Ayer Burbank in the West (1897–1910),* exh. cat. (Youngstown, Ohio: Butler Institute of American Art, 2000).

44. Burbank to Ayer, March 20, 1898, Flagstaff, Arizona, Ayer Manuscript 120, The Newberry Library, Chicago, box 1, folder 15.

45. *Portraits of Indians by E. A. Burbank,* exh. cat. (Chicago: Thurber Art Galleries, 1898).

46. J. Walter Fewkes, "Kopeli: Snake Chief at Walpi," *Brush and Pencil* 4 (June 1899), p. 164.

47. Charles F. Browne, "Elbridge Ayer Burbank: A Painter of Indian Portraits," *Brush and Pencil* 3 (1898), p. 33.

48. MacNeil to Ayer, May 15, 1901, Ayer Papers, folder 6.

49. Clara Smith to Charles C. Curran, June 21, 1901, Ayer Papers, folder 6.

50. Robert Rydell, *All the World's A Fair: Visions of Empire at American International Expositions, 1876–1916* (Chicago: University of Chicago Press, 1984), p. 137.

51. Benedict to Ayer, undated [1901], Ayer Papers, folder 6.

52. Clara Smith to A. L. Benedict, March 12, 1901, Ayer Papers, folder 6.

53. Ayer to F. Skiff, Field Museum, January 9, 1909, Registrar files, Anthropology Department, Field Museum, Chicago.

54. Charles Caffin, *American Masters of Sculpture; Being Brief Appreciations of Some American Sculptors and Some Phases of Sculpture in America* (1903; New York: Doubleday, Page, and Co., 1913), p. 226.

55. Burbank to Ayer, December 21, 1898, Ayer Manuscript 120, The Newberry Library, Chicago, box 1, folder 14.

56. Lorado Taft, *The History of American Sculpture* (1903; rev. ed., New York: Macmillan Co., 1924), p. 442.

57. Harriet Warner Chapin, "Hermon Atkins MacNeil," *Pacific Monthly* 15 (April 1906), p. 412.

58. "Last Will and Testament of Howard Van Doren Shaw," April 22, 1915, pp. 1–2, The Shaw-Wells Families, series II (1885–1926), Chicago Historical Society, box 7, folder 8.

59. French to Edward Robinson, June 25, 1917 (copy), Daniel Chester French Family Papers, Manuscript Division, Library of Congress, Washington, D.C., quoted in Thayer Tolles, ed., *American Sculpture in The Metropolitan Museum of Art, Volume II: A Catalogue of Works by Artists Born between 1865 and 1885* (New York: The Metropolitan Museum of Art, 2001), p. 478. The Metropolitan Museum had owned a reduction of the sculpture since 1906 but sold it in 1921.

60. MacNeil to Miss Barton, May 3, 1937, MacNeil file, Conner-Rosenkranz, New York.

61. W. J. McGee, "Strange Races of Men," *World's Work* 8 (August 1904), p. 5188.

62. Charles Carson, "The Indians as They Are," *Catholic World* 68 (November 1898), p. 156.

63. For "fine representation of essential idealism," see Holden, "The Sculptors MacNeil," p. 9415. For "distinctly American" and "faces in the group," see Rilla Evelyn Jackman, *American Arts* (Chicago: Rand McNally and Co., 1928), p. 342.

64. Taft, *History of American Sculpture,* p. 444.

Alexis L. Boylan

"The Spectacle of a Merely Charming Girl": Abastenia St. Leger Eberle's *Girl Skating*

In a *Washington Post* article of 1916 that prominently illustrated Abastenia St. Leger Eberle's *Girl Skating* (fig. 92), the artist was asked to discuss the question, "What is true art?" The problem, she responded, was that "a great part of the world is blind to beauty. People seek to find beauty where it is foreign to them. Beauty is a far-off illusion, alien, distant. It exists in places where one has never been; it is a condition of life one does not enjoy. It is something one does not possess."[1] Eberle argued that one must seek out beauty not only in the elite and exotic locales of the rich, but in working-class urban neighborhoods, such as New York's Lower East Side, where she lived. All around her, she believed, the beauty of life was reflected in everyday scenes of children running and playing or women moving through the streets. For Eberle, these moments of poor, working-class urban life were timeless, providing the human experiences she claimed "probably inspired . . . the most glorious pieces of classical art." Her challenge as an artist, Eberle held, was to harness the beauty and the thirst for life that was hidden behind the shabby facades of her neighborhood. Her quest was to discover "what could inspire me in the spectacle of a merely charming girl?"

Eberle's turn of phrase "the spectacle of a merely charming girl" is revealing, as it denotes both her hopes for the reception of her sculpture as well as the limitations that women artists encountered in the first two decades of the twentieth century. *Girl Skating,* one of Eberle's most enduring statuettes, is representative of the artist's oeuvre, which in theme consistently focused on the lives of young girls. As the embodiments of their elders' day-to-day worries and aspirations for the future, children have always served as metaphors of the nation.[2] This symbolism was particularly acute in the first decades of the twentieth century, but, not surprisingly, most of the political, social, and artistic concern for children focused on the growth and welfare of boys. Eberle's sculptures of girls have traditionally been categorized in the same genre as the images of mothers and children produced by other women sculptors of her day, or as part of the socially progressive agenda pursued by Ashcan school artists.

Eberle's images of girls break from both of these groups insofar as they reflect her assimilation of ideas from the growing women's movement in an attempt to counter what was a popular silence concerning the lives of impoverished, urban girls. Eberle's positive, even aggressively upbeat works proclaim her desire to envision new opportunities for this class of young women. At the same time, however, they also reinforced traditional middle-class codes of behavior. Such dueling pressures played upon Eberle's professional career as well. Although her art and political involvements pointed toward a new acceptance of women artists, members of the press nevertheless identified her in the traditional role of "mother" to her child sculptures, and as a surrogate mother to the children who served as her models. As a con-

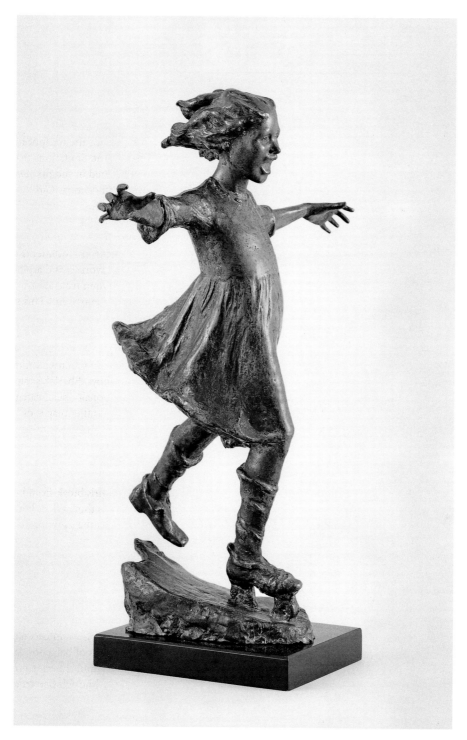

Figure 92. Abastenia St. Leger Eberle (American, 1878–1942). *Girl Skating,* 1906.
Bronze, 13 x 11¼ x 6¼ in. (33 x 28.6 x 15.9 cm). The Metropolitan Museum of Art,
New York; Rogers Fund, 1909 (09.57)

Figure 93. Detail of *Girl Skating* (fig. 92)

York, where she could pursue further training in sculpture. In the autumn of 1899 Eberle enrolled in classes at the Art Students League. She was awarded a scholarship in her first year and soon established herself as a serious artistic presence. In her second year she studied with George Grey Barnard, a sculptor trained at the École des Beaux-Arts in Paris who worked in an expressive figural style. By all accounts Barnard was an inspiring teacher; he took Eberle under his wing, encouraging her art and even allowing her to teach some of his classes.[4] His emphasis on the human form was also a significant influence on Eberle, since she shared his interest in the emotive possibilities of figural sculpture, even though her subject matter, as well as her realist aesthetic, diverged from Barnard's own work.

Eberle's first notable recognition as an artist followed a collaboration with another young woman sculptor, Anna Vaughn Hyatt (later Huntington), whom she met in 1903. Hyatt also took classes at the Art Students League, and she later studied privately with sculptor Gutzon Borglum. The two became roommates in late 1903 and together produced a large sculpture, *Men and Bull* (1904, destroyed), for which Hyatt modeled the bull and Eberle the two men. The group was shown that year at the Society of American Artists exhibition and then at the Louisiana Purchase Exposition in St. Louis, where it earned a bronze medal. Although the collaboration was a productive one for both women, in 1906 their friendship dissolved and they parted ways.[5]

Eberle's art began to undergo a transformation at this time. After a brief trip to Italy in the autumn of 1907, she moved into studio space on West Ninth Street, a poorer, far more ethnically diverse neighborhood than the one in which she had been living. Eberle had spent that summer working at the Music School Settlement on the Lower East Side, which served more than five thousand local children. The experience left her with an intimate knowledge of the day-to-day lives of

sequence, Eberle and *Girl Skating*, although both vibrant "spectacles," were similarly constrained as being "merely charming."

Born in Webster City, Iowa, Eberle (1878–1942) began her artistic career far from the streets of New York.[3] As a child and young teenager, she aspired to a career as a professional musician, but as she grew older she focused her energies instead on sculpture. She took classes in modeling at the local YMCA and looked to monuments in the cemetery for inspiration. In 1898, her father, who was in the military, was transferred to Puerto Rico; Eberle's family relocated, and she seized the opportunity to move to New

Perspectives on American Sculpture before 1925

immigrant children and the urban poor.[6] At the same time, she was becoming more deeply involved with the women's suffrage movement. The principles of feminism and social justice would become increasingly important to Eberle, particularly in terms of her professional identity. She frequently exhibited her work in all-women shows, and she was a noted participant in suffragette marches. In interviews, she would often speak affectionately of settlement-house activist Jane Addams.[7] In short, Eberle's political identity was intricately tied to the way in which she positioned herself in the New York City arts community and in the press. Her perceptions of the people around whom she lived and worked also quickly found expression through her artistic production. Although she made several images of working women from her neighborhood, it was in her sculptures of children that she found her most arresting combinations of form, emotion, and social message.

Girl Skating, which was purchased by The Metropolitan Museum of Art in 1909, is one of the most successful of these images. The child's body is carefully articulated through her dress as the wind blows the stressed material against her (fig. 93). She extends her arms like wings, with fingers splayed wide as if to seize the thrill of the ride. Her torso is thrust forward; there is no fear or hesitation in her stance. Her legs are stationed in a balletic pose; one, on a single skate, is in firm touch with the ground, while the other looks to join her arms in flight. Her expression, mouth agape, captures the giddiness of a child, as her hair, tousled by the wind, whips around to the back of her head. This girl is uninhibited, restrained only by gravity. In an unambiguous emphasis on physicality and movement, Eberle shapes a new identity for this poor urban child, who, momentarily freed from some of her day-to-day concerns, experiences her body in ways that are liberating and joyful.

Eberle's *On Avenue A* (also known as the *Dance of the Ghetto Children*) (fig. 94), which

depicts two girls clasping hands and twirling one another, is similarly effusive. The girls' preadolescent bodies are clearly defined under their thin dresses, yet there is nothing lascivious about the sculpture. The tightness of the fabric only accentuates the full ruffles of their skirts and the elegant lines from their hands down to the stockings slipping down their calves. These girls, too, are totally uninhibited, each utterly engrossed with the other and in their dance.

Eberle's sculptures are similar to, and yet fundamentally distinct from, depictions of children by her contemporaries. As noted before, at the time it was not uncommon for women to choose other women or children as the primary focus for their work. Historically speaking, this was the most readily available source material for women artists, who were encouraged to explore domestic or decorative themes rather than venture into what was considered more "male-appropriate" subject matter, such as history or politics. Eberle's images of children only vaguely relate to the child sculptures of her female contemporaries, however. Bessie Potter Vonnoh, for example, prominently featured genteel women and children in such sculptures as *Enthroned* (fig. 95). Vonnoh's delicate piece—of a modern, Madonna-like mother cuddling her angelic children as they cling to the hem of her skirt—takes on a mythical quality. These children have no real personality or function other than as symbols of nurturing femininity. Vonnoh's mother and children are so tightly bound, and her modeling style so fluid, one can hardly discern the end of one body from the start of another. This mingling of forms encourages a view of children as mere components of the costume of motherhood, insignificant as individuals but nevertheless critical to women's domestic charm and authority. Eberle's sculptures of Lower East Side girls, in contrast, focusing on the emotions of the subjects, refuse these easy associations. This is not to argue that Eberle's sculptures are not symbolic in function; they certainly are.[8] Rather, they push the viewer

Figure 94. Abastenia St. Leger Eberle (American, 1878–1942). *On Avenue A (Dance of the Ghetto Children),* 1914. Plaster, H. 14½ in. (36.8 cm). Kendall Young Library, Webster City, Iowa

Figure 95. Bessie Potter Vonnoh (American, 1872–1955). *Enthroned,* 1902; this cast, 1906. Bronze, 12 x 8 x 10 in. (30.5 x 20.3 x 25.4 cm). The Metropolitan Museum of Art, New York; Gift of George A. Hearn, 1906 (06.298)

to confront the children's class position as well as their physicality and individuality.

Child subjects were hardly the exclusive domain of women artists. The Ashcan school, a group of social realist painters who, like Eberle, lived and worked in Lower Manhattan in the first decade of the twentieth century, also depicted children as part of their collective agenda to portray everyday life in New York. Such is the case in George Bellows's *Tin Can Battle—San Juan Hill, New York* (fig. 96), which incorporates another prominent early-twentieth-century preoccupation: the function of play in the

Figure 96. George Bellows (American, 1882–1925). *Tin Can Battle—San Juan Hill, New York,* 1907. Crayon, ink, and charcoal on paper, 21 x 24 1/2 in. (53.3 x 62.2 cm). F. M. Hall Collection, Sheldon Memorial Art Gallery, University of Nebraska, Lincoln

lives of children, again particularly boys. The popular theories of G. Stanley Hall, a professor of psychology at Johns Hopkins University, encouraged a public fixated on the state of the nation's "manhood" to recognize links between the ways in which boys were encouraged to play and the kind of men they would grow into.[9] Boyhood, Hall argued, is a stage of primitive savagery that boys need to experience through play in order to mature into civilized adulthood. As Hall conceived it, this evolution also had significant racial implications. He held that the so-called problem with ethnic and racial

minorities was that they, as races, never evolved from the state of childlike barbarism into the civilized state of white manhood.[10] Bellows's *Tin Can Battle* seems to illustrate this theory, as the boys depicted in the street engage in primal aggression in the form of a mock battle. By using children from the slums as his subjects, Bellows accessed the fears that his upper- and middle-class audiences had about race, immigration, and poverty. Bellows's image never really commits itself either way: these boys may be "evolving" through play, or they may be unsupervised children learning "deviant"

behavior.[11] Through this pictorial ambiguity, Bellows encourages both readings, casting an anxious and tentative glance over the future prospects of these young boys.

In the rare instances when the issue of girls' play came to the fore of popular discussion, medical experts and cultural critics agreed that a girl's place was in the home. To encourage sports or organized play was pointless, for, as Luther Halsey Gulick, a prominent educator and friend of G. Stanley Hall, argued, "athletics have never been either a test or a large factor in the survival of women, athletics do not test womanliness as they test manliness."[12] Womanliness, as conceived by Gulick and others, required neither the same attention nor guidance in its childhood stage. "The essential need for the girl, is not to be brave and loyal to the crowd. It is required of her first that she be loyal to the home. . . . That is her evolutionary stage."[13] It was assumed that girls should follow an untroubled trajectory from childhood to a position that, eventually, would focus on the maintenance of domesticity.

Female reformers did not look upon a girl's childhood with such disinterest. To them, women's physicality served as a cultural marker of the growing power of the women's movement and of changing ideas about the place of women in society as a whole.[14] Women's physical exercise and strength—which had been deemphasized during the Victorian era as being too "manly" and unsafe for middle-class and elite women, who were already burdened with "fragile" temperaments—was thus revived as a concept. The "New Woman," for example—a phrase coined by the writer and cultural critic Henry James to describe the modern woman of the early 1900s— readily engaged in physical activity. This attention to women's physical well-being translated into concern for girls as well, as physical education classes were increasingly integrated into girls' public school curricula. These years also witnessed the rise of girls' walking clubs and tennis teams, encouraged

no doubt by more competitive sports programs at all-women's colleges. Of course, these were not the girls that Eberle depicted in her sculptures, but this contemporary movement certainly informs a reading of her works.

The context of early-twentieth-century transformations in popular ideas about women and physicality necessitates a closer investigation of *Girl Skating* as well as Eberle's other images of urban girls. At the turn of the century, roller-skating was a common part of the iconography of leisure. Skating had become a popular pastime for upper-class young women in the 1880s, and by the 1890s the sport had spread to the middle class, with roller-skating rinks being built across the country.[15] William Glackens, himself an Ashcan school painter, depicted such a rink in *Skating Rink, New York City* (fig. 97), made the same year as *Girl Skating*. In Glackens's painting the sport is the prerogative of well-dressed adults: men and women who flirt, fall, and perform across the rink. This genteel, heterosocial adult pastime could not be further removed from Eberle's sculpture, both in its hint of sexuality and its class markers. To skate in a rink, a child would need money, first to enter the rink and then to rent the skates. Such is clearly not the case with Eberle's young subject. The child has only one skate, on her front (right) foot; her left foot is lifted back so as not to slow her descent down a hill of some sort, most likely an uneven street rather than a flat rink. She is dressed in a thin, plain dress, with her stockings falling down her legs. The overall effect emphasizes the girl's class position. As contemporary critic Donald Wilhelm noted, "Two roller skates mean, 'My father has enough money to buy me a pair;' one means 'I borrowed these for five minutes, and, goodness, I've got to use it.'"[16]

Yet it is from this very economic constraint, Eberle suggests, that girls' freedom emerges, as she explained in 1916: "The children who play in Central Park undoubtedly

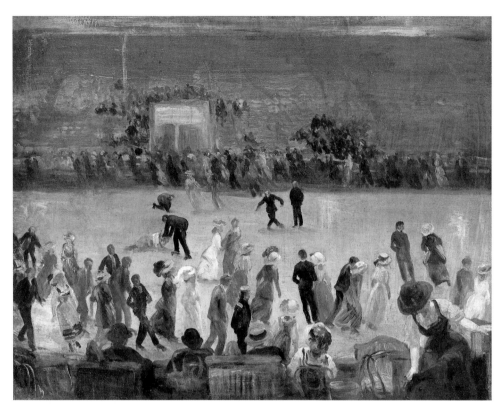

Figure 97. William Glackens (American, 1870–1938). *Skating Rink, New York City,* ca. 1906. Oil on canvas, 26 x 33 in. (66 x 83.8 cm). Philadelphia Museum of Art, Gift of Meyer P. Potamkin and Vivian O. Potamkin, 2000 (1964-116-7)

enjoy their play. But the dress they wear conceals their character. . . . Their spontaneity is repressed . . . the children of the East Side [are] not hidden by clothes, and their natural emotions are not restrained by the pretty curtseys taught by governesses. . . . They laugh loudly. They shout. They race on roller skates and dance unrestrainedly. . . . They express life."[17] Although a truism from this period held that the poor were "free" from the societal obligations and rules that bound the middle and elite classes, Eberle's language reveals a far different agenda. While she uses the term "children" as an apparently gender-neutral word, her attention to the constraints of clothing and mannered curtseys and her oblique reference to her own

sculptures, including *Girl Skating,* make clear that it was poor girls in whom she was most interested. By depicting and describing them, she expressed her own dissatisfaction with middle-class mores and trappings. It would seem, then, that in *Girl Skating* it is precisely the child's class position that enables her to gain joy and pleasure from her experience. Her poverty does not necessarily "free" her, but her exemption from repressive middle-class expectations does allow her to enjoy her body and the rush of speed. Eberle suggests the alternative to such repression, which she and her fellow feminist reformers sought, was to be found, and could be nurtured, in these young, poor girls of the Lower East Side.

Figure 98. Abastenia St. Leger Eberle (American, 1878–1942). *Girls Dancing*, 1907.
Bronze, 13 ½ x 7 ¼ x 7 5⁄16 in. (34.3 x 18.4 x 19.3 cm). The Corcoran Gallery of Art,
Washington, D.C.; Bequest of the Artist (68.28.4)

Another example of Eberle's attempt to reposition the identity of working-class girls through her sculpture is *Girls Dancing* (fig. 98), a statuette that reprises some of the physicality and unrestrained joy of *Girl Skating*. The movement of the two girls is powerfully articulated by Eberle through their kicked-up skirts, tousled hair, and uninhibited bodies. They are unself-conscious and seem to dance for no one but themselves. This image stands in sharp contrast to George Luks's *The Spielers* (fig. 99), in which Luks, another Ashcan school artist, portrayed two young girls similarly clasped together while dancing, but in a radically different context. Whereas Eberle emphasizes the self-motivation and insularity of the dancing girls, Luks's painting is about performance. His young girls have red-painted lips through which they smile artificially to the viewer, acknowledging their audience. After all, their dance was being paid for; "spielers" was a term for girls who walked the streets begging for money in exchange for a dance. Where Luks's image demands the spectator judge the girls (they are looking directly out at the viewer, who has no choice but to return their gaze and to access them), in Eberle's sculpture the viewer merely happens upon a captured moment in which the girls are seemingly unaware of their audience. Eberle thus fosters a sense of youthful innocence and abandon that encourages a sympathetic, almost sentimental reading.

In her work Eberle repeatedly refuted stereotypes of poor New Yorkers, or of early-twentieth-century city dwellers in general. Her subjects are not physically or mentally unhealthy; they are not begging or stealing; they are not lazy. In this way Eberle's sculptures of young girls break with the paintings of her Ashcan school contemporaries to relate a more complicated narrative of poverty and childhood. Eberle's girls, through their youth and class positions, seem to slip out of conventional gender roles and to evade the expectations of middle-class rules of decorum in a manner the artist clearly believed to be ideal. Critically, however, by removing the

Figure 99. George Luks (American, 1866–1933). *The Spielers,* 1905. Oil on canvas, 36 1/16 x 26 1/4 in. (91.6 x 66.7 cm). Addison Gallery of American Art, Phillips Academy, Andover, Massachusetts; Gift of an anonymous donor (1931.9)

girls from their surroundings, Eberle blunts and softens the edges of their poverty to focus on what she saw as their gifts: freedom from societal constraints, freedom with their bodies, and freedom to be themselves. This is a romanticization to be sure, but its function was not solely to foment sympathy. Rather, Eberle was harnessing the burgeoning hopes and expectations of the feminist movement onto the bodies of these young girls.

Figure 100. Jacob Riis (American, 1849–1914). *Minding the Baby, Cherry Hill,* ca. 1890. Gelatin silver print; original negative, 4 x 5 in. (10.2 x 12.7 cm). The Jacob A. Riis Collection, Museum of the City of New York (90.13.1.191)

The boundaries as well as the contradictions of Eberle's mixture of feminism and romantic imagery emerge perhaps most clearly in her depictions of young girls taking care of their siblings. The phenomenon of young girls left at home in charge of younger brothers and sisters while their parents went off to work was a point of crisis for both reformers and urban critics, such as yellow journalists and some politicians. Dubbed the "Little Mother Problem,"[18] this popular concern is evidenced by Jacob Riis's photograph *Minding the Baby, Cherry Hill* (fig. 100), in which an unkempt child, apparently not yet old enough to take care of herself, sits on the street holding a baby in her arms. Riis clearly uses the children to relay the tragedies of urban poverty. For Riis and his audience, however, the photograph not only reveals the degradations and inequalities of modern capitalism, it suggests the supposed barbarism and congenital inferiority of "new" immigrants. Children forced to care for other children reinforced stereotypes that immigrants and the working poor could not care for their own, and that their children would grow up to burden society at large. As one critic wrote in 1899, "of all the tragedies of child-life in New York City there is none so great as that of the Little Mother. . . . Herself needing a mother's care, her time is given up to the drudgery of 'minding the baby,' whose weight is sometimes more than her own. . . . What sort of womanhood can such a preparation produce?"[19]

Once again, Eberle approached the issue from a very different direction. In *Her Only Brother* (fig. 101), a much more controlled and contained composition than the exuberant *Girl Skating,* a girl no more than eleven or twelve holds a little boy in her arms, smiling as she gently places a kiss on his cheek. She is neatly dressed in a pleated skirt, and her hair is combed. In sharp contrast to the irrepressibly youthful figure in *Girl Skating,* this child is mature, affectionate, and attentive, a true model of caregiving. In the similarly composed *Little Mother* (fig. 102), Eberle again depicts the children exhibiting palpable affection. Although neither child is well dressed—the older girl's stockings are rolling down her leg and one of her shoes is unbuckled—the "little mother" holds tight to her infant charge. Both children have full, cherubic faces that exude not despair or malcontent but a contained, nurturing energy. Eberle produced several variations on the theme, and in each example the girls are decently dressed (never in rags), attentive, and postured. Once again, Eberle was defying popular visual associations to force audiences toward a broader awareness. In these statuettes, the girls stand as models for middle-class aspirations; they are not problematic, they are a source of sustenance and hope. Although Eberle's disavowal of middle-class mores on the one hand, and her promotion of maternal domesticity on the other, appear contradictory, it was a con-

Figure 101. Abastenia St. Leger Eberle (American, 1878–1942). *Her Only Brother,* 1919. Plaster, H. 16 in. (40.6 cm). Kendall Young Library, Webster City, Iowa

Figure 102. Abastenia St. Leger Eberle (American, 1878–1942). *Little Mother,* 1907. Plaster, H. 13 ½ in. (34.3 cm). Kendall Young Library, Webster City, Iowa

tradition common to much early-twentieth-century Progressive feminism. The need to find new ways to express one's feminine self, to experience one's body and mind as free and unfettered, was crucial to the political and social desires of feminists and suffrage activists. At the same time, mothering, or maternalism, was seen as the source of women's private power and of their public claims to political authority.[20] Thus, through a combination of images—of unruly and vibrant girls, and of caring, motherly caretakers—Eberle managed to express both the power and the contradictions of the feminist reform movement of which she was part.

It is all the more ironic, then, that the very constraints and contradictions Eberle sought to debunk through her work would come to define public perceptions of her as an artist. Eberle set herself a unique career path, eschewing more conventional markers of artistic success to focus her energies, artistic and otherwise, on politics and social reform. She lived her life as neither wife nor mother. She moved among downtown arts and activist communities, and she directed her own personal and business affairs from her studio on the Lower East Side. Yet later in her career, Eberle was cast in articles and photographs not as a bohemian or even remotely as a radical but, more often than not, as a maternal figure—as the mother-creator of her sculptures, and as a maternal presence in the lives of the children who modeled for her. Eberle's artistic and political convictions dissolve in this publicity; instead, her interest in the children is seen as deriving from personal relationships and motherly instinct. Eberle's life, thus compacted in the press, was distilled to a superficiality made palatable to a large audience. In the end, a woman who could have been seen as the "spectacle" of a radical female artist became, to borrow from Eberle, "a merely charming girl."

This critical shift has perhaps masked the complex political message of Eberle's art. Her insistent focus on young, urban girls as subject matter and her attempts to shift the dominant iconographic representation of these children reveal her desire to find both an artistic and a social voice as a woman artist. As Eberle herself suggested, "art is always far behind the times it reflects; it does not lead. But it should and can do both."[21] In *Girl Skating*, Eberle attempted to lead the viewer to conceive of this child not as a problem to be solved, nor as a social hurdle to overcome, but as a girl filled with vibrant potential, barreling into a life of opportunities.

1. "Which Is True Art?" *Washington Post,* February 6, 1916, p. 4.
2. Several recent exhibitions have investigated the relationship between the social construction of childhood and artistic production. See, for example, *The Preserve of Childhood, Adult Artifice and Construction: Images of Late-Nineteenth-Century American Childhood,* exh. cat., University Art Gallery (Binghamton: University Center at Binghamton, State University of New York, 1985); James Christen Steward, *The New Child: British Art and the Origins of Modern Childhood, 1730–1830,* exh. cat. (Berkeley, Calif.: University Art Museum and Pacific Film Archive, 1995); and Bruce Weber, *Ashcan Kids: Children in the Art of Henri, Luks, Glackens, Bellows, and Sloan,* exh. cat. (New York: Berry-Hill Galleries, 1998).
3. See Louise R. Noun, *Abastenia St. Leger Eberle: Sculptor (1878–1942),* exh. cat. (Des Moines, Iowa: Des Moines Art Center, 1980); and Janis Conner and Joel Rosenkranz, "Abastenia St. Leger Eberle," in *Rediscoveries in American Sculpture: Studio Works, 1893–1939* (Austin: University of Texas Press, 1989), pp. 27–34.
4. Noun, *Abastenia St. Leger Eberle,* p. 4. Of Barnard's teaching style, the sculptor Jacob Epstein wrote, "The students would gather around him, and as he was a man of great earnestness, he was very impressive." *Epstein: An Autobiography* (London: Vista Books, 1963), p. 10, quoted in Frederick C. Moffatt, *Errant Bronzes: George Grey Barnard's Statues of Abraham Lincoln* (Newark: University of Delaware Press, 1998), p. 213 n. 29.
5. Noun (*Abastenia St. Leger Eberle,* p. 5) has suggested that the cause for the rupture was rooted in disputes over money and politics. Eberle was obliged to support herself as a student, whereas Hyatt came from a wealthy family. Politics, however, may have caused the greater rift; Hyatt was a conservative woman who may have had difficulty coping with Eberle's growing interest in feminism and socialism.
6. Ibid., pp. 6–7.
7. See, for example, Christina Merriman, "New Bottles for New Wine: The Work of Abastenia St. Leger

Eberle," *Survey* 30 (May 3, 1913), p. 197: "Jane Addams' books have, more than anything else, she says, helped to clarify and mould her vision of the constructive part the sculptor may play in social readjustment."

8. In a 1937 letter Eberle noted her subjects were "people who were just enough apart from me to act as symbols, yet close enough to feel their common humanity." Quoted in Noun, *Abastenia St. Leger Eberle,* p. 7.

9. For a valuable assessment of Hall's impact on turn-of-the-century debates about gender and race, see Gail Bederman, *Manliness and Civilization: A Cultural History of Gender and Race in the United States, 1880–1917* (London and Chicago: University of Chicago Press, 1995), pp. 77–120.

10. See G. Stanley Hall, *Adolescence* (New York: D. Appleton and Co., 1905; reprint, New York: Arno Press and *New York Times,* 1969), vol. 2, pp. 648–748.

11. Marianne Doezema writes that Bellows employed this kind of political ambiguity in much of his work (and specifically in his pieces that focused on urban children) as a way to appeal to a broad audience. See Doezema, *George Bellows and Urban America* (New Haven and London: Yale University Press, 1992), esp. pp. 123–67.

12. Luther Halsey Gulick, *A Philosophy of Play* (New York: C. Scribner's Sons, 1920), p. 92, quoted in Benjamin G. Rader, "The Recapitulation Theory of Play: Motor Behaviour, Moral Reflexes and Manly Attitudes in Urban America, 1880–1920," in *Manliness and Morality: Middle-Class Masculinity in Britain and America, 1800–1940,* ed. J. A. Mangan and James Walvin (New York: St. Martin's Press, 1987), p. 129.

13. Luther Halsey Gulick, *The Healthful Art of Dancing* (New York: Doubleday, 1911), p. 160, quoted in Thomas Winter, "'The Healthful Art of Dancing': Luther Halsey Gulick, Gender, the Body, and Performativity of National Identity," *Journal of American Culture* 22 (summer 1999), p. 36.

14. For a general history of the changing physical and cultural ideal of women during this period, see

Martha Banta, *Imaging American Women: Idea and Ideals in Cultural History* (New York: Columbia University Press, 1987).

15. See Dwight W. Hoover, "Roller-Skating toward Industrialism," in *Hard at Play: Leisure in America, 1840–1940,* ed. Kathryn Grover (Amherst: University of Massachusetts, 1992), pp. 61–76.

16. Donald Wilhelm, "Babies in Bronze: The Life-Work of Miss Abastenia Eberle," *Illustrated World* 24 (November 1915), p. 330.

17. "Which Is True Art?" p. 4.

18. Ashcan artists frequently depicted the "Little Mother Problem" in much the same light. See Doezema, *George Bellows,* pp. 143–45.

19. E. Idell Zeisloft, ed., *The New Metropolis* (New York: Appleton, 1899), p. 565, quoted in ibid., p. 144.

20. Linda Gordon defines maternalists: "First, they regarded domestic and family responsibilities and identities as essential to the vast majority of women and to the social order, and strongly associated women's with children's interests. . . . Second, maternalists imagined themselves in a motherly role toward the poor. . . . Third, maternalists believed that it was their work, experience, and/or socialization as mothers that made women uniquely able to lead certain kinds of reform campaigns and made others deserving of help." Gordon, *Pitied but Not Entitled: Single Mothers and the History of Welfare, 1890–1935* (Cambridge, Mass.: Harvard University Press, 1994), p. 55. I would not argue that Eberle was a maternalist in the strictest sense, but certainly the gendered essentialism that informed many of her interviews reveals a familiarity with that feminist paradigm. See also Seth Koven and Sonya Michel, "Introduction: 'Mother Worlds,'" in *Mothers of a New World: Maternalist Politics and the Origins of Welfare States,* eds. Seth Koven and Sonya Michel (New York and London: Routledge, 1993), pp. 1–42.

21. "A Woman Sculptor Who Is 'Different,'" *New York Evening Sun,* May 28, 1913, p. 14.

Janis Conner

The Ethereal Icon: Malvina Hoffman's Worshipful Imagery of Anna Pavlova

The life and work of Malvina Cornell Hoffman (1885–1966) have been my special interests since the late 1970s, when I was the curator for her estate, a project that allowed me to study this important American artist in great depth. Granted access to all of the art and papers Hoffman had left to her heirs, I spent four years in a crowded and dusty warehouse room on Manhattan's Second Avenue becoming, in some ways, more acquainted with the details of her life than with the lives of people I actually knew. Her estate included a large body of art, comprising sculpture in varied media, plaster models, molds, and works on paper, as well as a trove of archival material, from photographs, negatives, and documentary films to financial records, letters, datebooks, and diaries.[1] As I mined the "Malvina lode," I gained a better understanding of this endlessly self-documenting, but also exasperatingly self-obscuring woman.

I have written about Malvina Hoffman (fig. 103) a number of times,[2] but until now I have never had an opportunity to relate some of the important formative aspects of her early career, aspects that are illuminated by her remarkable and entertaining diaries. In these and other personal writings, Hoffman, as a young adult, reveals an impressive capac-

ity for self-dramatizing and melodrama, often hilariously expressed. This over-the-top reaction to life, I believe, presaged her lifelong attraction to powerful, charismatic subjects, people whose lives were woven through with drama or tragedy, who stood bravely for a cause, or whose special talents made them objects of public admiration or erotic longing. Hoffman was aware of this aspect of her character, writing once, "Hero worship formed a major part of my emotional life."[3] Indeed, three busts by Hoffman in the collection of The Metropolitan Museum of Art are portraits of such heroes, namely, the great Russian dancer Anna Pavlova (1881–1931), the primary focus of this essay; the Yugoslavian war hero Milan Pribićević (1877–1937); and the Polish musician and statesman Ignacy Paderewski (1860–1941).

A Modern Crusader (fig. 104), modeled in 1918, depicts Pribićević, a colonel who fought in the Serbian Army during World War I. Hoffman met him in 1916 through her older sister, Helen Draper, who was on the board of the American Red Cross, which was providing clothing and medical supplies to the Serbian cause. "When he told me his story and his plan to enlist the services of . . . Yugoslavs working in America to return with him and fight . . . to regain their lost country," Hoffman wrote, "I was fired with enthusiasm to help in any way."[4] Hoffman, who was an officer of the Yugoslav Relief Society, accompanied Pribićević when he spoke at rallies of his fellow countrymen in Pittsburgh and Cleveland. She found herself thrilled by the charismatic effect Pribićević had on the crowds of immigrant workers who rushed the stage after his stirring speeches to shake his hand or hoist him on their shoulders in a display of patriotic fervor. During this moment of shared purpose, it seems likely that there was a brief romance

between Hoffman and the Serbian patriot, whom she portrayed three times. In the most successful of these (the Metropolitan's version), Pribićević wears a knitted "helmet" like those distributed to volunteers by the Red Cross. It effectively frames his deep-set eyes and blade-like cheekbones while suggesting, somewhat romantically, the chain mail worn by medieval warriors.[5]

Paderewski the Artist (fig. 105) was modeled in Hoffman's New York studio immediately after she returned from a recital by him at Carnegie Hall. To my eye it is the most affecting of the five different portraits Hoffman made of the great Polish statesman and musician. As a young girl Hoffman had been introduced to Paderewski by her father, Richard Hoffman, a professional pianist who knew and admired him. In later years Malvina found in Paderewski a heroic character who offered the warmth of friendship and the same kind of profound emotional association with music that she had shared with her father. The closeness of their relationship allowed her the pleasure of sitting amid an enthralled audience, all the while exquisitely aware that she was special to the adored performer on stage.

Hoffman began her career as a portraitist, and many of her portrayals are inventive and arresting evocations of her sitters' characters. Two of her earliest works, both modeled in 1910, are a bust in marble of her father (plaster version, New-York Historical Society)[6] and a head in bronze of Samuel Grimson (unlocated), an English violinist with whom Hoffman had a nineteen-year courtship and a twelve-year marriage. Later that year Hoffman presented photographs of these two works to Auguste Rodin, whom she met for the first time during an extended stay in Paris. (Rodin, an early influence who would become an important mentor to Hoffman, is

Figure 103. Malvina Hoffman and Anna Pavlova, Hartsdale, New York, ca. 1923–24. Copyprint made in 1984 from original photograph, ca. 1923–24. Malvina Hoffman Papers, Research Library, Getty Research Institute, Los Angeles (850042)

discussed later in this essay.) Both sculptures were accepted for exhibition in the 1911 Salon of the Société Nationale des Beaux-Arts, where the portrait of Grimson was awarded an honorable mention.

Despite her rather precocious success at the Salon, Hoffman emphatically proclaimed that portraiture would not be her primary genre. In a letter to Helen Draper in 1911, she wrote of being irked at having to rework a portrait bust: "I got sidetracked on the idea of busts—really they are not a possible profession for me."[7] One of the portraits she was struggling with depicted the American socialite and adventurer William Astor Chanler (1911); another was of the United

Figure 104. Malvina Cornell Hoffman (American, 1885–1966). *A Modern Crusader,* 1918. Bronze, 18¾ x 11½ x 10 in. (47.6 x 29.2 x 25.4 cm). The Metropolitan Museum of Art, New York; Gift of Mrs. E. H. Harriman, 1918 (18.122)

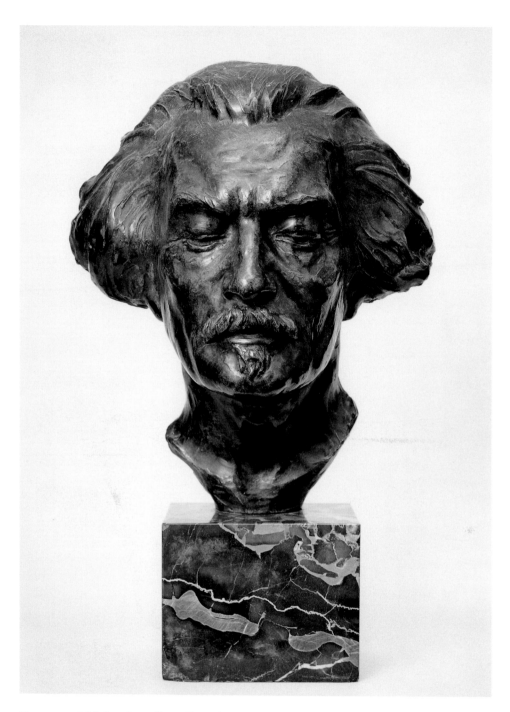

Figure 105. Malvina Cornell Hoffman (American, 1885–1966). *Paderewski the Artist,* 1923. Bronze, 16 x 13 ½ x 8 in. (40.6 x 34.3 x 20.3 cm). The Metropolitan Museum of Art, New York; Francis Lathrop Fund, 1940 (40.99)

Figure 106. Auguste Rodin (French, 1840–1917). *Right Hand; Left Hand; Right Hand; Right Hand,* possibly 1880. Plaster; greatest extension for each hand, 4 in. (10.2 cm); 1⅝ in. (4.1 cm); 2½ in. (6.4 cm); 3⅛ in. (7.9 cm). National Gallery of Art, Washington, D.C.; Gift of Mrs. John W. Simpson (1942.5.26)

States ambassador to France, Robert Bacon (1910–11, plaster versions of both, New-York Historical Society). These were especially prestigious commissions for a young artist newly arrived to the Paris scene, but Hoffman had entrée to the upper echelons of the American expatriate and diplomatic communities through her mother's family. Hoffman's background is worth touching upon because it illuminates her attraction to the disparate worlds of pedigreed society and the polyglot community of soldiers, explorers, poets, workers, and performers, all of whom were subjects of her art.

Hoffman was the product of both her mother's privileged New York City background and her father's theater-based lineage. Her mother, Fidelia Lamson, the daughter of a wealthy silk merchant, dismayed her society-conscious family by eloping with Richard

Hoffman, an immigrant pianist who came from a family of musicians and actors in Manchester, England. Malvina, the couple's fifth—and very unexpected—child, was born in 1885, when her father was fifty-three, an age that would have been considered old by the standards of the day.[8]

Once she had determined to be an artist, Hoffman received training from a number of notable instructors, including painters John White Alexander and Harper Pennington, and sculptors Herbert Adams, George Grey Barnard, and Gutzon Borglum, all of whom are represented in the Metropolitan's collection. Hoffman's predilection for three-dimensional representation became evident during a signal moment in 1909, when she saw sculptures by Rodin firsthand at the home of Katherine Simpson, a collector who had acquired more than twenty of the French master's works, including marbles, bronze casts, terracottas, and plaster studies (fig. 106). Simpson, who lived at 926 Fifth Avenue, a few blocks south of the Metropolitan Museum, generously made her collection available to any serious student. Hoffman later recalled her first visit to Simpson's home: "On the first floor were two or three glass cases filled with tiny studies in clay, terra cotta, and plaster. The infinitude of observation and knowledge embodied in these studies made the finished groups more eloquent. . . . When I was allowed to open the cases and examine these fragile objects in my own hands, the power and scope of Rodin's art took possession of me."[9]

In 1909, the year her father died, Hoffman received a gift from her godmother of a thousand dollars that bolstered her savings sufficiently to allow her and her mother to live in Paris for fourteen months. Determined in her ambitions to become an artist, she decided to seek out Rodin. Armed with a letter of introduction from Katherine Simpson and photographs of the portraits of her father and Sam Grimson, Hoffman met Rodin in 1910, when he was seventy years old (fig. 107).[10] At first awed by his presence,

she eventually grew at ease in their relationship and over time developed a proprietary, even protective affection for him. This was in many respects a reprise of her relationship with her father, who was seventy by the time Malvina was sixteen; she was accustomed to being beloved by an elderly man who was at once respected by the public and revered by his students.

For his part Rodin was sufficiently impressed by the young artist to invite her to bring her drawings and smaller models to his studios for occasional critiques. In Hoffman's diary is a record of one such encounter, when she had brought Rodin a plaster cast of a model of her hand for his review: "He examines it and mine very intently—each finger—une [*sic*] doux baiser."[11] During the same visit, Rodin remarked that Hoffman had become extraordinarily thin. She was, in fact, very thin, and for a number of reasons, among them a long-standing problem with anemia, her emotionally fraught and likely unconsummated affair with Sam Grimson, and her competing work schedule and social agenda. "Holding my wrists," she wrote of Rodin, "he says I am not built like other students, that I am a framework of the most fragile fabric—& that I should be cared for as such. When he told me I would consume myself if I did not find an outlet for my emotions, I turned to ashes on the spot."[12] Fortunately, only a few weeks earlier she had found such an outlet when she saw Anna Pavlova dance.

During a visit to London in July 1910, Hoffman had attended two evenings of ballet at the Palace Theatre. She recorded her response to this seminal experience in her diary: "For two nights, I have been out of my head during the performances of Russian dancing by the unapproachable miracles— Pavlova and Mordkin."[13] At the time Pavlova (fig. 108) had been touring continental Europe only since 1908, but she was already becoming one of the greatest dancers and celebrities of the twentieth century, a performer who had, as one writer put it, "a fer-

Figure 107. Malvina Cornell Hoffman (American, 1885–1966). *Portrait of Auguste Rodin,* 1913. Malvina Hoffman Papers, Research Library, Getty Research Institute, Los Angeles (850042)

vor about the very act of dancing that was akin almost to a religious mania."[14] Pavlova was a major factor in popularizing ballet, and her name remains synonymous with the term "prima ballerina."

Pavlova received her training in St. Petersburg at the Imperial Ballet School and danced at the Maryinsky Theatre until she left Russia. She was a traditionalist, and her programs reflected this conservative taste as well as her shrewd sense of what pleased her

Figure 108. Anna Pavlova in *La Fille Mal Gardée,* ca. 1912. Photograph in Keith Money, *Anna Pavlova: Her Life and Art* (New York: Alfred A. Knopf, 1982), p. 99.

the Maryinsky, the result of rigorous training combined with her ineffable, charismatic style.

When Hoffman first saw her in London, Pavlova was performing with her own troupe after having rejected the invitation of Serge Diaghilev to create the title role in the groundbreaking ballet *The Firebird*. She declined his offer after hearing the piano transcription of Igor Stravinsky's score, which she judged dissonant and ugly. It is an interesting insight that almost simultaneous with Pavlova's rejection of Stravinsky, Hoffman was spurning the paintings of Henri Matisse. In May 1910, after attending an exhibition of Matisse's work in Paris, Hoffman reported, "On entering I am struck dumb with horror and surprise—I feel utterly unable to cope with the walls. They writhe and scream from their frames in tones of violent chaos. I <u>cannot</u> understand it all—I am inwardly shocked beyond control—streaks of green paint laced over a face drawn in five great cruel dawbs [*sic*] of black inky line."[15] Hoffman and Pavlova shared an innately conservative taste and a dedication to the Romantic mode of expression. Hoffman, it must be remembered, was in Paris to study with Rodin, not to join forces with the vanguard of the modernist aesthetic.

There are no further reverberations from Hoffman's two momentous evenings at the Palace Theatre until a February 1911 diary entry in which she erupts in full cry: "Tomorrow I must trap some ideas—lash them in clay—decide on a definite piece of work—get away from portraits—do different groups—be free—oh God!"[16] She made a tiny ink drawing in her diary that was the first manifestation of the idea she was so desperate to try. That drawing, which she annotated "A week of Russian Dancers [.] I work them up—[.]"[17] (fig. 109), was the genesis of Hoffman's first dance sculpture and the germ of a much larger sculptural project she would work on for many years. In the six months since her first encounter with Pavlova's dancing, Hoffman's ideas had steeped sufficiently so that she could begin to tackle the subject

audience. There were scenes from the great classical ballets along with works specially choreographed for whatever resources and dancers were available to her, as well as a number of solos and pas de deux—wildly popular signature pieces that were very much akin to music-hall turns. The scores might have been banal and the choreography less than sophisticated, but with these dances Pavlova held her audiences in thrall. She performed these melodramatic concoctions with the same exquisite precision she had brought to her principal roles in grand productions at

Figure 109. Malvina Cornell Hoffman (American, 1885–1966). Diary entry with drawing of Anna Pavlova and Mikhail Mordkin performing *Autumn Bacchanale,* 1910. Ink on paper. Malvina Hoffman Papers, Research Library, Getty Research Institute, Los Angeles (850042)

in sculpture. Her diary entries over the following months record the growing momentum of her effort as she was swept up in the most exciting creative impulse she had yet to experience. March: "I work on Pavlova all AM." April: "Working daily on Russian Dancers with models." In June, she saw Vaslav Nijinsky perform with the Ballets Russes in Paris, and by July she was in the home stretch: "My dancers . . . won't dance together until after a few days of struggle." When the clay model was finally ready to be cast in plaster, she noted, "Off they go to Rudier [Foundry] and to bronze."[18]

Immediately upon her return to New York in August 1911, Hoffman struck a deal with Marcus & Co., a luxury emporium on Fifth Avenue, to take on consignment bronze casts of the new work, titled *Russian Dancers* (fig. 110). By the end of 1912 at least nine bronzes had been sold and a tenth cast given to Ambassador Bacon and his wife.[19] After making this deft business arrangement, Hoffman enrolled in anatomy classes at the Columbia University College of Physicians and Surgeons, where she learned to dissect human cadavers. Undertaken with the strong encouragement of Rodin, these demanding

studies were put to immediate and effective use in Hoffman's effort to grasp the complex workings of dancers' muscles and to translate this knowledge to her modeling.

By the summer of 1912 Hoffman had earned considerable money through sales of her sculpture, and she and her mother returned to Paris for three months. Soon after they arrived she took a cast of the *Russian Dancers* to Rodin, who, upon examining them, found the figures' expressions somewhat tortured and suggested "Tragedy" as an alternate title. His response understandably disturbed Hoffman, but he softened his remarks by explaining his belief that joy and tragedy were closely related and by praising her modeling.[20] The group was awarded a first prize in the 1912 summer Salon of the Société Nationale des Beaux-Arts. After that success, Hoffman immediately began work on a second sculpture she titled *Bacchanale Russe* (fig. 111). Like the earlier work, it was inspired by *Autumn Bacchanale,* the wildly popular pas de deux from a ballet called *The Seasons* that Pavlova and her partner danced at the end of nearly every performance. The authorship of this ballet is uncertain, but it was likely choreographed by

Figure 110. Malvina Cornell Hoffman (American, 1885–1966). *Russian Dancers,* 1911. Bronze, 10½ x 12½ x 6 in. (26.7 x 31.8 x 15.2 cm). Private collection

Mikhail Fokine, and it was performed to a score by Alexandre Glazunov. It was this pas de deux, so infused by erotic abandon, that had captured Malvina's imagination when she first saw it performed in 1910. To understand something of its extraordinary effect on audiences, one must imagine the beautifully muscled and handsome Mikhail Mordkin, barefoot and barechested, dancing with the sprite-like Pavlova, who was costumed in a short, filmy tunic, her head wreathed in roses. Bounding onto the stage to Glazunov's

pounding score, she flinging roses, the two dancers engaged in a frenzy of approach, rejection, and submission that ended with Pavlova's collapse into a sublimely exhausted little pile at the feet of her conquering partner.

Hoffman worked intently on the *Bacchanale Russe* during her brief stay in Paris in 1912. She hired models, often for twice-daily sessions, who were "on loan" from fellow sculptor Emmanuele Ordono de Rosales, an accomplished artist who also made

Figure 111. Malvina Cornell Hoffman (American, 1885–1966). *Bacchanale Russe,*
1912. Bronze, 14 x 9 x 9 in. (35.6 x 22.9 x 22.9 cm). The Metropolitan Museum of
Art, New York; Bequest of Mary Stillman Harkness, 1950 (50.145.40a,b)

a number of dance sculptures inspired by Pavlova. During this period Hoffman saw Rodin twice weekly for instruction and ongoing encouragement for her new dance composition. She considered *Bacchanale Russe* an improvement on *Russian Dancers,* describing it in a letter to her sister Helen as "nude, and larger than the others, and much nearer real sculpture."[21] Although Pavlova and her partner were the inspiration for both groups, Hoffman made no attempt to reproduce them literally; rather, she aimed to capture their grace and ebullience in this particular ballet.

Aside from the *Bacchanale Russe,* in 1912 Hoffman completed five additional dance sculptures, including two works inspired by Nijinsky—*L'Après-midi d'un faune* (Tobin Foundation for Theatre Arts, McNay Art Museum, San Antonio) and *Faun Surprised* (unlocated)—and three pieces that were fragments from earlier works based on Pavlova and Mordkin. Rodin was especially fond of the latter pieces since he had championed the figural fragment as a legitimate form of sculptural expression. In the autumn of that year Hoffman returned to New York, where she attended several of Pavlova's performances at the Metropolitan Opera and Manhattan Opera, afterward filling her sketchbooks with ideas for sculpture. In anticipation of Pavlova's return engagement in the spring of 1913, Hoffman threw a fancy-dress party at Gutzon Borglum's studio. Several tableaux vivants were presented, followed by the evening's spectacular finale: Hoffman and a partner performing a simulacrum of the *Autumn Bacchanale.* While the dancing was done in the spirit of fun, Hoffman confided to her diary the sense of emotional release it had provided, "the joyous sensation of having once really forgotten everything . . . to have really danced and become a Bacchic spirit."[22]

Early in 1913 Hoffman made the acquaintance of Otto Kahn, chairman of the Metropolitan Opera, who had engaged Pavlova and her troupe for their first New York performances. Later that year she saw Pavlova dance in New York with Laurent Novikoff, which resulted in another dance group based on a pas de deux called *Les Orientales* (unlocated). The following spring, Hoffman's friendship with Kahn provided the opportunity she had longed for: an introduction to Anna Pavlova. Below an April 1914 diary drawing depicting some of the choreography of the *Autumn Bacchanale,* Hoffman detailed their first, carefully orchestrated encounter: "Mrs Otto Kahn arranges our meeting at tea. . . . My two bronzes on the tables in the library."[23] In her rendering of this scene, and in most of her other personal writings about Pavlova, Hoffman takes the tone of a suitor: "The fragile, pallid sprite comes into the room—dressed in black—with fiery flashing eyes—quick, unexpected movements . . . a great artist—this is at once evident. . . . I watch her, as a panther might crouch in a thicket and watch a bird. Every gesture records its line on my sensitive plate. From now on I must become a reel to register endless fleeting impressions and characteristic movements."[24]

Hoffman's use of the photography metaphor—of moving film—is telling and prescient. It is an indication of her great determination to "capture" movement, to transmute the art of dance into her own and, somehow, to transcend the stillness of sculpture. This description also predicts Hoffman's later use of photography in her preparatory work for dance subjects, the result of which is a rare and important body of photographic images of Pavlova and her partners.

Hoffman recorded no conversation between herself and Pavlova that first day at the Kahns' Fifth Avenue mansion, and it is possible Pavlova was taken aback by the intensity of Hoffman's scrutiny. Nevertheless, Pavlova wrote out a pass granting Hoffman access to rehearsals and to the backstage area of the theater, privileges the artist had coveted. For the next two weeks Hoffman was never far from the action at the theater. "Each night I go—I prowl about in the shadows . . . taking it all in—the air, the expectance—the scene shifting goes to my

head like wine. The music and the dance thrill me—precious pictures made by her as she hesitates behind the wings to rub her toes in rosin and powder her neck. . . ."[25] At some point during this time Hoffman began to win Pavlova over, and she sensed the beginnings of a friendship. What she desired most, however, was a relationship that would allow for collaboration, a means to coalesce dance and sculpture. Hoffman noted the blossoming friendship: "La Muse and I have many exciting moments of discussion, posing, criticism, instruction in dancing, the history & art of toe pointing, pose, rhythm. . . . We study effects at rehearsals— change, add. . . ."[26]

In 1914, not long after this heady experience, Hoffman left again for Paris, where she intended to continue her work with Rodin. Upon visiting Rosales's studio she discovered that he, too, had new dance sculptures inspired by Pavlova, and feelings of competition arose. "There are many sculptors and painters trying to interpret Pavlova. I wonder who will finally win—I shall try to—for as yet nothing expresses her—quite."[27] But Hoffman's summer in Paris was abruptly cut short by the outbreak of World War I. She and her mother left for the United States in mid-August, stopping first in London, where she visited Pavlova at Ivy House, her home in Hampstead. Hoffman presented Pavlova with a proposition: the depiction of an entire ballet—Autumn Bacchanale—in the form of a bas-relief frieze. Pavlova consented to the idea, at least informally, and over the next two days Hoffman made drawings as she watched Pavlova practice in her studio. Diary passages describing these intense Ivy House sessions are undeniably erotic, as Hoffman seems to have fallen in love with her muse. Besotted, she watched and drew as over and over again Pavlova danced the Bacchanale with an imaginary partner, stopping to hold poses as Hoffman began to work out the composition the frieze would take. Hardly able to believe her good fortune in having Pavlova entirely at her disposal, Hoffman

describes the encounter as "[the] sudden chance of a lifetime, to catch a living, fluttering piece of antique beauty and have it willing, keen, sympathetic, responsive—the soft, warm quivering body panting and bending like a wind-blown reed."[28]

This extraordinary moment of creative and romantic excitement took place against the backdrop of war, and Hoffman and Pavlova were determined to join forces to aid the cause. Under the aegis of the Music League of America, a support organization for musicians Hoffman had established some years earlier, the two women made plans to organize a performance to benefit the Red Cross. Traveling to New York late in the autumn of 1914, Pavlova arrived unannounced at Hoffman's studio bearing an armload of flowers for "Malvinoushka," and in the days that followed she posed for a poster to advertise the benefit. The image was, of course, a pose from the Autumn Bacchanale.

Aside from the 1914 sessions for what became the Bacchanale Frieze, Hoffman began work on the first image of Pavlova that may be considered a portrait: a figure, completed in 1915,[29] which portrays her in La Gavotte (fig. 112). One of Pavlova's most charming and popular divertissements, La Gavotte was danced to the tune of "Glowworm" from Paul Lincke's operetta Lysistrata, a song even then considered hackneyed. One Berlin critic described how Pavlova seemed to transcend her own material, reinterpreting a minor ballet by performing it as a series of sculptural poses: "Lincke's 'Glowworm' is itself drowned out, extinguished, by the musicality of those limbs, and that which to most minds would appear as purest kitsch, she succeeds with her first step in transforming from the ridiculous into the sublime. . . . Every item of the performance is like the creation of sculpture, thought out, felt, modeled, perfected down to the last detail."[30]

Hoffman's small statuette (fig. 113) is an affecting image of an elegant pose from the ballet. To re-create the luminosity of the yellow satin and silk costume, she made the

Figure 112. Anna Pavlova posing for *Pavlova Gavotte,* 1915. Gelatin silver print. Malvina Hoffman Papers, Research Library, Getty Research Institute, Los Angeles (850042)

made reciprocal use of one another to enhance their respective "businesses." Pavlova saw Hoffman's concrete images as a means not only to promote but to immortalize what were, ultimately, her ephemeral works of art. Aside from the sessions for Hoffman's sculpture, she also made herself available to pose for prints, posters, programs, and flyers. Hoffman, in turn, gave Pavlova access to wealthy friends who were delighted to entertain the famous dancer and make her visits to New York more pleasurable. Likewise, Hoffman shrewdly associated herself with Pavlova's fame as a means of promoting her own work. One flyer, for example, its cover embossed with an image of Hoffman's *Gavotte* statuette, boldly announces that "This sculpture is the work of Malvina Hoffman, the American sculptor. The sole rights to interpret this dance in sculpture have been given to this artist by Mlle Pavlova."[31] The viewer is directed to inquire of Pavlova's agent about purchase of the sculpture, for which Pavlova received a commission on sales. Hoffman's proprietary attitude is further revealed by her response to meeting sculptor Paul Troubetzkoy at a party following Pavlova's final performance of the 1915 spring season: "Rivals for La Muse—I challenge anyone, this time my Gavotte shall win!"[32]

The years between 1914 and 1924 were interspersed with brief, erratic opportunities for Hoffman and Pavlova to work together, usually at Hoffman's studio during Pavlova's New York engagements. In 1915, when she realized there would be long stretches between modeling opportunities, Hoffman arranged to have photographs made of each of the twenty-six poses for the *Frieze* (fig. 114). The resulting studies of Pavlova and partners Alexandre Volinine and Andreas Pavley are uniquely "candid" among the thousands of photographs of the ballerina. Neither in full costume nor elegantly soigné in street clothes, she is without artifice, much at ease, and even playful. There are no tights to hide the inevitable bruises a dancer lives with, and she has not "edited" her points (she was notorious

figure's surface in tinted wax. A plaster form supports the translucent exterior layer, but attenuated elements such as the fingers and bonnet brim are especially fragile. It is a difficult work to maintain; the Metropolitan's example, purchased from the artist in 1926, has been damaged and skillfully repaired.

One aspect of the complex relationship that developed between Pavlova and Hoffman was how these two very ambitious women

Figure 113. Malvina Cornell Hoffman (American, 1885–1966). *Pavlova Gavotte,* 1914; this version, 1918. Wax, 14¼ x 7¼ x 7 in. (36.2 x 18.4 x 17.8 cm). The Metropolitan Museum of Art, New York; Rogers Fund, 1926 (26.105)

Figure 114. Anna Pavlova and Andreas Pavley posing for *Bacchanale Frieze,* New York, 1915. Copyprint made in 1984 from glass-plate negative (1915). Malvina Hoffman Papers, Research Library, Getty Research Institute, Los Angeles (850042)

for doing so) by shading them until her toes resembled sharpened pencils.

Bacchanale Frieze, which in total required ten years to complete, was a remarkable undertaking that resulted in a plaster cast twenty-four inches high and fifty feet in length (fig. 115). Sadly, it was never cast in permanent material. A leitmotif in the relationship between the two women, the *Frieze* became a symbol of their friendship and of their regard for one another as artists. The

period from 1914 to 1924, when she was working on the *Frieze,* was a prolific time for Hoffman, as she established herself as one of the better known and more successful American sculptors of her generation. She completed another dance subject, *La Péri* (1921, Yale University Art Gallery, New Haven), which Pavlova posed for with various partners. A sleeker, more modern, and pared-down treatment of forms, the work contrasts with the airy delicacy of the

Figure 115. Malvina Cornell Hoffman (American, 1885–1966). Detail from *Bacchanale Frieze,* 1914–24. Clay, approx. 24 x 120 in. (61 x 304.8 cm). Photograph: copyprint made in 1983 from glass-plate negative (1924). Malvina Hoffman Papers, Research Library, Getty Research Institute, Los Angeles (850042)

Bacchanale Frieze. La Péri, Bacchanale Russe, and a number of Hoffman's other dance sculptures were purchased by Alma Spreckels for the California Palace of the Legion of Honor, now part of the Museums of Fine Arts, San Francisco. Hoffman also modeled a number of portraits (about which she no longer complained), including a second portrait of Milan Pribićević and three more interpretations of Paderewski, as statesman, man, and friend. There were fountain and garden sculptures; a World War I memorial for Robert Bacon's son for Harvard University; and, in 1917, two enlargements of the *Bacchanale Russe,* one half-lifesize and the other a heroic version that was placed in the Luxembourg Gardens in Paris. This sculpture, like many others in Paris, was destroyed in the German occupation during World War II; a second cast is in the permanent collection of the Cleveland Museum of Art.

Hoffman made nearly all of this work at Sniffen Court, a cul-de-sac in the East Thirties in Manhattan where in 1915 she had established her home and studio. As the years passed, Sniffen Court became a gathering place for Hoffman's impressive array of friends—artists, performers, musicians, writers, intellectuals, and social gadflies—who made it one of the more interesting watering holes in New York from the 1920s through the 1940s. It was there in May 1924 that Hoffman gave an elaborate costume party to honor Pavlova and to celebrate the completion of the *Frieze.* The list of two hundred guests was studded with the glitterati of the day, including the Otto Kahns, Ignacy Paderewski, photographer Arnold Genthe, artists Charles Dana Gibson, Augustus John, Alexandre Jacovleff, José Clará, and Jo Davidson, monologist Ruth Draper, and stage designers Seraphin Soudbinine and

Figure 116. Malvina Cornell Hoffman
(American, 1885–1966). *Pavlova as Byzantine
Madonna,* 1924. Colored plaster, H. approx.
48 in. (122 cm). Research Library, Getty
Research Institute, Los Angeles (850042)

Boris Anisfeld. The courtyard, hung with brilliant lights, led guests into a studio proudly described by Hoffman as "transformed into oriental splendor by red and gold hangings, satins, and brocades all loaned by the fabulous Mr. Miller of Louis the XIV Antique Shop fame. . . . Forty thousand dollars' worth of hangings covered the walls and balcony railings. Dancers appeared in his rare masks and costumes dripping with semiprecious jewels."[33]

For this extraordinary fete Boris Anisfeld had created an elaborate frame whose structure was modeled on a Russian icon. Halfway through the party, the doors of this niche opened to reveal the luminous face of a "Byzantine Madonna" who, once she raised her eyes and smiled, was revealed to be Anna Pavlova. The lasting result of this remarkable evening's revelry is the *Mask of Anna Pavlova,* alternately titled *Pavlova as Byzantine Madonna* (fig. 116). Several variations of this work were executed—including a plaster of the arching frame and the head in relief; a lifesize bronze; and a reduced version of the mask only—but it is the eerily beautiful wax mask (fig. 117) that is most successful. As she did for *Pavlova Gavotte,* Hoffman employed tinted wax, this time to suggest the jeweled head decoration and the lifelike color and texture of flesh. Pavlova is presented as a serene presence, her eyes demurely lowered. It is an ageless Pavlova, a face that betrays nothing of the depth of exhaustion that, by 1924, after sixteen years of unrelenting travel and almost constant performances, was taking a toll.

In 1924 Hoffman and Sam Grimson finally married. They later entertained Pavlova and her longtime companion and manager, Victor Dandré, at a rented cottage in Hartsdale, New York. Following those happy days Hoffman saw little of her beloved muse, who, well into her forties, continued to tour in Europe, Asia, and South America at a daunting pace. Six years later, at the age of forty-nine, ill and physically spent, Pavlova died of pleurisy in The Hague. Only days

Figure 117. Malvina Cornell Hoffman (American, 1885–1966). *Mask of Anna Pavlova,* 1924. Tinted wax, 16 x 9 x 7 in. (40.6 x 22.9 x 17.8 cm). The Metropolitan Museum of Art, New York; Gift of Mrs. L. Dean Holden, 1935 (35.107)

earlier Hoffman had seen her in Paris and pleaded with her not to continue on her mad performing schedule. It was the end of a remarkable friendship and collaboration, one that proved fruitful and lasting. Several months passed before Hoffman wrote of Pavlova again in her diary. In August 1931, while sailing from France to New York, Hoffman recalled those magical nights in London twenty-one years earlier when she had leaned against the brass rail in the top gallery of the Palace Theatre and watched, transfixed, as Pavlova and Mordkin danced the *Autumn Bacchanale*. She filled two pages with reminiscences, which begin, "To my beloved Muse—Anna Pavlova—Spirit of Beauty."[34] She described the first *Bacchanale*, how Pavlova and Mordkin had looked, how they had danced, the ineffable joy she had felt: "The first wild rush of Beauty grabbed me so tightly . . . that my heart swelled and my entire being throbbed with a newborn consciousness."[35]

Hoffman's depictions of Pavlova range from the ebullient to the serene, from the burst of nearly uncontained excitement in the *Russian Dancers* and the *Bacchanale Russe* to the refined élan of the *Pavlova Gavotte,* a diminutive figure of transcending elegance. It is remarkable that, in the end, Hoffman chose to represent only the visage of this supreme symbol of physicality, a face in a stylized setting. The same year the wax mask was completed, Pavlova sat for a portrait bust that was more naturalistic and immediate, but in that representation, too, the dancer looks downward, inward, away from the physical. The vision of Pavlova as a Byzantine Madonna, with all its eccentricity and period oddness, suggests the literally worshipful feelings of the artist for her subject. Hoffman meant it to recall the stillness of an icon, to evoke a powerful presence upon which the viewer might meditate. She meant it as a remembrance of Anna Pavlova's extraordinary power to move spirits.

1. The four extant volumes of Hoffman's diaries, written between 1910 and 1914, provide invaluable information about her early years in Paris and New York, but they also present a conundrum. There are two versions: the original handwritten volumes, and the typescripts of the originals. The typescripts contain additional, often contradictory information that creates an obscuring layer of confusion. Tragically, the volumes kept between 1917 and 1929 were lost or intentionally destroyed. According to Gulborg Grøneng, Hoffman's longtime secretary, the journals from 1930 on were severely edited when Hoffman determined them to be too revealing (interviews with the author, 1978–82). For the subjects covered in this article, all quotations, unless otherwise noted, are taken from the early original diaries, now in the Malvina Hoffman Papers, 1897–1984, Research Library, Getty Research Institute, Los Angeles (850042) (hereafter cited as Malvina Hoffman Papers).

2. Janis Conner, *Malvina Hoffman, 1885–1966,* exh. cat. (New York: FAR Gallery, 1980); Janis Conner, *A Dancer in Relief: Works by Malvina Hoffman,* exh. cat. (Yonkers: Hudson River Museum, 1984); and "Malvina Cornell Hoffman," in Janis Conner and Joel Rosenkranz, *Rediscoveries in American Sculpture: Studio Works, 1893–1939* (Austin: University of Texas Press, 1989), pp. 53–62.

3. Malvina Hoffman, *Yesterday Is Tomorrow: A Personal History* (New York: Crown Publishers, 1965), p. 48.

4. Hoffman, "To Oblivion—Comments by Malvina Hoffman about Some of Her Works," typescript, Malvina Hoffman Papers, box 134, p. 21.

5. Other casts of this model are in the collections of the Art Institute of Chicago and the Smithsonian American Art Museum, Washington, D.C.

6. In the 1950s Hoffman gave a group of twenty-nine plaster portraits to the New-York Historical Society.

7. Malvina Hoffman to Helen Draper, February 26, 1911, author's copy.

8. During her childhood Hoffman spent a great deal of time with her father, who was by then retired. Early on in his career he had gained wide recognition playing in a piano duo that performed on Jenny Lind's P.T. Barnum-promoted East Coast tour in 1850. A much-respected performer, Richard Hoffman was known to the musical public of New York as a recitalist and soloist with the New York Philharmonic.

9. Hoffman, *Yesterday Is Tomorrow,* pp. 74–75. Hoffman's recollection of what she saw in 1909 is a conflation of her visits to Mrs. Simpson and later to Rodin's studios; however, major works she is certain to have studied then include *The Age of Bronze* (1875–76), *The Walking Man* (1878–1900), *The Kiss* (1880–87), and *The Evil Spirits* (ca. 1899). The Simpson collection of twenty-eight works was donated to the National

Gallery of Art, Washington, D. C., in 1942. A detailed discussion of the history of the collection is covered in an excellent essay by Ruth Butler in the National Gallery's recent addition to its systematic catalogue, Ruth Butler et al., *European Sculpture of the Nineteenth Century* (Washington, D.C.: National Gallery of Art, 2000), pp. 409–13.

10. Hoffman's first encounters with Rodin are recalled in both of her autobiographies, *Heads and Tales* (New York: Charles Scribner's Sons, 1936), and *Yesterday Is Tomorrow* (1965). The later book, published a year before Hoffman's death, contains a number of exaggerations and inaccuracies and should be read, in most instances, as an entertaining memoir rather than as a reliable historical record.

11. Diary, Malvina Hoffman Papers, box 134.

12. Ibid.

13. Ibid.

14. Keith Money, *Anna Pavlova: Her Life and Art* (New York: Alfred A. Knopf, 1982), p. 75.

15. Diary, Malvina Hoffman Papers, box 134.

16. Ibid.

17. Ibid.

18. Ibid.

19. Secretarial records of works by Malvina Hoffman, author's copy.

20. Diary, Malvina Hoffman Papers, box 134.

21. Malvina Hoffman to Helen Draper, August 26, 1912, author's copy.

22. Diary, Malvina Hoffman Papers, box 134. Hoffman incorrectly states in *Yesterday Is Tomorrow* (p. 140) that Pavlova and her troupe were in attendance at this party, when in fact Hoffman and Pavlova had not yet met.

23. Diary, Malvina Hoffman Papers, box 134.

24. Ibid.

25. Ibid.

26. Ibid.

27. Ibid.

28. Ibid.

29. This date is given incorrectly as 1914 in Conner and Rosenkranz, *Rediscoveries in American Sculpture*, p. 55.

30. Quoted in Money, *Anna Pavlova,* p. 195.

31. Malvina Hoffman Papers, box 103.

32. Diary, Malvina Hoffman Papers, box 134.

33. Malvina Hoffman, *Yesterday Is Tomorrow,* p. 148.

34. Diary, Malvina Hoffman Papers, box 134.

35. Ibid.

Photograph Credits

All rights reserved. Photographs were in most cases provided by the owners of the works of art and are published with their permission; their courtesy is gratefully acknowledged. Additional credits follow.

David Allison: fig. 61

Courtesy The Art Institute of Chicago: figs. 80, 84

© 2002 The Art Institute of Chicago, All rights reserved: figs. 78 (Robert Hashimoto), 79 (Robert Hashimoto), 86

© 1990 The Detroit Institute of Arts: fig. 50

Courtesy Gebr. Douwes Fine Art, Amsterdam: fig. 68

Niels Elswing: fig. 7

© Field Museum of Natural History, Chicago: figs. 82, 83

Valery Golovitser: fig. 108

Courtesy James Graham & Sons, New York: fig. 110

Helga Photo Studio, courtesy Conner-Rosenkranz, New York: fig. 30

Courtesy The Hispanic Society of America, New York: fig. 54

Franz Jantzen: fig. 9

Karin E. Johnston: figs. 69, 70, 77

Eric Mitchell: fig. 97

© Museum of the City of New York: figs. 47, 100

© 2002 Museum of Fine Arts, Boston, All rights reserved: fig. 20

Courtesy Board of Trustees of the National Museums and Galleries on Merseyside, Walker Art Gallery, Liverpool/photograph by John Mills: fig. 55

Jeffrey Nintzel: fig. 1

© Réunion des Musées Nationaux/Art Resource, NY: figs. 58, 71, 72

Michael Richman: fig. 57

Jerry L. Thompson: figs. 2, 14, 21, 37-39, 51, 63, 66, 67, 92, 93, 95, 104, 105, 111, 113, 117

Courtesy U.S. Department of the Interior, National Park Service, Manhattan Sites, New York: fig. 42

Courtesy U.S. Department of the Interior, National Park Service, Saint-Gaudens National Historic Site, Cornish, New Hampshire: figs. 44 (Jeffrey Nintzel), 48, 56 (Jeffrey Nintzel)

Ole Woldbye: fig. 13

Carson Zullinger: fig. 3